## PRAISE FOR *I, BIFICUS*

"From rock bottom to rock princess, Bif Naked graduated
from the school of hard knocks and punk rock by turning
her life 180 degrees. Her book would inspire anyone to
turn their life around with a bang."
—NAZANIN AFSHIN-JAM

"A no-holds barred account of [Bif Naked's]
tumultuous life and career."
—*Vancouver Sun*

"Spirited and sincere."
—*The Georgia Straight*

"One would expect a memoir by Canada's queen
of punk to be more about heavy days of partying than
facing breast cancer or embracing yoga. But Bif Naked
defies the stereotypes in her new memoir."
—*Metro Winnipeg*

"Nietzsche got it right when he said that
what doesn't kill you makes you stronger. Bif is living proof.
After all she has endured she maintains integrity and a sense
of humour. Her story is inspiring, to say the least."
—SAM FELDMAN, founder of A&F Music
and the Feldman Agency

# I, Bificus

# I, BIFICUS

a memoir

bif naked

HarperCollins Publishers Ltd

Published by HarperCollins Publishers Ltd

First published by HarperCollins Publishers Ltd in a hardcover edition: 2016
This trade paperback edition: 2017

This is the author's true story, as she knows it. Some names and identifying details have been changed.

HarperCollins books may be purchased for educational, business, or sales promotional use through
our Special Markets Department.

HarperCollins Publishers Ltd
2 Bloor Street East, 20th Floor
Toronto, Ontario, Canada
M4W 1A8

*www.harpercollins.ca*

Library and Archives Canada Cataloguing in Publication information is available upon request.

ISBN 978-1-44341-973-4

Printed and bound in the United States

LSC/H 9 8 7 6 5 4 3 2 1

This book is lovingly offered at the feet of my boyfriends and girlfriends, bandmates and crew members, record executives, managers, agents, friends, family, and animals who were all in the trenches with me, digging deep and fighting the good fight. You rule!

# CONTENTS

# FOREWORD

god save us from geminis            by peter karroll

I WALKED THROUGH THE FRONT DOOR OF FIASCO BROS
Recording Studios in New Westminster, British Columbia, where the
walls of the reception area were covered in band posters, handbills,
and musician wanted ads. The table just inside displayed a half dozen
stacks of music publications, both local and national. I stopped in
my tracks, picked up one of the publications, and stared at the full-
page eleven-by-seventeen-inch photo on the front cover. "Bif Naked"
it read in large print, with "Chrome Dog" in smaller print at the bot-
tom. The young woman with black hair, large eyes, and tattoo work
on her right arm was leaning on a table, head in hand, a glass of alco-
hol, an ashtray, and a café-style sugar dispenser in front of her. The
oversized eyes stared out at me, and at that moment, unbeknownst to
her, I became locked in the destiny of the artist professionally known
as Bif Naked.

I walked into the studio and called the only person I knew in the
Vancouver alternative-music scene, local soundman and road manager
Mike Price.

"Mike, it's Peter Karroll. Bif Naked—do you know her?"

"Of course I know Bif," said Mike. "I've done sound for her band
Chrome Dog."

"Good. I need a number. I want to manage the band."

That was the beginning of my journey with "the girl most likely to fail," the one with the most incredible story, with all odds against her. She did not ask for it, she didn't push it, market it, or sell it. Everyone who has met her, heard her music, come to her shows, and has been lucky enough to work with her, all of them have spread the word on her behalf. As her personal manager, guardian, bodyguard, and close friend, I have been continually surprised and amazed by her creative and academic potential, multiple personalities, and unstoppable humour, which she uses as her armour and weapons of self-defence.

Her life's journey is etched in tattoo ink across her body, and conveyed by her ability to transform her life stories into song lyrics. She found her voice as a solo artist. When no labels wanted her, she and I partnered to create her personal record company HRM Records, and, at twenty-three years of age, she became an international recording artist on this label. Throughout a remarkable career, armed with her unique talent and instantly identifiable look, Bif captivated the imagination of audiences and media alike. She released ten albums and twenty-two videos, embarked on seemingly endless international tours, and took on several feature film and television roles, only to be knocked down with breast cancer at the age of thirty-seven. Bif would fight the battle for her life—and discover her passion for advocacy. Throughout the journey, what she cherished most of all is her own resilience, strength, and unfaltering relationships with fur children Annastasia the bichon frise, and Nick Naked, her Maltese poodle. It's already been a long, winding road. This is Bif Naked's story so far.

# PROLOGUE

I HAVE BEEN WHAT MY FATHER REFERS TO AS A knucklehead for as long as I can remember. I was a born performer, and luckily for me, my parents recognized, encouraged, and celebrated this. I was enrolled in ballet, piano, art, and theatre lessons throughout my childhood, so perhaps it was only natural for me to find freedom from the strictness of home in music and, as it turned out, particularly in the subjective genre of punk. This, of course, was to my parents' surprise, having raised me on hymns from both Hindu and Christian traditions. Little did they know that I was headed into a successful career spanning more than twenty-five years as a rock vocalist and would be able to thread and weave my art and passion for poetry into the cloth of this work, creating a life of intensity and joy as a female straight-edge skate punk in a world of hardcore male mentors and heroes. Dodging death by violence, misadventure, cancer, and chronic heartache, I remain committed to this life of gratitude and total optimism because of my limitless sense of humour, my yoga practice, and my complete faith in humanity, still undaunted and unchanged. I love life and I love all the shenanigans it provides.

# ONE

**NOTHING EVER MATCHES ONE'S PRIDE IN ONE'S** heritage. I should know. I am a proud Canadian.

I am an Indian-born, born-abroad Canadian (or like I enjoy saying, "I was born a broad"). I have been these two things for as long as my memory goes back. I learned my patriotism from my father—or at the very least, how to brag about it. He was an American who gave up his citizenship to become Canadian. My mother never did, and remained a Minnesota girl.

Shireen, my sister, was Indian, and because Heather was my parents' "natural" child, she was American. I was the lone Canadian in the family. My parents made a point my entire life of introducing me to anyone and everyone as their "Canuck." They identified me as this, and I have self-identified as a Canadian every single day I have been alive. I can't imagine being anything else, no matter where I live.

Canada is my first love, or maybe my true love—or maybe Pierre Trudeau actually was. He was the prime minister when I was born and remained so until I was in my adolescence. Like many Canadian citizens, I had a crush on him. He was charismatic and good-looking, he had an unbeatable demeanour, and he had sex appeal. I wanted to be able to speak perfect French in case I ever had the chance to meet him. French was my best subject in school, second only to "boys." *Bien sûr.*

Pierre Trudeau was worldly, chased women, knew artists, laureates, and writers, and was demonstrative. Trudeau gave people the finger, which was forbidden, like cussing, by my parents, and it only endeared him to me more. He was like a rebel political rock star, and I absolutely loved him. I used to daydream that I would live in Montreal like Pierre and Irving Layton did.

Irving was another crush of mine, and as a young teenager I read his books in bed and masturbated quietly in the dark. I collected his books feverishly—finding one was like finding treasure, or a gift from a secret lover. I was such a dreamer, and was happiest fantasizing that some lovely man read Irving Layton's poetry to me while I lounged in the bath. And this was to happen every night for the rest of my life, or at least for a week in some filthy hotel in the Pigalle district of Paris. A man who was a younger version of artist-director Julian Schnabel would be perfect. I read that Schnabel had a bathtub installed in the middle of his bedroom so he could watch his beautiful wife bathe. This idea has burned into my mind and as a result prevented any man from ever winning me over completely if his idea of romance is anything less. I was a pure romantic and remain so to this day.

Because my father so loved Canada, he defected from America, much to the chagrin of his family. He loved Canada even more than I do. He used to joke that God talked to him through the CBC, and although I didn't believe this as a child, I believe it now. My father loved to pontificate, debate, and bestow his expertise through his constant advice giving and preaching of grand ideologies. I get my knack for this from him. My manager, Peter Karroll, nicknamed me "Bif Clavin," after the great know-it-all Cliff Clavin, from the TV show *Cheers*. I can convince anyone that I am an expert on almost any subject, no matter what. And if I make a statement with enough conviction, I often convince *myself* that it is true.

I am greatly influenced by my sweet, quiet mother. She is not the type of person to bring attention to herself. A saint, and a perfect example of kindness, grace, and femininity, she lives for the happiness of others. She would make a great Buddhist. She does make a great Christian, and I'm sure the Hindus and Krishnas would love to have her. Trust me, I'm Bif Clavin, I know these things.

Jeanette McCracken, my mother, was born in Hibbing, Minnesota, and had two siblings who were both ten years her senior. She went to high school with Bob Dylan but was too shy to say hello to him, and besides, in high school he wasn't famous yet. My mother says that, as a child, she was rarely spoken to by her parents. Her father worked all day, and when he came home to their rural house retreated to his room, coming out only for meals with the family. Most of the meals were eaten in silence. I wonder a lot about my mom's childhood in Hibbing. It must have been a lonely existence.

My maternal grandmother, Selena, was always talkative around us grandkids, especially after my grandfather passed away. Selena had a laugh that I still sometimes hear in my sleep all these years later, shrill yet beautiful, like scream-laughing, and once you heard it, you couldn't help but laugh at the absurdity and joy of the noise. She smelled of roses, and all her bathroom soaps were roses, which I hated—they stunk. It's funny, though, that now I wear rose-scented perfumes, embracing my childhood memories and the family love the scent holds for me.

My grandfather Oscar was a railway engineer who drove the trains in the open-pit iron-ore mines—steam engines, then diesels, he drove them all. When he was younger he was a firefighter, one of the extension-ladder guys. But then he came home one night from work and didn't speak for several days, not a word. He finally confessed to

Selena that several firefighters had been killed in a fire. He decided then and there that he needed to change jobs. My grandfather never had alcohol in the home—when Oscar was a small boy, his father had let the family down because of alcohol. I don't think my grandfather ever laughed; he was a quiet, thoughtful, serious man. As young children, we were afraid of the strange bump on his ear; we often stared at it. It was a growth that he had had since he was little, and he told us that God put it there so he would never be lost: it was such a distinctive, identifying mark that people who saw it would know for sure he was Oscar.

My father, Dr. Ken Torbert, loved to tell stories of his and his three brothers' boyhood shenanigans. They were preacher's kids getting into preacher's kid mischief. He grew up loud, was never shy or quiet, completely the opposite of my mother. I believe that I am the perfect blend of them both, though this is entirely environmental, as I have zero genetic links to them.

My parents were good Methodist children, both members of the Wesley Foundation University of Minnesota, and thoroughly involved in the United Methodist Church groups. They met at university. My mother was studying nursing and working as a nurse's aide in a Masonic hospital, where she dealt exclusively with cancer patients. She loved her studies but quickly realized that she loved the work she was doing with the patients—she was in the trenches with them. She decided she did not want to become a registered nurse and leave what she was doing. It seems a bit odd to me, as her daughter, to be now living an almost parallel experience.

My father's first year at university was so disappointing for him that he decided to volunteer for the army. He believed that serving in the military was exactly the self-discipline he needed to get serious about his studies. He claimed he needed an attitude adjustment and

so set out to give it to himself. He returned to his studies, and after taking all manner of courses, from Spanish to Russian history, finally received his degree, in zoology, and was accepted into dental college.

Zorah Torbert, my father's mother, was a beautiful woman with blonde curls of hair and little horn-rimmed glasses, as was the style of the day. I can still picture her vividly. We kids sometimes spied on her as she gave herself insulin injections. Every morning, she did the injections on her bed, her dress up, the needle into her blue-mottled leg hanging over the edge of the bed. Her name was Zorah, but my older cousins called her Zorro, and so I did as well. Grandmother Zorro was a lifetime member of the WCTU—the Women's Christian Temperance Union—and was very much opposed to alcohol or any other intoxicating substance.

My parents were both brought up in homes without alcohol, and they in turn kept it out of their home during their lives together. They were married in 1960 in a small church wedding filled with hope and their faith in God. How they came to decide to embark on a missionary trip to India I will never know for sure, but I believe they were probably just asked and thought it would be a great adventure.

They were extremely interested in and participated in the Civil Rights Movement, and were the only two people to accompany their pastor on the legendary march on Washington, where they heard Dr. Martin Luther King speak to the crowd at the Lincoln Memorial. They sat on the edge of the nearby reflecting pool and dangled their feet into the water as they listened to his words. My dad retold the story often, always marvelling at how positive everyone's energy was there. My parents both stood behind non-violent protest and encouraged this in others. My dad told me, "When we listened to Dr. King, it was so good. The words from his mouth were all you could hear, it was powerful and loving. I just thought, 'Right on, man! Right on!'"

My parents could not have known then that it was such a historic moment. All they knew was that they were united with Dr. King. The Civil Rights Movement continued to inspire and draw them. The year 1965 was a time of great struggle in America, and my parents were deeply involved in the efforts of non-violent activism. There was a call to action—for religious leaders and other citizens to join in another peaceful march for freedom—by none other than Martin Luther King himself.

Activists, including those with the Southern Christian Leadership Conference and the Student Nonviolent Coordinating Committee, who had been campaigning for African-American voting rights faced abuse, arrest, and much brutality. My dad and eight other men departed immediately for Selma, Alabama. My father was honoured to work with the committees, the young lieutenants, and the other young men, and marched with them from Selma to Montgomery, Alabama. He felt privileged and wanted very much to stand with his fellow human beings. He admitted to me later that he was happy to be in solidarity with the marchers but was afraid of the white troopers who called him a "white nigger" and threatened the protestors.

My dad was afraid for his life, as he knew men had died, some actually murdered by the very law officers and sheriff's deputies who had sworn to protect. He was trembling inside but he never flinched, and despite what the deputies might do to him, he was not leaving. He just prayed to God.

A few months after their involvement in the Civil Rights Movement, my parents prepared for their trip to India on behalf of the United Methodist Church mission, and which was to include Hindi language studies. Eventually, they embarked on a boat journey across the Atlantic. It took weeks to reach the Indian Ocean. My parents were both seasick during the trip, but it was much worse for my dad, as

he also had an allergic reaction to the mangos he ate on the boat. He suffered miserably the entire journey.

Upon arriving in India, my father began teaching at Christian Medical College in Bareilly, a city with a world-renowned mental health facility. To tell someone you were from Bareilly was to be met with riotous laughter and lots of teasing. My parents lived in a house provided for them there. They had a cook, a housekeeper, two dachs-hunds (Dinah and Schroder), and tiger lilies all over the property. My mother's nickname was Tiger, after the lily, a contrast with her personality, which was modest and had a quiet loveliness to it always. She primarily helped out at the local nursery and ashram.

My parents' work in Bareilly meant they were active in their local community, which suited them well, both being idealistic young social-ists. Soon, though, they would find themselves the guardians of two small children, with all that entailed.

# TWO

CHILDREN'S BEHAVIOUR IS USUALLY MOTIVATED BY desire. Mine was no different. My constant striving for validation, affection, and love often manifested itself in provocative displays. My birth mother was a provocative child, rumored to be not only uncommonly beautiful but also overly friendly. This overt friendliness ran through my blood too.

My birth mother, Maureen, was pregnant at age fifteen and gave birth to me at age sixteen. Those green saucer eyes of hers got her into trouble, I reckon.

My soon-to-be parents lived in a compound behind a seven-foot-high brick wall; the compound consisted of a hospital, a dental school that was part of a larger dental hospital, a seminary, and their house. The dental school had the latest state-of-the-art dental equipment, so that's where foreigners from all over India went for dental work. The mission's dental school saw a lot of patients—Bareilly was only a five- or six-hour drive from New Delhi—many of whom were regulars.

A nurse who worked at the local orphanage reached out to my mom, thinking she might be able to help with a baby who had been brought in. The girl had been surrendered by her family two months earlier and was now deteriorating in health, and not much more than skin and bones. When terrible sores began to threaten the infant's

life, my mother went every day to care for and hold the baby girl. Eventually, my parents took her to their home and began to care for her full time. The baby, named Shireen, recovered and began to thrive.

News of my parents' new baby girl spread, and the mission was excited for them in their role as new parents. Before long, one of the dental patients, a nurse from Lucknow, asked my parents if they might be interested in taking another baby. She was friends with Dr. Stringham and his wife, the couple running the psych hospital in Lucknow. Their friends were diplomats from Canada whose teenaged daughter was expecting a baby in a few months. They were trying to find a suitable couple willing to adopt this Canadian child. As my dad tells it, he said, "Sure, if nobody else wants the baby, we'll take it." (At this point in the story, my father always laughs.) Dr. Stringham began to correspond with my parents, acting as the contact person between them and the pregnant teenager's parents. My father and mother never had any direct contact with the Canadian family.

When the time finally came for them to go to New Delhi, my parents were ready with a letter signed by Dr. Stringham on behalf of the birth mother. They went to the Holy Family Hospital as per the arrangement, and attempted to give the letter to the hospital staff, who promptly waved it aside and handed the white baby to the white people. It was 5 a.m.—they had arrived early in an attempt to beat the heat of the day—and they had a long drive back home, so they left with me. They hadn't signed anything or received any documentation; they just went on their way.

And this is how the adoption process started, with their applying to the Indian courts in Bareilly to legally adopt my sister and me, so that they could return to America with us. Adoption by Christians was not all that accepted in India at that time, as only 3 percent of the population identified as Christians. The courts had difficulty understanding

how we came to be in our parents' care. There was no proper paper-work for me, a Canadian baby in India, no father listed. Good luck with that. My parents should have saved themselves all the stress and just lied. But they were good people and so patiently and painstakingly went through the process.

Shireen and I remained blissfully oblivious to the fact that we were almost seized and taken away from them. We just played under the big wooden desks as my parents pleaded with the judges, trying to explain why they had no proof that we had indeed been handed over to them, other than the agreement letters they had signed for guardianship of us.

India had no real way of dealing with Americans adopting Canadians within its borders, and it was incredibly difficult to get the proper paperwork from the US Department of Immigration once the court finally did give its approval for my parents to bring Shireen and me to the United States based on their intention to adopt. I was finally accepted into the States just two days before we were to depart from India. Many months later, in a South Dakota courthouse, and the adoptions of one brown kid and one white kid from India were granted to the nice Methodist couple.

We moved to Minneapolis, Minnesota, my parents still fresh from their mission work, and my mom now pregnant. Before long, Shireen, the eldest daughter, and I were adjusting to our new baby sister, Heather.

I battled ear infections monthly, likely caused by sticking all man-ner of things in my ears and nose. I had an amazing talent for get-ting up to things, from wrestling with geese at the man-made lakes of Golden Valley, the suburb of Minneapolis where we lived, to hiding in the church closets during service.

With optimism in their hearts, my parents sought out their next mission from the Church. They were unable to renew their visas to

India through the Board of Missions—likely something to do with funding—so they were asked to consider the Congo—there was a possibility of setting up for training for dental therapists in Kinshasa. Half the costs would be paid for by the United Methodist Church mission agency and half by the Congolese government, headed up by good ole Mobutu. The Congo had just produced its first five Congolese dentists. My dad asked these dentists if they might supervise the dental therapists he trained, and he even visited several towns with these brand-new dentists. Although it was becoming increasingly clear that this was no time for foreigners in the Congo to start up some new—and to many there, wacky—dental therapy program, my parents wanted to go to investigate the possibility nevertheless. It is amazing to me now to think that they were seriously considering moving all five of us to sub-Saharan Africa. What a life-changer that would have been.

My little sister was less than a year old when my parents left for the Congo (a fact that, I suspect, causes my mother a lot of hand-wringing to this day), Shireen was three, and I had just turned two. We two older girls stayed with a family who had a daycare in their home, with as many as ten or fifteen kids there every day. We would be staying with this family for the entirety of my parents' sojourn. Heather stayed with a lovely young couple who could devote their time to a baby.

Breakfast every morning involved all those white kids (I identified myself as an Indian kid like my sister, though the reality was that I was white as well) who attended the daycare standing around my sister and me as we ate our cereal at the kitchen table, still in our pyjamas. They didn't speak to us. They just stared. I can't even remember feeling anything at all in response to this early effort to alienate my sister and me (or so it seemed to us), even though *we* were staying there and they were there just for the day. People trying to alienate us was something

we'd battle throughout our childhood years spent at public schools. It was an action built on bigotry, and not helped by the fact that we moved to a new city every couple of years, just like military brats, so that we were always outsiders.

Within months, upon their return from Congo, my parents and the Board of Missions had grown unhappy with each other and mutually agreed to part ways. With only three more weeks of pay coming to him, my father was faced with looking for a new job. So he found an opening in a program in a place a far cry from India and Africa, but exotic nonetheless.

# THREE

**MY PARENTS RETURNED FROM AFRICA AND HAPPILY** announced that we were moving to Canada—"North of the fifty-third parallel, where the polar bears live." I will never forget their saying this. I was about three years old and I couldn't wait to see the polar bears.

My father accepted a teaching position at a community college in The Pas, Manitoba. We relocated there in winter. It was so far north that it seemed like it was dark night and day. My poor mother was much less excited about the move than Shireen and I were—I don't think the Great Northern Tundra was at all appealing to her. She was isolated indoors with three little kids—we girls couldn't run about out-doors during the northern Canadian winter—in a very cold, very dark, and very lonely little town. We lived in a heated construction trailer, the kind with a central hallway with rooms off to the sides and a small bathroom. We lived there and we ate there and we froze there. We stayed there for several months, until a house was available. It too was really just another trailer, but more permanent.

Our new trailer was stationed in a parking lot of the community college where my dad taught. It was cramped quarters, and I cannot imagine my mother being pleased with this existence either, but I know it was better for her psyche than living in, say, Calcutta. Or in

Africa. It was the right choice with three little kids like us, especially me, the holy winking terror. I winked at all men, at every opportunity. Everyone thought my winking was cute, but my mother knew better.

My best friend at age five was Amy, who had a dog named Chico. Amy's mother was from the Philippines, and her Canadian dad worked for the forestry company and was never home. By then, we had moved into a house my parents bought in a new development in The Pas, a growing town. My and Amy's houses were just down the street from each other.

The neighbourhood was beautiful and clean—and safe: back in the seventies, we kids were not often supervised while playing outside. To us, the "neighbourhood" was the last row of new houses in the subdivision, with a big greenbelt of forest at the back. Amy and I almost burned down that greenbelt in our makeshift fort behind her house. We were trying to smoke a cigarette, using some matches we stole, and in no time a fire had started at our feet. We swiftly sprang into action, Amy putting it out with a metal trash-can lid that we'd scavenged from someone's yard.

Amy and I were always into some small mischief. We ripped off the neighbourhood kids by selling lemonade that was so watered down it was flavourless. Our customers protested, but with Amy and me frowning, arms crossed and giving the kids the stink eye, no one did anything about it.

My parents finally gave in to my and my sisters' constant whining for them to buy us a dog. When summer arrived, we picked up a puppy on a trip to Minnesota, where my mother took us for holidays. We bought a little cockapoo-dachshund, hiding her under blankets in the car as we crossed the border back into Canada. This "smuggling" was a thrill for me, and I felt proud that my mother could pull the wool over the border guard's eyes. She became my hero.

Muffin was a loving puppy and so great with us all, so sweet. She was a cocker spaniel crossed with a poodle and a dachshund—a cocka-poo, a word that always made me laugh out loud. I said it often, knowing full well I couldn't really get in trouble for doing so. This little dog loved me and my sisters, but I was the most in love with her and monopolized the poor dog's time. She accompanied me everywhere. I loved dogs. I guess I have always been a dog person, with one exception.

The neighbours had a Great Dane that constantly knocked us girls to the ground, then proceeded to climb on top of us and hump us while we screamed and shrieked in horror, the neighbourhood boys laughing hysterically. The huge dog remained undisciplined for at least as long as we lived there, and we avoided the beast as much as possible.

The Anderson family had all boys. Kenny, who couldn't have been more than twelve years old, was skinny and blond, and wore dark-rimmed glasses. He was very responsible for his age, so he was often asked to babysit us. Shireen and I were terrors. Heather, the youngest, was too shy to misbehave, but Shireen and I were a constant handful, especially me.

I felt it was my duty to torture Kenny, and it was never long before I took all my clothes off and ran naked, yelling "Chase me!" and waving my arms madly. I'd laugh and squeal down the hall, then down the steps of the back porch. I'd run naked down the lane, the poor kid desperately running after me, waving my footed pyjamas and begging me to come back. This was to my utmost delight, and I repeated the pattern over and over with every single babysitter who came to the house. (I learned that Kenny later went into the priesthood. It would not be the last time I drove someone to religion.)

Shireen and I endured the first few school years of what seemed like constant spankings from schoolteachers. One teacher pulled me

right out of my chair and paddled my butt in front of the whole class. Nobody said a word about it—not the other teachers present (it was an open-space school), not my classmates, not my sister, nobody. I was too ashamed to tell my parents—doing so would only ensure that this action was repeated at home, as they would have suspected—quite accurately—that I had earned the walloping.

"The Lord's Prayer" was broadcast over the school's PA system every morning. Wherever you were, you had to stop and stand still while reciting along with the taped prayer. At some point, this was replaced with a sung version of the prayer, so then we had to stop and sing. I had a dance routine I performed to the song, to try to get laughs from the other kids, and it never failed.

In The Pas, about half the students were white kids and about half were Cree. It was a wonderful introduction to public school in Canada. When I was six, my father caught a couple of boys and me in the garage, attempting to copulate. They were from the neighbouring Cree reservation, and the three of us were constant companions for getting into trouble. I wrote letters to the boys saying they were beautiful and often waved at them in class. I learned a lot from them. They taught me how to skip a rock across a pond, how to tie a perfect knot, and games that sexually curious kids sometimes play when no parents are around. One day they taught me how to steal.

I stole a package of chewing gum from the grocery store. I was so nervous about the package fumbling around in my parka pocket. Later, my mother found it in my pants pocket while doing laundry and asked where I had got it. Consumed with guilt, I confessed, and she promptly marched me down to the grocery store to give it back and apologize to the owner. I was so mortified that I never stole anything ever again.

My poor mother used to find the strangest things in my laundry, including blue fuzz. Without fail, I had bright blue fuzz in my

underpants. She must have eventually figured out what I was up to, as she took away my Grover doll. I never asked about him, but I knew my mother knew. It just made me pray harder to God.

Shireen and I asked my dad a lot of questions a lot of the time, about bodies and sex and things people do and, in between fits of giggles, other sex questions. My dad never flinched. Instead, he laughed his big laugh and answered our inquiries without hesitation or embarrassment. That was just how my dad rolled. We never dared ask my sweet mother, as we didn't want to embarrass her. So all the tough questions went to my dad.

During my prepubescent years, I had no real concept of girl-love, with the exception of what I shared with my two girl buddies from my first-grade class. The three of us had spent a great deal of time in the tent pitched in my backyard all summer. My parents' intention was to keep us out of trouble with this offering of a canvas pseudo-fort. But inside the tent, we were fooling around, exploring—a lot. Long summertime sunsets in northern Manitoba and the innocence of laissez-faire parental supervision didn't hurt. Predictably, once back at school in the fall, without discretion or secrecy, we held court every recess, educating the other kids on how to have a special nap, just like parents did. Our classmates abandoned their recess plays, their homages to George Lucas's new film, and sat, chin on hands, transfixed by our embellishments and theatrical descriptions. We should have charged speakers' fees. We loved those captive audiences.

Now, these were the seventies, and by that I mean they were "happier" and more "whimsical" times. We simply had no frame of reference for anyone or anything that might cast a judgmental, negative, or sinister shadow on our innocent play, our private games. That is, until one of the older girls got wind of our information assemblies and crashed the playground party, announcing to everyone that we

were—*gasp*—lesbians. Hilarity commenced among our loving fans, our loyal audience, and they abandoned us, cackling. With one word, that girl pushed us off our pedestals, crushed us, knocked the wind out of us. And we didn't even understand the meaning of the word. Yet she changed our perspective on our little sessions, and that of our young classmates.

I felt embarrassed and ashamed. I didn't know why the girl would say that. Why did she want to make us feel so bad? I decided to muster up the guts to ask my dad, not that it was particularly frightening to ask him a question; it was the question itself that had me flustered. But I had to know what the word meant, this word with so much power, this word that silenced us all in the schoolyard. And my father would know—he knew everything.

That morning, I insisted on having my hair done first, ahead of my sisters, so that I could seek my father's wisdom before we left the house for school. I stared at him quietly, breathing nervously, inhaling the scent of his shaving foam. It smelled like trees and mint. It smelled like my dad smelled when he hugged me.

The water was running in the sink as he stood over it, the steam rising, fogging up the mirror. The upstairs bathroom in my parents' home needed repair, but the hot water pipe sure worked. I was convinced it might burn my skin clean off if I got too close. So I stood in the doorway.

Dad was wearing those white underpants that all dads wore (or so I thought), kind of baggy and weird, and his church clothes were hanging on the hook on the back of the bathroom door. That silver hook, high above my eyeline, jutted out like a big knife.

"A lesbian is a woman who loves other women," he said, rinsing his razor in the half-filled sink, then going back for more. He didn't look at me, just answered my question. My father was absolutely

neutral about the whole thing. This pragmatic approach was typical of both my parents. I said nothing, willing my six-year-old brain to memorize his words.

I said it to myself, "A woman who loves other women." I was astounded.

"Why? Do you think you're a lesbian?" My father stopped shaving and looked at me.

My mother's voice carried through the house, "Beth? Beth! Are you dressed?"

Grateful for the timely interruption, I broke into a little self-conscious smile. "Thanks, Dad." I turned on my toes and ran down the stairs two at a time, pulling on the thin iron railing, my clammy hands squeaking all the way down. Although I don't think I ever did answer him, his honest and matter-of-fact response made it one of the most impactful and integral conversations I ever had with my father.

So impressionable was I, so prone to even the slightest indication of negativity, that when my dad imprinted this concept onto my growing mind, it was as if any shame or self-doubt I would ever have regarding whom I chose to love washed down the sink along with the scalding-hot whisker water that morning, never to threaten to burn me again.

I have loved languages my whole life, starting with the sweet sound of spoken Hindi, which I heard especially at the kitchen table. We were far from a formal family, and there was a certain casualness surrounding our mealtimes. As I've said, this was the seventies, with its "TV table" culture, and we often ate gathered around a small television set, grateful to not have to make conversation. And on many occasions when we did eat at the table as a family, my parents spoke in Hindi, knowing full well we girls understood little, if anything,

that they said. "*Ap ki marzi*" often escaped from my mother's lips. I remember this specifically, as it was an expression I knew well. It meant "Whatever you like." There was a surrender about it—or was it just my mother's courtesy? In later years, I regularly fell back on this same style of martyrdom in my own adult relationships. Like mother like daughter.

Also burned into my ears was the expression "*chup*," meaning "quiet," or, more likely in my sisters' and my context, "Be quiet!" Dad was rarely home, and when he was he resumed his dictatorship, imparting totalitarian rule. Being an absentee parent must have been difficult for my father, but it was much harder on my mother. I was a nightmare, Shireen was also, and Heather barely even spoke. It's hard to comprehend the true dynamic between my parents. I can't say either of them would do things the same way today if put in the same situations. Like many couples of their generation, they simply stayed together—long after today's partners would have separated. That is either a good thing or a bad thing, depending on how you look at it. What I failed to understand was that my dad was basically an absentee husband also, and that that was normal for the times. My parents were never malicious toward each other. They never spoke ill of each other or put each other down, not once, that I know of.

My dad was simply working; he was his work. My mom was often also working outside the home, as well as volunteering with many organizations, but most of her work was raising us ingrates. She was and still is endlessly forgiving, a woman with an unselfish heart. I don't know how she did it—I think I would have blown my brains out.

Eventually, my parents did split (in 1991). My father had taken yet another teaching job, this time in Prince Albert, Saskatchewan. My mom was done: she simply didn't want to move again. After their divorce, my mother thrived in her new job with Winnipeg's

Handi-Transit, and my father soon met Anita, who would become his second wife.

I know that as an adult my relationships replicate that of my parents and their dynamic with each other. I'm not blaming them for anything in my life. But they did provide me with my basic model for adult romantic relationships: I become the breadwinner, the head of the family, as well as the martyr. This behaviour is exhausting and counterproductive. I think one of the worst manifestations of it is that I am too easily seduced into believing that "this one" is my "someone," my soulmate. As a matter of fact, I've probably met about a hundred versions of my soulmate, each with the missing perfect facet of the last one. If only I could put them all together, like puzzle pieces.

I am an avoider, chronically avoiding conflict—except on stage, where I blossom into a very candid individual. Suddenly I can take control, actually say no, express my disappointment, my sadness, my fears and anger. My lyrics say the things I can't in everyday life. I can say them through my show the way that I want to because it is the well-thought-out, one-sided conversation of the lyric writer. And I could fist fight, or simply just scream.

I built my stage show on that emotional explosion completely unintentionally. I was used to internalizing, and to its simmering anger and angst, to regrets for not speaking out. I'd put every disappointment or wish in writing, then bring the list to rehearsals in my bag filled with Hilroy scribblers, pens, bus transfers, soda pop receipts, chewing gum, smokes—and hopes, stashed there just waiting, just like I was.

# FOUR

kentucky

**MY DAD ACCEPTED A POSITION SETTING UP A DENTAL** program at the University of Kentucky, and as a result our family made the move, the huge transition, from The Pas, Manitoba, to the big city of Lexington, Kentucky. I was halfway through grade two. We moved two days after Christmas 1977, on the front end of a freak ice storm, the worst Kentucky had ever seen—an appropriate greeting for the Torberts from the Canadian tundra.

My parents had decided that we needed a change as a family, a fresh scene for the sake of us kids. Shireen and I were both getting into a lot of trouble in The Pas, but particularly me. I loved moving, even though it held its challenges, but my sisters were not pleased about it.

We found that, much to our naive surprise, many people in Kentucky were racist. And my sister Shireen was brown. In the move from Manitoba, we had to change schools, we had to change churches, and we had to change cultures. The racism thing seemed weird to us, and because it was surprising for all of us kids, we became a bit aggressive and defensively shouted back or flipped off any kids who said something to us. Except for Heather. My little sister became even more introverted and isolated at first, withdrawing even further.

Apart from our new-found extracurricular-activity schoolyard fist fights, I enjoyed the change: I am quick to adapt and up for just about any adventure. I loved having new opportunities to horse around and to meet new people and to reinvent myself, really. I loved escaping my past, escaping the neighbour's humping dog.

For the first week of school at Stonewall Elementary, I pretended to speak fluent French. I didn't actually speak any French, but the Kentucky kids thought I was an "Eskimo," for God's sake! So what did they know? Since they believed me, I kept it up. In the school cafeteria, I told them that "sissy" was the French word for "napkin," and they believed me. And I kept on making up words. They didn't know anything about Canada except that Canadians speak French.

There were so many kids at this new school compared with our sweet little elementary school in The Pas—it was a school so huge that it had a cafeteria, which served corndogs for lunch every single Friday.

Kentucky cuisine was a miraculous thing, in my world. A real mixed bag of Mason-Dixon line–crossing unhealthiness, but delicious. It was like my entire menu-item count suddenly quadrupled overnight. And it was a far cry from my mother's Hindustani *khana*, Ayurvedically balanced food that was good for the soul. My mother infused love into her food; it was nurturing and healthy, like her intentions. But we were a busy family, and three school-aged girls who wanted McDonald's was a new thing for my mother, who was now working full time out of the house. She couldn't win. Gone were the quiet northern lights to dance our little eyes to sleep, the sound of the wind on the ice lakes, the music of the trappers' festivals, and the powwows, with their scent of fresh-cooked bannock and burning sage.

My sisters and I took the school bus to school. We learned a lot on those bus rides: lots of derogatory words, and lots of songs. The rides

home were noisy, riotous. None of us kids had seatbelts, and we ran up and down the aisles without supervision or intervention.

My sisters and I were thrust into this society, one that had Sambo dolls for sale and Aunt Jemima pictures as decorative kitsch in every grocery store. This was also a culture in which my sister was called a "nigger" and I, a "white nigger." Shireen was the only South Asian, the only Indian kid, at the school, and to all the others, she was basically one of the black kids. We fought at school constantly. I wanted to kick every racist kid in the balls, and so I did just that.

Defending Shireen during recess bullying sessions made me hated, and as a result, a line was drawn in the sand. And, of course, children can be the most cruel of all in the consistency of their teasing and psychological torture. It was devastating to us, and Shireen took this ostracization extremely hard. It wouldn't be the last time we were exposed to bigots. My parents despised bigotry, and so did Shireen and I. And so did God, even if Jesus forgave them—and I believed, Jesus would forgive me too.

For some reason I never figured out, my parents believed we were at fault for even entertaining the notion that fighting to defend ourselves against bullying, racist kids was okay. They could not understand why we weren't able to use reason to avoid fights. When I proclaimed "They are racist assholes," this heated outburst earned me a spanking so hard that the wooden spoon broke across my behind. My parents simply believed we should be better mediators. That looked good on paper but didn't work in real life.

We were finding it difficult to navigate the classrooms, schoolyards, bus rides, and even church services without feeling the pressure and feeling on edge. Bigots were everywhere, trained by their bigot parents. They couldn't be reasoned with, just forgiven, just like Jesus would forgive. That's what they told us at church. The church where Jesus worked. And what a church!

The churches in the South are architectural landmarks, holding congregations of up to a thousand faithful—and singing—worshippers every Sunday. They were the biggest buildings for miles around, and always full. My parents drove out to Trinity Hill United Methodist Church, which was a distance from our house. They were quite immersed in church culture and by default so were we kids—choir, Sunday school, service, after-service tea and coffee. Our church was chock full of white people.

We lived in a pretty homogenous place. My dad had accepted a professorship at the University of Kentucky, and while we lived in Kentucky, the Wildcats were NCAA champs more than once. This was of the utmost importance to me—I was a big fan. My parents believed that I was actually a fan of the athletes themselves. I certainly was developing a thing for boys—lots of them.

Although at first I was struggling with a new school, new city, new environment, I soon gained a fresh prepubescent perspective along with the fresh audience. I was delighted with the change of scenery. I morphed my personality to suit whoever was in the room, and this coping mechanism, this survival skill, was developing quickly—I was becoming the consummate actress.

In grade four I learned a thing or two about training bras: the straps really snap when you yank on them from the back and then let go. This type of attention was high comedy for some, and enduring it, a great pathway to acceptance for me. It seemed all in fun, but really, my acceptance of it was acknowledgement of my objectification and sexualization, and both of these, as I now understand, suited me just fine. This was the game of choice in my class that year, and I was not about to complain or protest.

I managed to make some friends at Stonewall Elementary despite my constant scoldings and having to write lines as punishment for

talking too much or clowning around by deliberately making fun of myself while singing "My Old Kentucky Home," which played every day on the PA system for students to sing along to. "Self-discipline requires doing what is necessary, when it should be done, whether it is a pleasant task nor not." I wrote this sentence, assigned in my first few days of grade six, five hundred times a week for the entire school year, using a ruler to give the exact angle to the words that Mrs. Spifey, my homeroom teacher, wanted.

I was obsessed with the Farrah Fawcett look-alikes at school. Some of the girls hit puberty early, I guess. They had long blond feathered hair and wore Bonne Bell lip gloss. Donna was the tallest girl in my class, and her clothes were always perfect, as was her hair. And if that wasn't torture enough, making the rest of us feel inadequate and shamefully aroused every time she flung her long hair, there was her mom: a sexier, more glamorous version of Donna. Donna's mother was the most ravishing creature I had ever seen. I may have been just a kid, but I was in love with her.

One fateful day in grade six, Donna's mom floated into the classroom. Time stood still, my heart stopped, my breathing ceased. She was wearing skin-tight white pants, a blue-and-white-striped fitted T-shirt, and a blood-red silk scarf, which was tied around her neck and billowed behind her as she walked. Her blinding white, toothy smile highlighted pouty crimson-red lips, and she had the same perfect long blonde feathered hair as her daughter. She looked like Christie Brinkley, only better.

But the best part was her smell, the beautiful, lingering scent of much too much sickly sweet perfume. I closed my eyes and just sniffed, trying to inhale the entire roomful of scent into my lungs. Her smell permeated my nostrils and grabbed hold of my insides. As with many of my richest memories, I can still smell the moment—in this case, the moment I first laid eyes on Donna's mom.

The bigger impact was that I fell in love with everything she represented to me. To me, she was pure sex, and by "sex" I mean the embodiment of my childlike idea of femininity and beauty. How ravishing she was, and she needed no words to say so much to the world. She seemed intimidating to everyone, even other adults, commanding respect and adoration even if she did breathe the same air as us mortals. To me, Donna's mom was, and still remains, the ultimate ideal of female perfection. My love of makeup, perfume, and all things that she embodied has been injected into my psyche, both on stage and off. For this, I am grateful.

Donna's mom and Sophia Loren were my first girl-on-girl crushes. I don't think I sexualized my feelings as much as I idolized what those women represented to me: power. They held such commanding power over me, over any room they found themselves in, even over society, it seemed. I used to claim to my poor parents that Sophia Loren was my birth mother. "She just has to be, Mom!" I pleaded with my mother, begging her to tell me it was the truth.

I identified with these two powerful women. They were the answer to everything. They both created a brand-new and visually arresting image for me, one of a happy and attractive and confident powerful woman. My mother was such a modest woman, the embodiment of sweet. She was graceful and shy, polite to a fault, thoughtful and humble, deeply sincere. She didn't wear much makeup or draw a lot of attention to herself. She lived for other people.

My mother would sit up at night in a plush chair in the living room, with all the lights off, only the light from the street lamp at the front corner of our lawn illuminating her dainty frame. And there she'd sit, in her housecoat, waiting for me for hours into the quiet night. Curfews came and went, cars passed by the house and kept going. She just waited. Half the time I was just sitting in the park near

our house with all my little naughty girlfriends, talking about boys or making out with each other, practising our kissing techniques—it never occurred to us that this behaviour actually attracted boys.

I always laughed in the mouths of the other girls, blowing hot air down their throats. Sometimes boys would drop by the park. I kissed Bobby Frew for thirty-eight whole seconds, and then laughed so hard that he never spoke to me again. I also sometimes made out with my pillow, pretending it was the boy from my homeroom, the science teacher, or the lecherous guy at my parents' church, or, of course, Donna's mom. Oh, I was no stranger to the aching desire of youth. I wanted a boyfriend, like all the other girls. I just could never understand why we had to practise on each other when we really should have been recruiting nice boys to practise on. In my mind, that was the perfect solution.

# FIVE

hognose snakes, julie lennox, and the poole family

IN LEXINGTON, KENTUCKY, THE WILLOW TREES HUNG low over the abandoned sewer drains, where the neighbourhood kids could most often be found. It was here that we gathered and played. Well, mostly it was the neighbourhood boys plus my sisters and me, or, most frequently, just me and the boys.

Most of the time, we were in the drain sloshing in our wet tennis shoes through the water, trying to catch crawdads and little snakes. I myself had no desire to touch snakes, especially the hognose snakes, which were everywhere. They had big teeth and horns, like the devil, and when touched, flipped upside down on their backs and went completely limp, as if they'd died. This never really sat right with me. The first time I saw this happen, I cried, and went straight to my room when I got home for supper, praying on my knees by my bed. I thought I'd hurt or maybe even killed the snake, and I couldn't bear the thought.

Two years before, I had whacked a mosquito while practising piano and the poor mangled thing tried and tried to pick itself up, only to struggle and fall. I raced to the fridge, my lips trembling and eyes welling up with tears, and grabbed anything I could find—a just-washed lettuce leaf, as it turned out—to try to nurse the squished

mosquito back to health. I slid the lettuce underneath it but just ended up drowning it in the water pooled in the groove of the leaf. The experience changed me, and since then I have been extremely sensitive to harming anything.

At eleven years old, I had successfully got myself into a lot of trouble sending dirty notes to a kid named Dan, one of the boys I played with in the drains, who lived up the hill from me. Dan was a year younger than me, and had dishwater-blond hair and blue, blue eyes. He was beautiful, and contemplative and introverted, but he was intrigued by me and my loud mouth and attitude. In reality, my notes to Dan were not dirty. They were my art, my attempts at erotic poetry, and I enjoyed describing our interactions. I wrote him pages and pages of the stuff every day in class.

This was going quite well, until his mom found the notes and called my mom and the school principal and I was ordered to stay away from Dan. It was embarrassing, but mostly to my parents. His parents were extremely angry about the whole thing and demanded that my mom sit me down and ask me what Dan and I had done. I didn't have to cover anything up, as it was all right there in the letters.

We had been meeting every day after school. We would hug and kiss each other on the neck, and I'd kiss him on the ear and whisper things. He'd do the same to me, and I'd scream and giggle. I had to devise ways to avoid this tickling, so we'd neck—for hours. I told no one. We were lovers of a sort, ten- and eleven-year-olds with secrets. It likely would have continued if we hadn't got caught. He was careless with my explicit love poetry to him, and I got blamed for it all. But I wasn't embarrassed by the things I had written; I knew it was just poetry and told his parents as much.

"It was just a poem," I muttered in the principal's office.

"What did you say?" The principal put on a great show for the parents.

"How can they not see its merit, the art in this writing?" I thought. They were simply unsophisticated, I guessed. They didn't get it, and they definitely didn't get me. And Dan and I never spoke again.

But Julie did. She loved my writing and wanted me to read it to her every day. Julie was a year older than me. She was a rich kid, a Southern belle, born and raised in Lexington, and she lived two blocks away. She was a firecracker. We read poetry to each other and lay on the Kentucky bluegrass to think and dream and watch the clouds go by, and we laughed and giggled long into the lazy afternoons.

Julie had a thick Southern drawl and dreamy eyes. Long cascades of curls in varying shades of blonde dripped down her back, and also covered half her face at any given time. She had all that Southern feminine lusciousness, but she had a mischievous side too. Julie was the other bad girl in my class. She wore tight sweaters and had real boyfriends, all of whom were already in junior high or even high school. I idolized her.

Her dad drove an Oldsmobile 442 with stripes painted down the front and sides, and seats that swivelled. It was like a race car to me. A Shriner, he seemed to always have a long cigarette dangling from his lips. The smoke would drift up to his eyes and he'd squint, or squint with one eye while closing the other. He had a dark tan. Julie's mom had a tan too. It seemed like they were always just returned from vacation.

Julie was an only child and didn't look like either of her parents. Her mother was tall and thin, with short blonde hair, and always wore dresses. She was never home, it seemed, but my mom wasn't either after school. So we were left to our own devices.

Usually, Julie and I tried to figure out what the big kids at the end of the street were up to. They always talked about pot. They were ugly rocker boys who wore jean jackets and had fat stomachs. They didn't even go to the roller rink, which is where all the other kids went. They just sat around on lawn chairs in the one fat kid's yard smoking Mary Jane. It stunk, and we didn't want anything to do with it; it never occurred to me or Julie to try drugs. We had Julie's parents' cigarettes instead, which were way better because you didn't have to roll them yourself, and they didn't stink as much. "Why in the world would anyone choose pot over a cigarette?" I'd ask. Julie always answered, "'Cauzz pea-pole awh stewwpid, honeeeybun." And we'd laugh, me marvelling at the loveliness of her voice.

Her mother was pretty wonderful also, a Daughter of the Nile, and, as Julie said practically every time she talked about them, both her parents were in the Order of the Eastern Star. I loved the whole Shriner thing with Julie's parents. It was a pretty big deal, and for me, surrounded by so much mysticism. They dressed in fancy ball gowns to go to their nighttime functions, and they laughed loudly (unlike my very quiet parents), and the best part was that both of them smoked cigarettes and were never home.

These two last facts were to our benefit, almost as much as her skinny mom's padded-brassiere collection and long ball gowns. Most afternoons after school, I went to Julie's house. We played Rod Stewart loudly on the stereo in Julie's parents' bedroom—Julie said we couldn't break the speakers just by turning up the volume, so we did. We poured grape Kool-Aid into tall plastic tumblers and then dressed up in Julie's mother's clothing, found her parents' cigarette stash—cartons of Tareyton 100's menthols—and lit up. We smoked and danced in front of the mahogany three-way mirror in her parents' bedroom.

Julie's bedroom was across the hall. It was all white eyelet curtains

and four-poster canopy bed. It was the most inviting place I had
ever seen. The bed was like a big fluffy white cloud, floating on air.
Everything matched beautifully—the six pillows, four for sleeping and
two the shape of Tootsie Rolls, even the white eyelet teddy bears. And
I had never seen so much stuff before. My family lived an austere life,
being simple church people. Julie's family were not traditional church-
goers, and certainly not United Methodist ones. Julie and I spent a lot
of time in her room—we generally retired to the boudoir after Donna
Summer faded on the hi-fi and we were coughing from chain-smok-
ing. (Somehow I never got caught smoking—my mother didn't detect
the smell of cigarettes on me when I returned home.) In fact, her bed-
room was integral to our secretive doings. It was there that Julie taught
me how to French kiss, with her expertise and demonstrations. (Purely
educational, of course.) Now, I don't know if Julie actually knew any
French people (and she never busted me for my full-out lying in school
about speaking fluent French) but, regardless, Julie seemed to know a
lot about sex, and she was achingly sexy.

Julie was also extremely affectionate. She was a touchy girl, always
putting her hand on my arm when she spoke, or on the small of my
back. She did this to other kids and adults too—both men and women.
And sometimes she ran her fingertips across the fuzzy blonde hair on
my forearm and asked if it tickled. It always did, as I was terribly tick-
lish, but it was not the regular tickle with Julie. I always said it didn't.
I liked her attention too much to ask her to stop. Pretty soon that
behaviour became a paradigm of our relationship.

We were inseparable, and mimicked each other the way friends
do, dressing the same, walking the same, even saying the same things
and enunciating the same way. Our individual idiosyncrasies began to
morph into each other's, and our friendship started to grow into a very
different one. I thought Julie was breathtaking. A beautiful girl with a

strong gait and a foul mouth, Julie commanded attention everywhere she went. The boys absolutely loved her, especially Rick, her boyfriend.

His family lived in a two-room house on a half country road dotted with suburban homes and farmland. I was great friends with Rick's little sister, Evelyn. Her family was poor, the real kind of poor that usually ends with the family living out of their car or trailer. His mom was huge and usually taking a nap with Rick's father. His older sister, Mavis, was pregnant. She was sixteen and seemed to be the only one there who cooked and cleaned. She would clean right around her sleeping parents, dusting around them in the darkened room while Evelyn and I watched. They had no covers over them—the sheets were hung over the windows.

Evelyn was a tomboy. She even looked like a boy and was mistaken for a boy all the time by teachers and bus drivers. She hated this and swore at anyone who dared mention it to her. She dressed like Rick and wore his hand-me-downs, which was half the problem. She had long, fire-engine-red hair, freckles all over her face, and broccoli-green eyes.

I should have been more afraid of Evelyn Poole. Evelyn was such an accomplished tomboy—she was so tough, if she was your friend, no kid in the whole school dared cross you. When Shireen and I fist fought the bigots, Evelyn was often there beside us. In fact, she was the one who taught me how to kick the boys as hard as I could, right in the balls. She said that all the bigot kids were in the Ku Klux Klan and that this justified our ball-kicking. I kicked in compliance. And she became the other half of my pair of best friends. No two girls could be more opposite than those two, but with me as the common denominator, there was always harmony. It didn't hurt that Julie and Rick were a couple. And I guess, in a way, so were Evie and I.

# SIX

MY LONG-WIDOWED GRANDMOTHER, SELENA, HAD AGREED
to move into a nursing facility in her hometown in Minnesota. She
had had a couple of heart attacks and her Alzheimer's had worsened.
The time for her to move had finally come. Just before school ended
in June, my mom decided she needed to go to Minnesota, so Mom
and I packed up the beige Chevette and off we drove. Fortunately, I
didn't have to stay to write end-of-year exams, as most every year I was
exempt from them because of my high grades.

We stayed at my grandma's house, which was now being packed
up so it could be put on the market. Her nursing home was several
miles away and we drove there every morning. Decorated in the typical
yellow colours and floral patterns, it was bustling with nursing staff
and volunteers, and full of weird smells. Many of the patients had irre-
versible and deteriorating states of dementia. I didn't bat an eye, and
always felt comfortable there. Being around sick, old, and dying people
never bothered me.

They had their own society. Like any collection of institutional-
ized folks, I suppose. My grandmother's nursing home was like a small
town unto itself. We met all of my grandmother's friends, including
a young male nurse. His name was Jim, and my grandmother adored
him. This ensured that my mother also adored him. I thought he was

achingly beautiful. He had brown hair, feathered like that of the popular *Teen Beat* magazine stars of the day—David and Shaun Cassidy, Leif Garrett—short in the front and long at the back. His uniform consisted of white shoes, white pants, and white top. To me, he looked like an angel.

My mother was convinced Jim was nineteen. I think my grandmother told her that was his age. Perhaps she made it up, but more likely it was simply her Alzheimer's at play. He was certainly older than nineteen. I was twelve years old, just shy of my thirteenth birthday, but I told him I was turning eighteen. Jim asked my grandmother if he could take me out for ice cream, and then she asked my mother on his behalf. I think my mother agreed to it because she didn't want to disappoint her mother, who was so enthusiastic about it—she was a budding matchmaker, with a renewed sense of passion and joie de vivre. My grandmother even gave Jim twenty bucks to pay for my ice cream.

Jim picked me up later that day, after supper. It all seemed safe enough. It was only 6 p.m., and the sun was still quite high in the sky, lighting up the faces of the Minnesotans. They were nice people and polite to a fault, just like my mother, aunties, and grandmother. Why would this Minnesota boy be any different?

I waved goodbye to my mother as she watched us drive away, off to the ice cream parlour. As soon as we were out of my mother's view, Jim did a brake stand, then promptly produced a marijuana joint from his pocket. My heart was pounding. A joint! I could not believe it. I had seen joints before at the house of the guy next door. I had never had the guts to smoke pot, nor really the interest, so I wasn't about to try it now, in this Jim guy's presence. I mean, what if I fell asleep?

"I'd love to, but I'm so allergic!" I said, then followed that with an encouraging "You go ahead!" I put my best smile forward, trying hard

to be nonchalant. He lit up the joint and pulled down a side street. There was no ice cream parlour on that street. We weren't going for ice cream at all, much to my great disappointment. No mint chocolate chip for me.

Jim pulled up outside what I guessed was his house. It had a yard of brown, dry grass, enclosed by a wire fence, long ago painted white. The house was desperate for fresh paint. From where we were parked, I could see motorcycle parts, including gas tanks, strewn all over the backyard. Jim collected car and bike stuff. He explained to me the history of the Birmingham Small Arms Company and told me about how it used to make "guns and bicycles." I hung on his every word, dreaming of being on the back of a motorcycle with Jim the Nurse with the Hardy Boys hair, going for ice cream, then riding off into the sunset.

We went inside his house, and he asked me if I wanted to watch television. I just wanted to be cool and, obviously, cool people watched television. I sat on the couch and stared at the TV, which was playing a music video—the first I had ever seen. I was mesmerized by the images on the screen and even more so by the music. The video was by a Minnesota artist named Prince, the song was "Little Red Corvette," and I had never heard anything like it before. I felt myself become aroused listening to the breathy singing and watching the body movements of the doe-eyed singer. I couldn't look away, and Jim's close presence intensified my arousal.

My parents' Nat King Cole 78s and Glenn Miller Orchestra and Ravi Shankar could not have prepared me for this feeling, this reaction to the music and to the sexy singer's delivery. My legs squirmed and my thighs pressed each other tight. I felt my face flush; I felt like I was going to faint. Jim handed me a bottle of beer. Too embarrassed to say no lest I offend him, I sipped the disgusting beverage, accidentally letting the cold bubbles foam out of my mouth.

"Don't waste it, babe!" Jim said as he planted his lips around my whole mouth and sucked the beer off my face. I was shocked. His tongue was fast and strong. I improvised, keeping my mouth open, unmoving. I was out of my league and starting to worry about being found out. I didn't want him to think I was inexperienced or, worse, a virgin. His hands were small but they snaked up the inside of my sweatshirt, found my ribs, and climbed from there. My breath was heavy and I felt an intensity, like a drowsiness, a strange sleepiness. I was done for, a goner.

He picked me up into his arms as a firefighter might and, still necking with me, carried me up the narrow, creaking staircase. I giggled nervously. When we got to his bedroom, he practically threw me down onto the bed. I bounced, still nervously laughing. I felt self-conscious and was freaking out inside. Without warning, he expertly slinked his hand down inside my jeans and underpants. I grabbed his wrist to stop him. I felt dizzy, and wanted to go back to my grandmother's house, but I also didn't want to be rude.

Pretty soon we were both naked, Jim lying on top of me, his hands everywhere. His breathing was heavy with determination. I had to get myself out of this somehow; I had to act quickly. I knew I had to distract him from taking my virginity away, so I broke his kiss and asked if I could kiss him "on the wiener."

He laughed. "Weiner? How old are you? Don't call it a wiener, sweetheart."

"Okay, I won't." I said. "Lie on your back."

He laughed and flipped over onto his back, his intention staring me in the face. I let my instinct take over.

As soon as he had finished, the next words out of his mouth were "I'd better get you home."

I was so relieved. I think half the blow jobs I have given in my life

were so enthusiastic because of my sheer relief of avoiding penetration. "Yeah, it's late," I said.

We got dressed and made our way downstairs and to his truck. Without any awkwardness, we chatted all the way back to my grand-mother's house—about his motorcycles, his job, my school. It was practically jovial, and he seemed to be in a good frame of mind.

My mother was already sleeping, though I was home before my curfew of 10 p.m. It was as though nothing had happened, and in my mind, nothing had. I had simply found a solution, a way to avoid an unwelcome situation, an effective skill for squirming my way out of such jams. I was rather proud of myself for staying a virgin. To my twelve-year-old brain, anything else was fair game. I had started down my path of agreeability and coping, surviving whatever may come while staying true to my morals. This, of course, was self-delusional thinking. But I couldn't help thinking, "It's what Julie would have done."

# SEVEN

dauphin

DAUPHIN, MANITOBA, WAS CANADA'S NATIONAL
Ukrainian capital, a town of about ten thousand people, about half
of them of Ukrainian background and the other half mostly First
Nations or Metis. It also happened to be my father's next destination
after his time at the University of Kentucky. The community college
in Dauphin had a government-sponsored dental therapy and dental
assistant training program, and this was right up my dad's alley. My
mom drove all the way from Lexington to Dauphin—over a thousand
miles—the month before to find a house for our family. Once this was
accomplished, she drove all the way back to Lexington to collect us
and move us up to Canada in a big rented truck.

That summer, we said goodbye to the weeping willows, the blue-
grass fields behind our house, the Kentucky horses, our best friends,
our plum tree in the front yard, and the grits with butter.

It was a whole new world. *Bitaemo* means "welcome" in Ukrainian,
and everyone in Dauphin said it to my family. We were welcomed in
the community—on the street, at the new church, even at the grocery
store. My mom had picked out a charming yellow house on a street
teeming with kids, right across from a park. We watched the other
kids' moms make pickles out of little cucumbers, and we started grow-
ing dill in the backyard, and eating perogies and borscht.

I loved Ukrainian. Languages came so easily to me. The word for money was the first word I learned: our move to Dauphin happened to coincide with my now receiving an allowance, though it was constantly being withheld because of some bad behaviour—breaking curfew or sass-talking my parents. Ukrainian was offered at school as a language course, along with French. I took French and so did my sisters. Generally, only the Ukrainian kids took the Ukrainian-language course; it was sort of frowned upon by the other kids.

My first day at school in Dauphin, me starting seventh grade, was the best day of my life so far. My hair was feathered perfectly, I got to wear lip gloss, and I still had the Southern drawl I had acquired in Kentucky. Shireen and I were attending junior high; Heather, my little sister, elementary school. Life was pretty perfect that first year. I made friends at school, had great marks in my classes, and enrolled in dance classes taught by visiting Royal Winnipeg Ballet instructors.

Until I attended a party at the end of the summer, before the new school year, with my neighbourhood girlfriends. We were all dressed up and had essentially lied to our parents about just "going for a walk" around the neighbourhood, which was a common thing for us to do. The party was packed with kids, and there were a lot of people there we didn't know. The boys were drinking beer. It was typical in the town that either someone's parents let their kid invite all their friends over to drink, or you partied at someone's house when the parents weren't home. The latter was the case that night, and the house party was the event of the summer.

I was never very good at drinking alcohol and, being a young teenage girl, even one beer rendered me rather agreeable. So it was no surprise that I was happy to follow one of the boys into an upstairs bedroom that evening. It was also no surprise that our disappearance

was hardly noticed, since the party was in full swing. What *was* a surprise was his friends waiting for us in the room, with the lights off.

It was what was referred to in those days as a "gang bang" and it was the loss of my virginity. My life was changed by the experience; it was an emotional milestone and a major trauma.

After the boys left the room, I quietly got dressed and left through the front door, not speaking to anyone. I looked straight ahead as I briskly walked home.

I didn't mention it to my mother, who was sitting in the dark waiting up for me, as I had missed my curfew. I felt very bad about that too. I felt terrible about the whole disastrous night. I blamed myself, and some of the other girls, who learned of it from the boastful boys at the party, blamed me as well. Classic victim blaming, I suppose. Before classes started that September, just about everyone at the school already knew, mostly through rumour, what had happened. I was tarnished, damaged goods, a slut. Or, as I was often referred to, "a fucking slut."

Schoolyard fist fights were events not to be missed, and I had my share of them with girls who insisted I had wronged them in some manner and challenged me to a fight (a challenge referred to as "calling on" a person). "I got called on!" I would whine to my mother, who grounded me every time I came home with a scratched face or bloody lip. "They hate me, Mom. I can't go to school." But, of course, I had to whether I liked it or not.

Faced with having to defend myself constantly, and desperate for the approval of the kids at school, I did what any self-respecting young lady might do. I became the class clown. I transformed into a comedian, relentlessly tripping myself, shoving things in my nose, mimicking teachers, telling jokes, and making faces, anything to endear me to the mean girls.

I was also an affectionate and complimentary friend, genu-inely gushing over the smallest things that my beloved friends or acquaintances did. I did just about anything to get the girls to like me. And the boys too, and they knew it. Eventually, though, my classmates stopped mentioning the "big gang bang," and about that I was glad.

I had few friends, but the ones I had were good and true, like George Finch. He was a few years older than me, and had the best hair of all the tenth graders. George's mom played piano at the church and taught it as well. George had an older brother and sister, and was seemingly the perfect son. George taught me to smoke hash off a pin using a blowtorch he stashed in the back of his Dodge. He took me on my first formal date, to Dauphin's pizza parlour. It was the first time I used a purse, and I still remember the event well.

George knew everything about music and was the singer in a band that played at the high school's assemblies and Battles of the Bands. George gave me my first record, Judas Priest's *Unleashed in the East*, which I listened to on my grandpa's hi-fi in the basement. I lip-synced Rob Halford's expert singing in the bathroom mirror. George introduced me to Mean Gene and all the WWF heroes, and we'd watch for hours in his parents' basement. He loved comics like *The Fabulous Furry Freak Brothers*, and that made me love them too. I loved anything and everything he did. I loved George.

I never did entirely transcend my reputation, and I knew my par-ents would want me to forgive them, so I did. The survival skills I had begun to hone were effective and served as the foundation for needed strength in the coming years. And the year ahead was certainly unfolding in an interesting way, as my dad announced that he had accepted a position at the University of Manitoba, in Winnipeg. I was

so happy to leave Dauphin and put my memories behind me that I lay on my bed and cried with relief. My pillowcases matched my sheets, adorned with images of horses and Kentucky bluegrass, encapsulating the glory days we had left behind, when life was simple and I was still just a little girl.

# EIGHT

pope john paul ii and predators

**JOHN PAUL II WAS LATE, AND PEOPLE WERE ANTSY.**
I was sure God had something to do with the Pope being late. People were mumbling around us.

"Was he really shot?" I asked my mom.

"Don't you remember? It was the same year that Princess Diana and Prince Charles were married. We watched it on television." My mom was lighthearted and positive despite the noise of the whining Winnipeggers. The sunshine beat down on the good people of Winnipeg awaiting the papal parade. Yes, the Pope was late, and my mom and I were standing among the hundreds of thousands of other onlookers that morning.

Pope John Paul II was on a tour and, like just about everyone else in Winnipeg, we had gone to stand in the street to try to catch a glimpse of the old man. He was in a gold cart surrounded by Plexiglas, I would later tell those classmates who had not been forced by their parents to witness the mayhem.

All the images you see of any Pope, with his outfit that looks like a big, white dress, his stance, legs shoulder-width-apart, arms in a perfect balletic second position . . . well, that's exactly how he looked.

Seeing the Pope was a historical milestone in my life, but more for how it relates to my mother's and my relationship than anything else.

As soon as he rode past, we bum-rushed the Portage Avenue Burger King ahead of hundreds of other sloppy, sweat-soaked red-faced idiots (at least, that's how I saw myself). The place was crowded, everyone eating burgers lemming-like. But really it was about me with my mom and my mom with me, a theme that started that day and would continue on through our lives—special times, just the two of us together. Although I'm going to guess she remembers that time in the Burger King more vividly than I do, as I was hungover from the small amount of beer it would have taken my teenage body to get tipsy on the night before.

I always got drunk on just one drink. This would be perfectly fine except for my penchant for being a clown. People like me when I'm drunk—I'm funny. To the great amusement of others, I rarely stopped at one drink; in fact, as soon as one hits my system, I am sufficiently judgment-impaired to have, say, ten or seventeen more. It is of little surprise that my mother, desperate to save me from myself, intervened, marching me right to the front doors of the Alcoholism Foundation of Manitoba (as the Addictions Foundation of Manitoba was then known).

The counsellors there embraced my family and assisted my parents in designing a program for me: Alcoholics Anonymous meetings, Narcotics Anonymous meetings (despite my trying to convince everyone I didn't do drugs), and one-on-one counselling. I was a teenage girl in a program with recovering adult alcoholics and drug addicts, with dozens of others in treatment for various combinations of substance abuses, the majority being men. It became my dating pool. I was getting a lot of attention and liking it. I dated in-patients and guys from the meetings; proximity was the key component at work here. Naive.

And I assure you, everyone at the foundation was kind to me, took me under their proverbial wing, educated me in the ways of

the Big Book, but in reality, I was ripe for the plucking and I was plucked. I did develop friendships with some very kind people—artists, parolees, even Claude, a man in his sixties who was a notorious pimp in the city.

Claude was extremely helpful to me one of the times I ran away from home during that period. My poor mother could say very little to me without my taking it extremely personally, becoming distraught and stomping out the door to go stay the night at a girlfriend's. But this time, I realized I had no place to go, and Claude gave me a place to stay. I immediately came down with the flu, and he took care of me. For about four of the six days I was gone from home I was deathly ill, unable even to get out of bed by myself. Claude helped me get up to use the bathroom. He fed me and made sure I was getting the care and attention I needed. I felt so grateful to him for treating me with such kindness that I wanted to show him my appreciation. So one night after I had recovered from the flu, I climbed into his bed completely naked, climbed on top of him, and gave him the only gift I thought I had to give. You might think having sex with an old pimp would be a difficult thing for a teenaged girl. But to the contrary, it was the first time I had an orgasm during sex.

When I returned home, I was immediately delivered to the Salvation Army's "home for wayward women." I had to sweep the floors and bunk with two homeless women who had scabies on their legs. I don't think my parents had a clue of what they were working with here.

The Salvation Army Home was not for me. The staff there didn't approve of my language, and I was uninterested in the mandatory church attendance, And I was completely unhappy with the early nights and the policy of lights-out in the dorm at 8 p.m.

That bright day as my mother and I watched the Pope wave at the applauding onlookers, all hastily crossing themselves while shoving

their hot dogs and doughnuts into their mouths, I felt happy to be there and even happier about not feeling like I had to ask the Pope's forgiveness for anything. Little did I realize at the time that on that same city block where we were standing stood the Salvation Army building. My whole life was still ahead of me. But the clock was ticking, *tick tick tick*, just like a time bomb.

# NINE

I DREAMED OF BEING AN ACTRESS, A STARLET, JUST like every other girl in my high school drama class. Well, any girl in drama class who knew who Shannon Tweed was, that is. "She's Canadian," I'd say to anyone who'd listen. "Just like me." And I'd beam. I was the only Canadian in my family. Winnipeg was a big city compared with Dauphin, and I knew that somehow this was where I would make it.

My ever-supportive parents, happily paying for acting classes and theatre workshops, musical theatre, and continued dance training, saw nothing wrong with my going for head shots for my acting, or even on shoots with my ballet class. They never asked about it, and I never asked them for a ride to the venue.

When I met a photographer at the mall who told me I should be in *Penthouse* magazine, well, I really sat up and listened. "Wow! Me?" It was music to my ears. "Yes," he said, "I could do your test shots." I was so happy I hugged him. "You could be on the cover," he said.

To my teenage brain, I had been discovered.

I readied for my big shoot and met him at a street corner near my house but out of my parents' sight. They both happened to be home that day but unaware of what I was up to. I was meeting a photographer who shot for *Penthouse*! I had *arrived*! He pulled up in his sedan

and we drove to a motel room for the shoot. "I do this type of thing all the time," he said. "The pros always shoot in motels." I believed every word he said.

The motel room had a bed, its bedspread with a brown-and-turquoise geese motif; a matching painting on the wall; plastic plants in plastic pots; and a bathroom with a toilet, a sink, and a bathtub.

"Do you want to have a bath?" he asked.

"Yes?" I said hesitantly, and he grabbed a towel from the metal towel rack over the toilet and handed it to me.

"Wash it good," he said, smiling. I was nervous but did not want to appear unsophisticated in any way.

I went to the bathroom and shut the door, drew a bath, took off my clothes, and got in the tub. I had been fasting for several days, so I was very satisfied with my stomach and staring at it when he thrust open the door.

"I forgot to give you something," he said. "I'm so sorry! It's so unprofessional of me!" He showed me a pill. A "blush" pill, he said. "All the top models take this on shoots. It's for your skin—it gives you a healthy glow."

"I can't actually swallow pills," I said, feeling a little sick, though I wasn't sure why. I scrambled for something to say. "I'm just too young, I guess," I told him, chuckling.

"Don't worry, happens all the time. I usually just crush it in water." And so that's what he did.

He handed me a glass with the pill crudely crushed and floating on the water, like Styrofoam on the ocean. I choked it down while he sat on the edge of the tub rubbing my back. The pill kicked in quickly and I started to feel hot and flushed. I felt like I was drowning, even though the bathwater level was low. I fell into semi-unconsciousness, only to awaken on the bed, the photographer on top of me.

After he pulled his pants up, he said, "What an amazing shoot. You're a pro. You're gonna be in the magazine."

But he had relieved me of my dreams of stardom. Even though I was disappointed in him and even more in myself, still foggy from the pill, I wanted to act professional—or how I thought would be professional. I thanked him as I collected my things—my costume earrings, my mother's shoes—and stuffed them into my knapsack, then politely thanked him again. "I appreciate your time, sir," I almost whispered.

He smiled. "C'mon kid. I'll give you a ride home."

And that's what he did, just in time for supper.

# TEN

norman the cabbie

I CAN'T HONESTLY SAY THERE WAS A CATALYST. THERE was no gunfire or earth-shattering exchange between my mother and me. She was trying to rein in a wildly defiant, highly sexualized, and self-harming seventeen-year-old daughter. I didn't have a bad existence, really. I held a summer job at the video store on Academy Road, with all the Eddie Murphy videos and a big coffee can full of cigarette butts outside the back door. I had also developed the bad habit of driving my mom's station wagon on the weekends while inebriated. My friend Connie and I frequented the clubs, dancing all night to the new hip-hop club tracks, like Rob Base, even though we were not legally old enough to be in these places.

My mother knew I was always getting myself into dangerous predicaments, and she tried everything to keep me out of trouble. But I was absolutely determined to counter every suggestion and railed against any parental guidance. She didn't stand a chance. I was relentless in my self-destruction.

On a cloudy Monday in autumn, I decided to run away. It was morning and everyone in the house was getting ready for school. I packed a small duffel bag with some belongings and off to school I went, armed with fresh defiance. I skipped the first class so that I could badger Connie into joining me. She was delighted to, as a best friend

61

would be. This reinforced my belief that solidarity was mandatory for absolute best friends. And so the wheels were in motion, or rather, our feet were.

I knew that my little sister, Heather, was in class (she was now at the same school as me)—and that my plan would only be worthwhile, only effectively attention-getting, if people knew what I was up to. So I wrote a note and passed it along to her. Connie and I did not stick around to watch Heather read it. Instead, we immediately headed downtown on a city bus. Connie had money on her, but I had only a few dollars, which were not going to last long. I had decided we should go to Toronto, where the "acting schools" were. Where actresses go. That was in part my motivation: to become an actress of enough acclaim to get on *Saturday Night Live*, like Eddie Murphy. I just needed to get started, and that meant we needed Greyhound bus tickets. Of course, I hadn't discussed my acting ambition with my parents, as I was convinced they wouldn't take me seriously.

As it happened, my first boyfriend, George from Dauphin, had moved to Winnipeg and into a band-house right beside the bus depot. George was in the band, and he was usually home sleeping during the day because the band partied at night. I called him from the pay phone around the corner and asked if we could come over: I had to say goodbye, as Connie and I were running away, I told him.

"Sure, come on over," he said.

"George said yes," I told Connie. "I'm going to ask him for the bus fare."

I was quite pleased with this plan of mine. We marched up the walkway to the door of a house falling apart and surrounded by weeds. It looked like every other house in the rough north Winnipeg neighbourhood. We spent most of the day with George and his roommate, Gary. Being an enterprising young miss, I suggested that Connie and

Gary get to know each other while I went with George to his bedroom. George and I had the kind of friendship where we were like childhood sweethearts or forever lovers, despite my having broken his heart three years before when I unceremoniously broke up with him and began dating a classmate of his a day or so later.

Later, as Connie and I gathered our backpacks and coats, preparing to depart, I asked George for money. He was not happy with my decision to jump on a Greyhound but gave me fifty bucks anyway. Little did George know that his actions that day would lead to so many songs being written just for him. Little did I know either.

The Greyhound depot in Winnipeg is a terribly dirty place, with soot from the exhaust everywhere. It covers the countertops and the inside of your mouth like pollen.

We discovered that fifty bucks only buys a ticket to Thunder Bay, Ontario, which was just ten hours' driving distance of the about thirty-six hours it would take to get to Toronto. Undaunted, we purchased our tickets. It was already dark. I knew in my gut that my mother would be in a sad state by now. My stomach hurt.

We slept most of the way on the bumpy drive over the Trans-Canada Highway. The bus was full, crowded with seniors, trappers, and families. Then there was us, sitting in the smoking section, bumming cigarettes off the other passengers. I felt very grown-up.

We got off the bus at our stop and were basically left standing on the side of the highway with our backpacks and secret stash of cigarettes. This was great—freedom, the life, the road! We started walking up the highway, talking excitedly and smoking and feeling pleased with ourselves. It was a mild autumn morning. The maple trees covered the land farther than either of us could ever see. The view was breathtaking, and I was ecstatic. We were really doing this!

I was going to follow my dreams as soon as we got to Toronto.

We were not quite out of the city limits when a big car pulled over, a First Nations man in his twenties in the driver's seat. He told us he was from Fort William and going to work at a construction site thirty miles or so up the road. He smiled. "Get in," he invited. "I can't get you too far, but at least you'll be moving." This made sense to us, so we gratefully jumped in.

He smoked a joint while he drove. When our new friend politely offered to share his marijuana, we both politely declined, and he was not offended. It was all civilized, but it bothered me a great deal that he was getting high while driving. I started nudging Connie: I wanted out of the car.

We made something up about feeling car sick and he pulled over to let us out. We thanked him and got out of the car unscathed. I was very relieved.

We walked for a while, smoking and talking about boys and giggling and generally having a good time. We were best friends, after all. Eventually, we decided to hitchhike again. By now, there was a lot of traffic on the highway. We walked backwards, sticking out our thumbs, smiling and waving at every logging truck or big rig that passed us. And passed us they did. For hours and hours, it was just these big trucks driven by big men honking their big horns. And then it started to rain.

Both Connie and I were in jeans, jean jackets, and running shoes. We were laughing and yelling, and our shoes were sloshing and slurping with every step, and it was very funny—for a while. It was getting frustrating, none of the trucks stopping for us. We were getting cold and feeling defeated.

Then, in the distance, we saw a beige sedan burning down a hill, then up a hill, getting bigger and bigger as it got closer. We stuck out

our thumbs and jumped up and down, waving. The driver pulled over and we ran up to the car.

"You girls need a ride?"

He looked like Les Nessman from the TV show *WKRP in Cincinnati* and was dressed like him too, in a short-sleeved white shirt with small black buttons done up all the way to his neck. He wore glasses, was clean-shaven and slim, and was probably in his forties. He looked okay to me.

"That'd be great, sir!" We climbed into the car and away we went.

"You girls like Jesus?" he asked us, much to our surprise. Being thankful for the ride and not wanting to rock the boat, I piped up, "Oh, you bet! My parents are missionaries. My grandpa was a preacher from South Dakota. I go to a United church with my parents 'cause they sing in the choir." I continued to drone on to try to win him over.

Connie fell asleep and remained asleep for much of the conversation, and I couldn't blame her. The driver did not stop talking about Jesus and Mary Magdalene and how they were lovers and how that was a secret. Then he asked if I had ever seen pictures of them "in union." I was not alarmed by this, nor was it a red flag for genius me. I was oblivious to any bigger picture. I was just tired and annoyed, I badly wanted to sleep, and he simply would not shut up. I decided right then and there that we had to get out of this vehicle too.

When I asked where the next stop was, when we could stop to use the restroom, he didn't answer. He just looked ahead and said that there was "nowhere." This made me uneasy, not only because I wanted to get out of the car but also because I really was worried about where to go to the bathroom. I whined a bit more, waking up Connie, who asked for the bathroom as well. The driver was getting angry. That set off an alarm bell in me—not that he was a potential predator necessarily, but that he was mean or, at the very least, grouchy. He pulled

over at a gas station somewhere on Highway 17, still not too far past Thunder Bay, and waited for us in the adjoining coffee shop while Connie and I went to the washroom.

Whispering to each other from the toilet stalls, Connie and I agreed that we were going to bail out of there. We didn't want to hurt his feelings and couldn't think of a reasonable excuse to give him as to why we didn't want to get back in the car, so we decided to take the easy way out and just sneak away. As luck would have it, as we were briskly walking away from the gas station, an eighteen-wheeler pulled out from the station and onto the highway headed in the direction we were going. No sooner had we turned around and waved our thumbs in the air than he stopped. "I saw you two kids back there. You need a ride to Toronto? 'Cause that's where I'm going."

The driver was elderly and looked remarkably like my science teacher. He also looked kind, so we jumped right in.

We exchanged pleasantries. He didn't smoke, but he let us. He suggested we crawl into the bunk and go to sleep, as he would be driving through the night to Toronto. We were so tired, we did not hesitate for a second, just crawled right back through the drawstring curtains behind the seats and went to sleep. We woke up with the sun rising, practically blinding all three of us through the windshield.

This was it—Toronto! We had made it!

"Where are you kids going? Where can I drop you off?"

I stammered, "Um . . . my sister is meeting us at the Greyhound depot." It was the only thing I could come up with.

"I know right where that is, but my rig ain't going that way. I know a guy who can drive you the rest of the way in his car. I'm going to pull into this motel." He pulled over into a motel parking lot, where five or six other big rigs were parked. There was a diner there, and the three of us went inside.

Everyone in the diner knew him. He was given a greeting worthy of Norm from *Cheers*. One of the other drivers typically left for the city around that time in his car, a beat-up hatchback. Our sweet grandpa friend asked him to drive us to the bus station downtown. The man enthusiastically said, "Let's go," and we jumped into his jalopy.

He looked like Ozzy Osbourne, but he talked like a Muppet. He let us smoke in his car, which meant that we liked him instantly. We chatted with him all the way to the station, thanking him as we emerged from the car.

"Wash time," I declared and we headed to the busy women's washroom. In front of a sink, I took my white T-shirt off and started washing my underarms with soap from the soap dispenser. I was full of pretend confidence and bravado—and I was wearing a black bra, just like Madonna, so I believed that entitled me to behave in this way. No one said a thing. I was on to something. Connie followed suit, and we had our half-baths, emerging from the can feeling refreshed.

"Let's get a cup of coffee," Connie said.

I was in. "And pie."

The diner in the Greyhound station had a semi-circle counter, just like a diner in a James Dean movie. We took our place at the counter, trying to eat slowly as we gulped down our coffee and asked for refills. It was just the beginning of the day and we were truly thrilled with ourselves.

"Do you want to walk around and get our bearings?" I suggested to Connie, putting the dollar and change down on the counter and my coat back on. Connie agreed. Out the door we went in search of something, anything.

I had never been to Toronto before. The city was teeming with people, going to work or school or somewhere, and we sauntered through the crowds, smoking. I felt as if we owned the sidewalk. The

legendary Toronto Eaton Centre was only a couple of blocks from the Greyhound depot so, naturally, we gravitated toward it. We were high school girls, after all. Malls were our natural habitat.

Already busy with commuters, the mall had just opened. Within ten minutes, we were spotted by the two cutest boys on the planet—they looked like Bobby Brown and Eddie Murphy in sixteen-year-old bodies. They started following us. This was the height of validation for us.

Connie flashed her smile and right then, we were fucked. The power of a smile like Connie's was like the power of a life-changing sermon at church, or of a monster truck running over a bag of potato chips. It was unstoppable. Connie's blonde curly hair, bright blue eyes, and athletic body, all wrapped up in a bow that screamed "I listen to Grandmaster Flash," was the stuff dreams are made of. She was always the belle of the ball.

The boys were our own age, nice boys in polo shirts with the collar turned up and preppy Air Jordans. They were polite and soft-spoken. They told us they were skipping their first two classes that day and just hanging out at the mall. We agreed to go for coffee at a place they liked down Yonge Street.

Leaving the mall was Connie's and my first big mistake. The second was telling these boys the truth. Oh sure, we spun an elaborate story and even gave fake names (Connie's was Tatiana). Mine eludes me now but I guarantee it was even faker. Upon learning that we were runaways, the boys offered their help. They said we could stay with their sister, who had an apartment downtown.

We finished our coffee and gathered our duffel bags, then went outside to hail a taxi. We happily jumped in and away we went, winding down roads among red brick buildings, the industrial part of the city shifting into the suburban the farther we drove.

"First we have to stop at my cousin's," one of them said, and told the driver to pull over on the busy street and drop us off.

We climbed through a broken fence of a rundown apartment building and made our way to a basement suite. An older guy appeared from the back of the apartment, eating a bowl of cereal and smartly dressed, but wearing a blue plastic shower cap on his head. He sucked air through his teeth at the two boys.

"Why ya no tell me company is comin'?" He cuffed one of the boys not quite playfully around the neck. Then he turned to me and Connie and said, "Ladies, my apologies. Please come in and sit. Sit." Then he left the room.

He talked from the hall. "I'm just conditioning my curls, one moment." Connie and I were laughing at the cuffing, and the boys were giggling with us.

"How old is your cousin?" I asked for the sake of making conversation.

"My cousin?"

"Yeah, your cousin there—how old is he? But we are still going to your sister's, right?"

The boy dropped his gaze.

The Jheri-curl fellow returned to the room. "Ladies!" he said with a toothy smile, "what will we drink? You like rum?"

Ever polite, we both nodded yes. He poured the rum into two small glasses sitting on a shelf in the living room. I don't think they were clean.

"My name is Cash. What's yours?" He handed me the drink, about four fingers high in the tumbler. I was not all that familiar with rum, since Connie and I pretty much always drank beer, like every other self-respecting Prairie girl—light beer so we wouldn't get fat.

"Beth," I said. "Beth Torbert." We had long ago given up on using our fake names.

Cash handed Connie the other dirty tumbler, smiling at her.

"Connie," she said. "Just Connie."

Cash laughed. "Well, Beth and just Connie, it is a pleasuah ta meet ya bott."

The front door opened. "Cash! Where ya be?" From the dark hall emerged a tall man in a red leather jacket and pants to match—just like Eddie Murphy! Around his neck was a thick gold chain that looked like it weighed two hundred pounds.

"This is my roommate, T.J.," Cash announced. Then, turning to T.J., said, "Ya got it?"

T.J. nodded, then came over and shook our hands before waving the boys away. Our pals promptly got up.

"We'll see you later," one said. "I'll go make sure my sister's home." He looked me right in the eyes. The boys left, never to return.

"Let's light it!" Cash said as he poured more rum into our glasses and turned on the stereo, and T.J. produced a joint from his jacket pocket. They high-fived and T.J. gleefully lit the reefer. Of course, I was not at all interested in smoking the marijuana, and particularly not in this situation, but it dawned on me that not only would it be impolite to decline but saying "No, thank you" was not an option. Neither was not kissing them. Within a short while, Connie and I were quite drunk and incredibly high—likely their goal. The experts had us petting with them, in separate rooms, without any protest.

I knew I could deal with the danger, but I did not wish it upon anyone else, especially my sweet best girl, Connie. Much to my relief, the phone rang.

Cash got up to answer it and I straightened my bra, which was pushed around my collarbones, still fastened under my shirt. I buttoned the top button on my jeans, which, remarkably, had not yet come off. He was on and off the phone in all of ten seconds.

"We gotta go!" Cash banged on the wall. "T.J., we gotta go!" He smiled at me. "Get your coat, girl. We are going out on the town!" He laughed and finished the rum in his glass.

Cash called a cab, I got my coat and running shoes on, and Connie joined me on the couch to lace up her sneakers. We exchanged looks. She seemed just as relieved as I was. We had both been saved by the bell.

"Cab's here," T.J. said, looking out the window. "Bring your bags," he said to us.

We left the apartment and hopped into the taxi, all four of us in the backseat, like children at the back of a school bus. The dark night was brighter than Christmas, with all the streetlights and stoplights.

I was still so relieved and grateful that nothing had happened at the apartment that I was in a good mood. I took in the sights of the big city and didn't pay much attention to what the two guys were talking about.

Our drive took us through an unusually winding road that became more desolate as we drove and the fare meter ticked on: eighty-nine dollars so far. Connie and I were quiet—we were tired and starting to sober up. The cab passed several motels with women hanging around outside. They were girls, really, but dressed up like women, and as if they were going to a nightclub. It struck me as very peculiar, since there didn't seem to be any bars around.

"Shitty bus service here," I joked. I should have kept my mouth shut.

"What the fuck kind of thing is that to say, girl?" Cash was offended.

I tried backpedalling immediately. "Oh, I didn't mean—"

"Shut ya mouth, bitch," he shouted. I was stunned. Suddenly, I was very sober and alert. I grabbed Connie's hand and squeezed it; she squeezed mine back.

Cash pulled out a gun from his jacket and discreetly pressed it against my side; I held my breath.

"Pull over here!" T.J. instructed the cab driver, indicating the driveway of one of the motels. The driver complied. He seemed unaware that the man seated behind him had a gun. T.J. angrily waved a girl toward the car. She flipped her long blonde hair and turned on her heel, sauntering away from us. T.J. looked at Cash. "I'm going to go deal with this," he said, getting out of the cab and slamming the door behind him.

Connie started to cry but tried to stifle a whimper. Cash pressed the tip of the gun harder into my side. "You shut her the fuck up and you shut the fuck up. You will both be tried out tonight, so pull it together, girls!" he whispered through clenched teeth. The driver was not interested in paying attention, that much was clear.

T.J. was having an all-out fight with the blonde girl now, and they were causing quite a scene, prompting other girls to run over to them. "Get the fuck back!" Cash yelled out the car window. He was furious.

Connie was crying and I was still squeezing her hand, trying to reassure and soothe her. Cash got out of the cab, telling the driver to "keep it runnin'" and slamming the door behind him. He shouted at the group of girls, "You fuckin' girls better . . ."

I didn't spare one second. I leaned over toward the front seat and said, "Please! Please, mister!" I started to cry. "Please help us. We don't know them. I'll do anything you want! Just please get us out of here!" I looked him in the eyes in the rear-view mirror.

He looked back at me, annoyed. "I don't need this shit, kid." He didn't make a move.

"Please. He has a gun." I was bawling.

"For fuck's sake," the cabbie muttered. He kept my gaze in the mirror for what seemed like a whole minute before he let out a big

sigh and turned off the meter. "Put your fucking seatbelt on," he said and slammed the gear into drive, peeling out of the motel driveway, the pissed-off pimp running after us, shouting and waving his gun. Cash became smaller and smaller as we left him in the dust. He even shot his gun off into the air, but we simply kept going.

The driver wasn't driving for his life; he was driving for ours. Connie and I ducked down in the back and held hands and cried like schoolgirls, the type of schoolgirls we had never been, the innocent kind. We drove and drove, the silent driver just looking at us through the rearview mirror from time to time without saying a word. The window on my side was down a crack, and the cold breeze stung my cheeks.

Eventually, the cab pulled into a 7-Eleven parking lot, and the driver parked and turned off the engine. He sat still for a minute, looking straight ahead and saying nothing. Connie and I just looked at our feet. Then he turned around to face us. "What do you want in your coffee?" he asked quietly.

Afraid we'd start blubbering all over again, Connie and I could barely get words out. "Sugar . . ." I said. "And . . . and cream." My voice was shaking.

"Black," Connie said.

"You smoke?" We nodded, and he left the cab.

Connie and I didn't even think about taking off from the cab. Instead, we both began to cry again, this time with relief. And because we did not want to be turned out by pimps. And for our mothers. And we just kept on crying.

The cabbie came back to the car and handed us each a cup of coffee. He threw a package of menthol cigarettes over the seat and turned on the engine.

"My shift's up, girls. Let's go home." He slowly pulled the cab out of the parking lot.

We drove through the dark, tree-lined streets. I didn't know what time it was, but it was somewhere in between night and morning, and it was time to pay the piper. I started to get anxious. We should have taken off while he was in the 7-Eleven, instead of just sitting there crying! I leaned into Connie. "I can blow him, but you have to fuck him, you're on the pill." She whispered back, "As *if*. You are doing all of it." I glared at her. I had nothing to say. What *could* I say? She was right. I had to do it; it was my fault we were in this predicament in the first place. It was the fee for him having saved our lives, and it was the least I could do.

I took a deep breath and looked up into the rear-view mirror. The cabbie was looking straight ahead at the road and didn't catch my stare. "All right, then," I whispered. Connie lit another cigarette and blew the smoke out the window into the night. I looked out my window, watching the trees and street lamps and parked cars as we passed by, gathering myself before putting my game face on.

The driver stopped the car on a street across from a darkened house with awnings over the two front windows. The front door was a handsome blue. A car sat in the driveway. The neighbourhood was quiet and old, but the houses were close to one another, and all had cared-for lawns and flower beds.

"This is my place. I live in the basement suite." He got out of the car and we did the same, sheepishly and not looking at each other. We didn't look at him either. We just looked at our feet as they dragged beneath us. He unlocked his door and we all went inside.

"Might as well take your shoes off," he said.

We sat down on the couch and watched as he went into the kitchenette and filled a kettle with water.

The living room had very little furniture and no pictures on the white walls. There was a coffee table with an ashtray and rotary-dial

phone on it, a bookshelf behind the couch, and two chairs across from it.

"You can smoke in here," he said from the kitchenette. I pulled out the cigarettes he had bought for us, handed one to Connie, and lit one for myself.

The driver came over and sat in a chair across from us. "I'm making more coffee," he said, smiling. We just sat there, watching him and scarcely breathing.

"I've decided what I want you girls to do for me."

"I will be the one," I said quietly. I looked him right in his eyes. "It's the least I can do, sir," I said, hoping to sound respectful.

He chuckled. "My name is Norman. You can call me Norman." He picked up the telephone from the table and placed it in front of me. "I want you to call your mother." He sat back in his chair. "That's all."

I sat there in shock. Connie started crying again, and I couldn't blame her. I felt like crying too, but I wasn't getting out of negotiation mode just yet—I wasn't sure I believed him.

"Right now?" I asked. It was the middle of the night and surely my mother would be asleep. I didn't want to wake her.

Norman motioned to the telephone. "Trust me. Just call her."

He waited. I waited.

"Just call her," Connie said.

I picked up the receiver and dialed my home number back in friendly Manitoba.

Three rings.

"Hello?" My mother sounded as if she had been startled awake, but alert. It was either me or the cops. Who else would be calling her in the middle of the night?

"Mom?" I started, and my voice cracked. All I heard through the receiver was the sound of breathing, like a long exhale. It was her soft sobbing.

I was silenced, hearing what a broken heart sounded like. I broke my mother's heart into a million little pieces that autumn. I can't say if she ever found all of them. We talked a few minutes, but I didn't say much other than that we were with a friend in Toronto and okay. I promised to call her again the next day and hung up.

Norman was in his kitchen making Kraft Dinner and hot dogs. "How am I supposed to know what kids eat?" he said, laughing.

Connie called her parents next and talked with them for a while. By the time the phone calls had finished, we'd each eaten two hot dogs covered in macaroni and cheese, and the last cigarette was smoked down to the butt, we were sleep-walking tired.

"Up you get," Norman said. "Got to pull the bed out."

He pushed the coffee table aside, pulled out the hideaway bed, flinging the cushions onto the floor, and unfolded the blanket that was tucked in there. "Now we sleep. You can both use my toothbrush if you want to. I'm sorry I don't have another."

"No. It's okay," I said.

Connie and Norman and I all slept in our clothes on the pull-out bed in the middle of the living room. The sun was starting to come up, but it mattered little; we were dead asleep before our heads hit the pillows. We were safe, and Norman had saved us.

When we woke, Norman had already made coffee and been out to buy us more cigarettes and arrange our bus tickets home to Winnipeg. Back then, people didn't transfer money via the Internet like they do now. There was Western Union, but it was a Sunday. So there was no possibility of our quickly getting money from our parents. On Norman's persuasion, the staff at the Greyhound station took up a collection to send us two girls back home that day, reaching into their own pockets.

"Come on, girls, we have to get a move on. I want to show you

around before I drop you back at the bus station," Norman said downright jovially. We spent most of the afternoon touring the city, learning about the Danforth, the CN Tower, and the waterfront, eventually winding our way up to Little Italy.

"Let me get you two the finest meal you will ever experience in your lives!" he said, pulling up to a takeout restaurant. The windows were painted with the words *deliziosa* and *famosa* and *polpette*—a hint of the culinary experience Norman was about to give us. We loved the food, and we loved Norman.

"Now, these sandwiches are the only authentic meatball sandwiches in all of Little Italy. From a crime family, a real crime family, big time. These families you want to belong to, like I do. Families you can never leave, but that you would never want to leave. They run this city, this neighbourhood. Take that place across the street . . ." He told us how one particular crime family blew up another crime family's restaurant, which used to be in the building he was pointing out to us. He seemed extremely proud to be able to show us the crime scene. What a wealth of information he was. Then he spoke at length about the rich history of Italians—not just those from crime families—in Toronto. Unfortunately, it was lost on me and Connie. But we were lost to begin with. We were runaways.

"The spices are magnificent," he said in between mouthfuls. "The delicate use of oregano and basil . . ." But Connie and I weren't really paying attention anymore. We were too busy inhaling our meatballs. It was a beautiful moment, sitting there eating in the back of the cab—and so different from the previous night's mercy dinner of Kraft Dinner and hot dogs. We ate with a kind of desperation, and from a relief of having been saved. Of not running. We were hungry for safety, and satiated by Norman's nurturing and our trust in him.

Trust—what did I know about it? I was born swaddled in the concept, enshrouded in it, covered with it. I still have blind trust of just about anyone, but especially of heroes, and this cabbie who saved our lives was a hero. Norman truly did deserve our trust. It had been an exhausting few days for Connie and me, all because of my stupidity.

# ELEVEN

BY THE TIME THE GREYHOUND BUS HAD WOUND ITS
way out of downtown Toronto, the bus depot staff waving goodbye,
and eventually pulled up in the sooty Winnipeg bus depot, we were
exhausted. Both sets of parents were there to meet us. Connie's par-
ents never spoke to me after that, and I didn't blame them. I blamed
myself for the whole thing.

Connie and I were home in time to resume our senior year at
John Taylor Collegiate, and in time for the yearbook photos, extra-
mural basketball, and after-school jobs. But somehow, no mat-
ter what I did, it seemed, I was always getting myself into some
predicament.

*Calato* is the Spanish word for "naked." It's a word I picked up
one snowy night in a luxurious hotel room, where I was with a much
older man from Peru. He told me that he was descended from the
Incas. I believe this was his way of impressing upon me that he was
exotic, and descended from kings. Both may have been true, but I
didn't really care much.

I met The Peruvian on my way home from ballet class in down-
town Winnipeg. I loved ballet—I guess you have to love it to be
doing ballet when you're seventeen years old. I was on my way to
catch the bus to our house in the suburbs. He was walking with

another man to their hotel. He said something to me and I answered him back, it was as simple as that.

He decided, I guess, to go for it. And fortune was on his side: I didn't want to go home and was happy to follow anybody, like a puppy. I went with him of my own free will.

Once in the hotel room, it dawned on me that he could kill me. I realized it was a dangerous situation, but not surprisingly, stayed anyway. After all, he had charisma and was kind to me, treating me with what I considered to be respect—he was courteous and warm—and for that I was so grateful that I was receptive to his advances.

He was a big man, and he roared with laughter when I told him this. I loved being there with him that night, and he liked me, and that was all I needed. He smelled of cologne, and I felt that this was of particular importance—I loved perfume and I loved men who smelled good. Smells had begun to be a message of sorts to me. Each person has his or her own particular scent, and I loved this. If I could have, I would have inhaled The Peruvian. He was loud and he smelled loud. I inhaled the heat from his skin in deep, steady breaths. I was drunk on him.

He told me he was in politics—"not military but ministry," he said. Delighted and falling over with giggles, I told him that Ministry was a band. At his request, I sang a Ministry song, dancing around in a good imitation of the singer. This was met with huge laughs from him. (His laugh, like his voice, was big—in fact, everything about him was this way.) I felt validated by his laughing and enjoyed his company for this very reason. He laughed constantly and seemed joyful and, just being in his presence, I too felt joyful. I really felt that he respected me. He told me I was smart, beautiful, and sexy, and I loved hearing it all.

He told me his mother fed him cow-heart stew his entire childhood. When I said I thought this was abusive of her, he found this

adorable and started kissing me, deeply and aggressively. His big hands held me in his grip and left bruises on my body. He didn't know his own strength or, perhaps, my fragility. But I didn't care. He was a passionate storyteller and a passionate lover. He taught me some Spanish words. And he blew smoke rings. I felt mature and empowered. It was a mutually beneficial encounter—we both enjoyed the time we spent together.

There is something vulnerable and intriguing about professional men in suits that appealed to me on a sexual level, I was starting to realize. I never considered myself to have a chance with a professional, especially a political man. Girls like me who feel they are not likeable or desirable enough to attract these types go for skate-boarder punks, or dudes in jail. The Peruvian? Well, I never really intended to have sex with him. I was actually just saying thank you to him. I had got myself into another potentially compromising situation, as I was so prone to do—I seemed to have a knack for it. I was saying thank you to him for not beating or drugging me, for simply extending me common courtesies.

The fog of his cigar smoke choked me, or maybe it was just fatigue. But I smoked and laughed appropriately, and sipped whatever godawful drink was in the champagne flute. It was sour and foamy and sucked all the saliva out of my mouth, like his kisses did. I was grateful that things hadn't gone terribly, terribly wrong. He was not exactly handsome, but I didn't care. He had been nice to me.

# TWELVE

**I WAS PRETTY DISILLUSIONED WITH MY COURSES** at the University of Winnipeg, and I felt useless. I was unmotivated and lost, with no focus other than on the male college sophomores. There were a lot of highly intelligent boys at university. Except I never seemed to attract any of them.

I would have likely completed my courses that fall, my first year at university, had I become someone's full-time girlfriend and felt a part of the student culture. Perhaps I would have been raised up socially by dating. Not that I had that ambition—I'd seen it before, the cheerleaders dating the football heroes, the socially power couples. It was many a college girl's dream, but it wasn't my dream.

My ambition was to have a career in the performing arts—in theatre or film acting—or in medicine, if I had to have a second interest to fall back on. I was extremely optimistic, to say the least, about being successful on either of these career paths—and trusting in my abilities. Indeed, I had confidence about performing but not about my real life. And, as per usual, with my subconscious quest for unconditional love and acceptance, or whatever childhood bullshit I chased every day of my life, men or boys always wound up in the picture.

The trouble with men is that they are actually the more cunning of the sexes, contrary to popular belief that it is women who

83

are calculating. Men certainly have a host of tricks up their sleeves, though often they are completely unaware of their own wizardry or manipulative skills. Often their behaviour just comes down to sheer stupidity.

The frat boy was my new secret boyfriend. I was a fresh-out-of-high-school eighteen-year-old and he was very much an eligible bachelor. He was definitely one of the popular boys, and the fact that he even talked to me was (what I considered) a miracle. I was never introduced to his friends, nor did we ever go to any student-union or fraternity functions. I was completely okay with being a secret; in fact, I told him I preferred it that way. The truth was, though, that I privately hoped he would change his mind and make our relationship "real." But not a soul knew, and I was an invisible girl for him.

The big surprise for me came the night he invited me back to his dorm room. It was the first time I had ever gone with him to his place. He showered me with attention, then swiftly tethered me to the bedposts. He kissed me, his mouth covering mine, leaving behind, like a slug, a trail of sticky man-spit.

I coughed into his mouth, then laughed nervously. I was instantly embarrassed but, as you may have guessed, too polite to protest. What is a young lady to do? He was popular and I was a nobody, and I didn't want to be rude or hurt his feelings. If this was his thing, well, who was I to not go along with it? I didn't ever want anyone to feel judged. And besides, who was I to judge?—*that* I had been taught in Sunday school in fifth grade. God would judge him; I just felt lucky to be there!

I would remain there, tied to the bed, for the rest of the afternoon and into the night, in the dark, by myself. He had left the room after he had finished with me—he said he had to go out—and that was it. I felt totally humiliated. I knew he would eventually come back, but I

didn't know if he would bring his friends with him, to have their way with me too. The thought terrified me.

I tried hard to not choke on mucus—my nose was running profusely from all my sobbing. My tears came and went, but I never yelled or screamed. Finally, I fell asleep, exhausted. He did not return until the sun had come up.

I was so relieved. I was still feeling humiliated, but I guess that was the point. He untied the restraints silently. He didn't speak; he didn't look at me. He never apologized or explained, and I didn't say one word to him. I was trying to not appear frightened, but I got dressed as quickly as I could, then ran down the stairs to the street. I never looked back, just swiftly scurried away along the snowy sidewalk. I didn't stop moving until I was in my pyjamas and safe in my own bed. I was too ashamed to report him to the campus authorities.

I never saw or heard from that frat boy again.

# THIRTEEN

## the chopin café and jungle milk

**SUNLIGHT HAS A WAY OF ILLUMINATING DUST SO THAT** it sparkles. Dances and shimmers and floats. As sunlight shone on the musty rugs of the Chopin Café in Winnipeg's old Exchange District, I felt transported to a 1930s Parisian bistro, me in my thirties, say, a tortured artist, surviving on bread and wine, and madly in love with some mad man who wore a dark green hat. Me with a haircut like Clara Bow and long false eyelashes. Maybe freshly heartbroken and freshly fucked. Smoking, the cigarette filter stained from the deepest shade of crimson lipstick. The pale grey ribbons of smoke joining the rays of dusty sunlight.

My mother would laugh and laugh whenever I told her this. "Beth! My stars! What an imagination you have." But it was easy to envision every fantastical detail. I had read Anaïs Nin, of all things, in high school, and dreamed, somewhat melodramatically, about living the artist's life. The Chopin Café held that dream for me; the place had an energy. It was small, dark, and mysterious. Rich brocade ties gathered the burgundy velvet that hung on either side of the windows. Dark, worn floors and brick walls. Billie Holiday, Glenn Miller, Count Basie, or some George Gershwin tune would be playing on the sound system whenever my mother and I arrived. Never once did we hear any Frédéric Chopin playing at the café bearing his name. My

mother and I loved the café nonetheless and frequented it for tea. It was our place.

The café allowed my mother and me to live another life, even if for only a lunch hour. It was a sophistication far removed from our real life and from the constant struggles my mother had with my disobedience. I was not a disobedient girl when she took me for tea to our special café.

Jeanette Violet McCracken was the most dedicated, well-meaning, and conscientious mother any asshole-runaway-ingrate like me could ever dream of having. The least we could do was nurture our budding friendship in a neutral place, free of our former restraints and expectations, helped along by our loyal waiter, Marcos Torres—or Marcos X, the name by which he went.

Marcos would bow deeply to my shy mother every time we entered the café. She was always embarrassed by this, but it was such a respectful gesture that we both always appreciated it. And she deserved it, this grand bow by a gracious young waiter. It made me feel good too, and I adored Marcos for it, and vowed to thank him properly for it one day.

He knew our order—it was always the same—and without fail would grab an ashtray for me as soon as we had sat down at our favourite table by the window.

The café was down the road from the university, and my mother and I met there often. We were entering a new era, my sweet mother and I. She had successfully reared me, I was growing up, eighteen now and in university.

The University of Winnipeg was, like any academic institution, a society within a society, like a walled city or a ringed planet off by itself at the edge of the Milky Way. I had begged my parents for the tuition money, enrolling through the university in Musical Theatre at the Prairie Theatre Exchange, a professional theatre company that

also had a school. The program was theoretical rather than perfor-mance—it was all that was available, as I had waited too long to choose my courses. This upset me greatly, but I figured it was better than nothing.

I also took courses in sociology, political science, and French, being forced to wait until the next semester for the courses I really wanted, like English, calculus, biology, and chemistry, courses I wanted to get past sooner rather than later. The trouble with school for me was me being in one. I felt extremely vulnerable. The truth is, I would have had sex with my sociology professor if he'd asked me to. I knew it the first class. He was young enough, and had a head of dark brown hair. That first day he wore a smart camel-coloured blazer over a white button-down shirt tucked into faded jeans, with a brown worn belt and matching shoes. He was right out of the *What Professors Look Like* stylebook, except he didn't have a pipe. He was awkward and quirky and somewhat self-conscious. I loved it. And I loved staring dreamily at him, not listening to a word he said.

Luckily for my professor, a prominent member of the university basketball team started chatting me up in the cafeteria. He always had lots of fun things to do, and he kept me busy and distracted. I believe that the universe connects people for a reason. This basketball player was kind to me and helped me build my self-esteem back up. As Marcos X had.

In the short periods between my classes at the university, there wasn't much to do. This meant that I was usually found in the halls with certain other students. We were quickly resembling the Sweathogs from *Welcome Back, Kotter*. We were all theatre students, and horsed around and acted like jackasses. Anything for a laugh.

Marcos and a friend were cutting through the campus on their way downtown one afternoon when he spotted me with my boisterous

friends. I was surprised and happy to see him. He introduced me to
his friend, and when I shook the hand of Brett Hopkins and looked
into his emerald-green eyes, my life changed in an instant. He was
a towering oak, a six-foot-four-inch tree. And a vegetarian with a
mohawk. His dreadlocks were tied back with an elastic band that hid
his mohawk from the view of those folks whom had never seen such a
thing in the daylight. I was enraptured completely and fell in love with
him that afternoon.

Brett and Marcos were in a project called Jungle Milk, a world
music group that had more than ten drummers, all playing bongos
or congas or tabla drums and singing to accompany the four or five
female singers the band had at any given time—often totalling fifteen
or so people on the stage at once. The band was popular and had shows
all over the city. And it had an opening for a female singer.

"You should come by," Brett and Marcos chimed together. "Come
to rehearsal. There's tea." And so I attended several rehearsals, held
in an old house in Winnipeg's River Heights area. The attic rehearsal
space doubled as Brett's bedroom. All fourteen or fifteen people would
sit cross-legged on the floor, drumming and humming, drinking tea
and burning Nag Champa incense. Keeping everyone company were a
couple of pet chickens.

It was all quite marvellous, in my opinion, and I was thrilled to be
there, not knowing, as everyone else in the room did, that Brett had
more than one girlfriend in attendance—something even Brett's vari-
ous girlfriends knew. I had no real desire to sing; I just wanted to stare
into the green eyes of one Brett Hopkins. Before long, I began to sing
with the band. My parents came to every Jungle Milk show I played,
as did my rocker friends from Chocolate Bunnies from Hell and their
singer P.J. Burton. P.J. led the cheers, shouting "Bif! Bif! Bif!" from the
back of the room. The name stuck.

Right around this time, a new music cabaret opened in Winnipeg, famous for being a music city, and lots of musicians applied for a job there, including me and Brett. We got hired. Not only did I get to perform with my new boyfriend (still hoping to eventually be the Only Girlfriend), I got to work with him too. It seemed like nothing could go wrong, until it did.

# FOURTEEN

lola, johnny thunders, and me

**THE NIGHT SKY WAS LIT UP LIKE BURNING PARCHMENT**
paper in an oven, singed orange flecks floating through the black sky,
the noxious smell of chemicals in the air, the smoke making us cough.
Fire trucks and police cars screamed down the streets, and the seep-
ing stench overtook the usual smell from the neighbourhood sausage
factory. People ran around in all directions at once, like Keystone
Cops, a menagerie of Winnipeg nightlife—the patrons from the rock
pub upstairs and from the gentleman's cabaret on the main floor, plus
the strippers. To make things even worse, it was a cold Winnipeg
winter night.

Now, you may think you know a thing or two about Winnipeg
winters, but unless you're a Winnipegger or have spent any time there,
you don't. Really, you don't. The band rehearsal or jam spaces often
had no toilet facilities. Musicians (with the exception of me, they were
all male) who absolutely needed to go would, in the warmer months,
step outside and urinate in the alley or, in the winter months, fill a
7-Eleven Slurpee cup while huddling in the doorway. Upon filling the
cup, the next step was to open the door and somehow disperse the
contents without them blowing back on oneself. This called for a fine-
tuned technique in the sixty-mile-per-hour wind and heinous sub-zero
temperatures, which combined into what felt like a winter hurricane.

The wind threatened to blow you out the door and down the alley. The contents of the cup, tossed out the door, froze the moment they hit the ground into a flat puck you could pick up with one mitten-clad hand. Occasionally, a semi-drunk band member would find this a very funny thing to toss at other semi-drunk bandmates, and the inevitable fight would break out. Of course, I didn't participate but ran for cover.

Similarly when travelling in a band van, deadheading—driving non-stop—from, say, Quebec City to Winnipeg to make the next show, the guys would pee into a cup. Even if you had time to stop for a pee break, there weren't any towns or gas stations to stop at. With the exception of Wawa, Ontario, halfway between Sault Ste. Marie and Thunder Bay. I am sure that every band that has ever travelled that godforsaken highway has taken pictures of themselves in front of the Wawa town sign—it was a landmark of sorts.

Winter touring in a van with a band is no place for a nice girl and neither was the St. Boniface Hotel's strip club in Winnipeg, but that's exactly where I was when I met Lola. She was a dancer and miffed that her shift had been cut short by the inconvenience of a factory explosion that saw the entire area evacuated.

I was working as the coat-check girl at the cabaret, a legendary stopover for some of the most infamous underground rock acts. GWAR and Soul Asylum were well-known touring acts, and both played at St. Boniface's. Pandemonium had broken out among the patrons after the police announced that the area was being evacuated: we were to collect our personal belongings and calmly vacate the premises. People were outraged that they would be unable to continue drinking until closing time.

As I desperately tried to return coats to angry patrons forced to leave, Lola burst through the front doors of the club and marched right up to me. She smiled and plopped herself down with a huff on my coat

table. She was still in her bra-and-panty costume, complete with high heels, a stripper floor-show blanket wrapped around her shoulders. She lit a cigarette and started talking to me as if we had known each other our whole lives. It was like looking into a mirror, only Lola was extremely good-looking.

She had big boobs, long legs, long hair, and a tattoo. She was the coolest girl I had ever seen. Moss-green contact lenses covered her God-given hazel eyes, cloaked in long black eyelashes that didn't flutter but waved at you. She had big lips and wore the shade of blue-red lipstick that makes men weep. Lola was a throwback to an era few alive today have actually witnessed in the flesh. She was a modern-day Tempest Storm, Bettie Page, Eva Gabor. A timeless beauty whose image burned in your memory for a lifetime.

"Can you fuckin' believe this shit?" she said.

I nodded, still handing over coats to the whining patrons leaving the club.

"I tell ya, I will bet the owners set the fire! They didn't want us girls making our tips!" She exhaled a ring of smoke.

I nodded again.

"So, do you want to split a cab?"

I looked at her blankly. "I have my mom's car," I replied.

She lit a new cigarette from the burning tip of her old one. "Great!" she said, exhaling another cloud of smoke.

This girl lit up the room brighter than any chemical sky could light up the night. She laughed such a natural and warm laugh, it grabbed you by the throat and held you suspended, holding your breath waiting for the next thing she'd say. Lola was the funniest person I had ever met. Just being in her presence, I was funnier than I ever hoped to be. I effortlessly fell into being the "straight man," and together we were magic.

I drove Lola home in my mom's burgundy Ford Fairmont station wagon. I was, as usual, half-drunk from the bartender's Italian coffee drinks and talking a mile a minute. A beautiful, lifelong friendship was born that evening.

Lola and I were so similar and so emulated each other, there were few differences between us. We hung out practically every waking moment we weren't working.

The world-famous punk band The New York Dolls was scheduled to come to Winnipeg to our little cabaret, which was quite the coup, since they were legendary and such an integral part of music history. They would be performing on a night I was working. I was pleased about this—the coat check had a pretty clear view of the stage. Lola was even more pleased than I was that the Dolls were playing. She knew everything there was to know about music. She must have told me the history of every band there ever was. She thought Johnny Thunders of The New York Dolls was the best-looking and most prolific guitar player in history. I couldn't see it at all.

My job that night, as always, consisted of taking the cover charge and coats, then taking more cover charge and more coats, all the while getting drunk on alcohol-laced coffee drinks. And then the show was done.

I was trying to locate my Lola so I could give her a ride home compliments of the burgundy station wagon and she was eluding me—I couldn't find my best friend anywhere. So I waited, and I looked, and I waited some more. But she didn't turn up. It was getting late, just after 4 a.m., and I was not pleased. Finally, one of the dancers told me she had left with Johnny Thunders. Now I was really pissed. I set about finding his room—the Dolls were staying at the motor hotel attached to the cabaret.

I had knocked on just almost every door when one opened to

reveal Johnny Thunders himself, naked and with red lipstick covering the lower half of his face.

"Where's Lola?" I demanded.

"Who? I don't know." His eyes were slits. Wobbling, he held himself up by leaning on the doorframe.

From behind him came a voice. "Bif? Bif? Is that you?" Lola popped her head out from under the thin sheet on the bed. "Hi, Bif!" Smiling, she jumped out of the bed, naked, her face covered in the same red mess as her gentleman friend's. "Is it time to go?"

"Yes," I said crossly. "I'll be out front in the car. You've got five minutes."

As I turned to leave I saw her scurrying around the room, collecting her clothes. Walking away, I heard her consoling the whining rock star. I sat in my mom's car with the engine running, trying to warm it up. Long sobered up, I was dead tired. When Lola got in, she was laughing and began talking a mile a minute. She told me of the evening's events and excitedly reported that Johnny Thunders was in love with her and that she was moving to New York to be with him. I rolled my eyes, having heard this song and dance about every rock star she made eyes at. Of course, they did all love her, but I loved her more.

# FIFTEEN

I WAS THRUST INTO A NEW-FOUND CAREER PATH AFTER my very first Jungle Milk concert. I had left my academic ambitions behind and was no longer in the theatre program, but I still didn't really want to be a singer. I just wanted to be in the band to be around Brett. Besides being in Jungle Milk, Brett was playing in a few other bands, including a couple of hardcore ones, and it was through them that I was introduced to a new style of music and to the punk rock lifestyle. It was quite an eye-opener.

Vegetarianism, hardcore and punk music, stage-diving, and fighting skinheads in Winnipeg's mean punk rock scene—all these Brett introduced me to. The local band Gorilla Gorilla had a singer named Geoff, who unexpectedly announced he was moving to Seattle. The band was left scrambling looking for a vocalist. Before long, it became clear that Geoff's move was shaping up to be a great opportunity for the band and especially for me. But switching the gender of the vocalist in any band, and especially one with an established following, can be a dangerous move. With Gorilla Gorilla, it was scandalous to fans, and the band was risking their hard-fought-for credibility.

Few punk bands had female vocalists then. The concern was that switching to a female vocalist would be looked down upon by the male punk rockers, especially those in Winnipeg. The guys in Gorilla Gorilla

decided to go out large, making gig posters to advertise the upcoming show that read "Come see Bif Naked." It was a double entendre that basically baited the naysayers—peers, friends, and fans still disappointed about the previous singer's departure—to come to the show, even if only out of curiosity to see if I really would be naked. The band plastered the posters all over the city, putting them on practically every street lamp post and mailbox, even gluing them on store windows. It was a massive street-level postering campaign, and it worked.

A lot of people came to the show, for whatever reason. And we kept them there for the entire performance, stage-diving, slam-dancing, and cheering. And the name stuck. Bif Naked was born.

Being in Gorilla Gorilla was an amazing time for me. As a band we were very lucky, getting lots of gigs and increasing our fan base. Most of the bands we toured with were respectful toward me as a female. And I tried hard to be respectable, professional, and humble. I never missed an opportunity to thank the headliner for having us on the show. I never wanted to come across as flirtatious or sexual in any way, and I was deliberate in my behaviour. My stage show was aggressive, angry, and sometimes violent, but regardless of how much I manned up, because I was a female, it was often misinterpreted as being overtly sexual. This was devastating to me, as it was never my intention and I prided myself on not being promiscuous. We were on national tours supporting bands like The Wongs, DOA, NoMeansNo, Bad Religion, Boston's The Mighty Mighty Bosstones, and even Los Angeles's ska punk kings Fishbone, and it was important to me that my femaleness was not a weakness or a reason for people to discount our band.

We were in our infancy as a band, together less than a year, and it was all or nothing every day. The more successful bands were generally much more polite than those mid-level or at the bottom. But there were exceptions. We were opening for a popular American band

at Vancouver's Commodore Ballroom—it had been our dream to play with them. As we waited for our turn to take the stage and do our sound check, one of the members approached me and asked, "Which one are you here to fuck?" He hadn't even said hello. It was like being sucker-punched, and the wind knocked out of me.

Having just arrived at the venue, I was still in my coat. I mean, it wasn't as if I was in some skimpy dress or a bikini. At first, I assumed he'd made a mistake. Maybe he thought I was a groupie hanging around to pick up a band member. "Oh, I'm in the opening band," I said, smiling but feeling mortified.

"I know that, bitch. Which one of my band are you fucking tonight?"

I almost choked. "Oh, well, no one, actually. I'm here to start the mosh pit and warm up the audience for you guys," I said enthusiastically, trying to get him off the topic.

"Then which guy in your band are you fucking?"

"Nobody," I quietly answered, my voice—and heart—shrinking.

"Well, you gotta be fucking somebody, honey. You wouldn't be here if you weren't." And with that he walked off, leaving me standing there feeling humiliated. I wanted to run home and die.

My band was still unpacking gear, and Kent, our bass player, walked over to me. "Biffy, there's coffee."

I nodded and started to head over to the bar with him to get some.

"Biffy, were you guys talking? What'd he say?"

"Nothing," I answered, not looking at him. "We just talked about the weather."

I played that night giving it everything I had, and we had a great show, and I felt good about myself.

This type of misogyny was not uncommon on tour. The road ain't no place for a lady or the faint of heart. It's a place for people who can

handle their misogynists and their beer. Beer and gigs, it's what you did in a punk band on a punk tour. It didn't matter if you were a thrash band, a ska band, a hardcore band, or a skate-punk band. Many nights you were lucky just to get paid in beer—at least it was something. A six-pack for the entire band as pay, that was the night's paycheque.

Both hands are not enough to count how many promoters leeringly asked me to blow them, fuck them, fuck their bouncers, fuck the waitresses, you name it. It was demeaning. Usually, I would make light of it and laugh it off, as I'd still be trying to get our fifty bucks for playing the show. This was the all-important gas money to get to the next show, and what was left over after paying for gas was divided between each person in the band, for food.

A couple of girls in some town told me one night that a trick promoters try is to make insulting, sleazy, racist, or bigoted remarks to get a band member angry enough to take a swing or storm out, then he would refuse to pay the band because of the bad behaviour. Knowing this, I never let such comments get to me, and I never took it personally. Misogyny isn't personal, it's against everybody. But I never ever forgot a misogynist. They stick in your memory like dog shit on your shoe.

# SIXTEEN

**the wedding**

"CAN'T BACK OUT NOW," I THOUGHT, STANDING UP THERE with my dad. He was tired, having recently travelled, but he looked so nice in his suit and tie. He had polished his church shoes and had shaved close, and smelled of astringent. It smelled good. I was relieved my dad had come. My parents were definitely not pleased about the wedding, but, as usual, they were unyielding with their support and encouragement. I think they were both surprised that I wasn't pregnant. The baby's breath in my bouquet was quivering as we walked down the aisle between the folding chairs, smiling faces all around us. Soul II Soul's "Back to Life" was the processional music, and it was playing loudly.

Getting married was a pretty big milestone. Brett and I had been playing in the band and living together for months. We were in love, real love, just like in the Jody Watley song. Our engagement caused a bit of a stir in the local scene and was a source of great discussion among the Winnipeg punks. I mean, nobody got married anymore, not punks, anyway. But they all were invited to the wedding. It was an event not to be missed, and they didn't miss it.

It was just how any bride wants it: my head was freshly shaved on one side, and my white dress was in what I perceived to be the style of Jackie Onassis. I was a bit off the mark, really, but I thought

I looked lovely. The mother of my maid of honour told me I looked pinched and drawn. I think she meant "sick," but I chose to take it as though she meant "thin" and about this I was ecstatic. I wore white satin shoes with five-inch heels, and a strapless bra and garter belt. That was the best part—it made me feel extremely provocative. The trophy; the inaccessible, sexy punk prize bride.

My mom helped me organize the wedding and paid for my dress, even giving me extra money for makeup and pantyhose. My dad flew in from some remote community, where he had been doing dental exams, to walk me down the aisle, or should I say, up to the stage. Brett and I had decided to have the wedding at Winnipeg's West End Cultural Centre, an old church converted into a hall. We were married on the stage there, facing the guests.

We had a good history with the venue. Gorilla Gorilla had performed there and recorded there, and even Jungle Milk had performed there. I stood on the stage thinking about how fast things had changed. I remembered how my parents had come to see Jungle Milk, with our five singers and ten drummers, plus myriad other guest percussionists. It was a benefit rally for El Salvador, and Marcos Torres, the band leader, stood on top of one of the conga drums making a speech in a loincloth with nothing underneath, right in front of my father's seat. What are the odds of that being my parents' first exposure to my budding music career?

The wedding had been announced a mere two months before, in February 1990, and was thrown together in DIY skate-punk style. I was being married by a Muslim—named Mohammed, of course. (I was a proud non-denominational girl despite my upbringing—or is that, *to spite* my upbringing?) Brett's parents hosted our wedding reception at their house. Brett's cousin marked our arrival with her squealing bagpipes, to the delight of all the baked and half-drunk punks who had descended on his parents' place.

The truth is that Brett and I were so drunk that neither one of us remember the rest of the evening. Somehow we were returned safely to our apartment. Our roommate, Al, was elsewhere, in honour of the night being our first as husband and wife.

The next morning when I woke up, Brett was gone from our futon bed. I smelled food and heard a Jungle Brothers cassette tape playing on the stereo at full volume. I could hear my new husband singing along merrily, clanging pots, and running the tap. I smiled and lay there on the futon, feeling very good about life.

# SEVENTEEN

**unexpected, unprepared, and undone**

THIS HANGOVER WAS DIFFERENT. THIS RICE-PUKE, beer-smell hangover, with its retching and hurling, was exhausting. I was in London, Ontario, where a sold-out crowd saw Gorilla Gorilla for the first time. I probably should have known I was knocked up, I was sick a lot that tour. The smell of stale beer and smoke in the bars made me puke as soon as I entered them. For some reason, I thought nothing of it. I barfed every day and night, and in fact, I barfed so much that I started losing weight.

I was still smoking cigarettes, which was a disaster because I'd just get sicker each time I smoked. The show in London was difficult, as I was very ill. But as far as I was concerned, puking made the show hardcore—or my idea of hardcore, anyway: it was very punk to puke, I thought, a real crowd-pleaser, and of course, anything for the show. I used it as armour against my insecurity of being the only girl front man. (I would remain one of the only female singers on tours for years to come.) But being in the band felt natural to me, and puking only added to my punk rock identity, to my mystique as a performer. It never occurred to me that I could be pregnant.

I wrote the story of Brett and me into a song called "Chotee," and put it on my second record, *I, Bificus*. I even made a music video for it. I

sang the song two thousand times and cried every time, transported as I was, the way my songs seem to curse me with.

> *Chotee*
> *I was just out of high school in my first band.*
> *I married my drummer, our love was grand.*
> *I thought it was forever. Till death do us part.*
> *Then, he cheated on me, and he broke my heart.*
> *Chotee . . .*
> *So young, so confused. What was I to do?*
> *I'm so sorry, Chotee, but I couldn't keep you.*
> *I hope you can forgive me.*
> *I hope you can forgive me.*
> *My baby. My baby. My baby, Chotee, please forgive me.*
> *Me and him were fighting on the road for two years.*
> *He never loved me, anyway. It still brings me to tears.*
> *Chotee.*
> *He didn't really want you, 'cause he didn't want me.*
> *He didn't want to be a husband, didn't want to be a daddy.*
> *I hope you can forgive me.*
> *I hope you can forgive me.*
> *My baby. My baby. My baby, Chotee.*

Brett and I were in love, and in love with the band. We were married first to the band and second to each other. Our collective priority was the band. Gorilla Gorilla was the biggest thing in our lives, and we were committed to putting the band first. But as time wore on, Brett was confronted with the reality that he really did not want to be married, or at least not to me.

When I became pregnant, things really fell apart. I simply could

not understand how he couldn't be overjoyed. We were married, and though the pregnancy wasn't ideal timing, I truly believed having a baby was our destiny. Brett did not believe it was destiny; he believed it would ruin my life and his life. I think that he was feeling overwhelmed.

Our fighting was relentless, and by the time he finally broke up with me, I was a complete mess. My heartbreak was immeasurable.

Terminating the pregnancy, though, probably was for the best, given my various health conditions every Saturday night. In hindsight, I know that my health and drunkenness would have been to the detriment of the child, but at the time, I could not forgive Brett. I was completely immersed in my grief.

We both remained in the band for the greater good, and it sucked. Ignoring his flirtations with girls backstage during shows took every bit of disassociation and resolve I could muster, but I managed. I believed it was a great opportunity for me to learn, to grow, and to act professionally at any cost.

Brett was already in a new relationship, with a long-legged, red-headed waitress. I couldn't take it. My hair was coloured red; worse, it was the identical shade as that of his new girlfriend. I immediately dyed my hair black as night, and it never went back to red. I would remain raven-haired from this point on, and it suited me. I was never a real fan of Bettie Page, but the black hair with bangs quickly became my trademark, and I embraced it. I wanted to look as different as possible from my estranged husband's girlfriend. That was the bottom line. I started being accused of being a Goth and, taking this as an insult, would occasionally end up in a drunken fist fight.

It was a sensitive time for me. I was lost. I was twenty-one years old and separated from the love of my life, silently devastated, vulnerable.

I filed for divorce, using a divorce service I found through an ad at the back of a newspaper. Brett and I had no shared assets. In fact, we had no assets at all. There was nothing to divide and there was nothing to lose.

My dad gave me the five hundred dollars I needed for the divorce. I was divorced fifteen months after the wedding, after a year of separation. I never got over this and would go on to replicate the relationship again and again. Luckily, I found that my therapy was writing songs. Brett would find his way into much of my writing, and "Chotee" was all for him, telling my true story of us.

# EIGHTEEN

## choked

**THE GREAT VOLTAIRE IS SAID TO HAVE DISTRUSTED** democracy, which he saw as propagating the idiocy of the masses. Perhaps no truer sentiment has been so beautifully put. Well, that is until my manager, Peter, later said, "It was meant to be this way, otherwise it would be different." Or, as is said in the film *Slumdog Millionaire* (quoting the Gospel of Matthew), "It is written." Any way you say it, sometimes you just can't stop fate. Fate is fate, and that's all there is to it.

Gorilla Gorilla had decided to relocate either west or east. I can't remember if it was heads or tails on the coin toss, but all I know is, whichever it was, it was meant to be for reasons that unfold to this day even as I write this.

Vancouver in 1990 was a place not far enough north of Seattle to be immune to the infection of grunge. Post–punk thrashers and Prairie skate punks like us were beginning to show the signs of this dreaded "grunge infection" in the form of mid-tempo and drop D–tuned distorted fuzzy guitars—and growing out our mohawk hairstyles. The choice to move to Vancouver instead of to Toronto was a risky one for the band, and at that time I had no idea it would be where I'd finally root and stop running away. It would become my home.

Vancouver had a rich music scene and band culture, and its proximity to the United States was taken advantage of by American bands,

which added to their tour schedules a couple of shows past the usual Portland-Seattle-Tacoma-Spokane circuit. This was always welcome by both the bands and the fans. And it was great for Gorilla Gorilla. We had so many opportunities to get on shows by opening for bands like 24-7 Spyz and Bad Religion. We opened for Canadian bands too. One infamous night we opened for NoMeansNo at the Commodore Ballroom. Infamous because Kent Jamieson, our bassist, fell backwards down a flight of cement stairs, banging his spine on each one. It was only by sheer luck that it was not me tumbling down: one of the bouncers had grabbed me by the neck of my hoodie and spared me the trip to the bottom.

Bouncers and I had a bit of a history by this point, not because I was always in fights but because I was constantly trying to break them up. One enchanted evening, my beautiful sidekick, Lola, and I managed to weasel our way into some show at one of the Vancouver clubs. I can't remember if the band playing was Faster Pussycat or Skid Row, but Lola and I were having a typically riotous good time. "Here's to us, kid! Here's to us. No muss, no fuss!" she'd say, flinging her long red hair from her eye. And we'd drink a shot, laughing at her genius wit.

It may really have only ever been Lola and I who thought we were funny. No one laughed as hard at our silly remarks to each other as we did. In fact, she and I never stopped joking and laughing, even when we went to the washroom. The lineup for the women's washroom at bars always seemed longer than it needed to be, but the time waiting passed quickly, as Lola and I just continued on with our asinine talk.

That night at the club, though, some monstrous oaf of a meathead came barging into the women's washroom, right past the lineup. All of us girls did the usual hen clucking. "Hey, man. Back of the line."

Undeterred, he banged on a stall door. "Get out! Get the fuck out here!"

The door opened and a girl's face emerged. "No!" the girl declared.

The man reached in after her, grabbing her by the hair and dragging her out. She lost her footing on the greasy honeycomb-tile floor, and he held her down, practically on her knees.

I didn't think, I just jumped in. "Let her go!" I said, grabbing his wrists and trying to pull them off the small girl.

He immediately let go of her hair and grabbed me around my neck, picking me up with both hands. I kicked my feet out at him as I tried to pry his hands off me.

Lola jumped in and whacked him on the back with clenched fists. "Get your fuckin' hands off her, asshole!"

It was no use: he would not let go. I started to lose consciousness.

The commotion caught the attention of a big bouncer, who proceeded to kick the crap out of my strangler, then dragged him out of the washroom, leaving me clutching my neck, coughing and in tears. "Just go on home," I kept thinking, "we should just go on home right now."

The club manager came to talk with Lola and me, saying that nothing "bad" had actually happened to anyone, so we might as well accept the club's apology and offer of a night of free alcohol, and, in fact, "If you don't say anything to the cops or can't remember, you'll drink in this bar for free for life." I felt sick.

"Great." Lola said. "We'll drink to that!"

I just felt sicker. It's not that I wasn't happy about free drinks for life. More likely it was nausea from the vascular injuries I had sustained. It never occurred to me to get checked out at the hospital.

"C'mon," said our new best friend, The Promoter. "I'll give you girls a lift home; my Cadillac is just outside." We both wanted to call it a night, so we happily followed him to his long brown car.

The three of us sat in the front bench seat. Just when we were almost home, he was pulled over by the police.

"Ooh, Bif!" Lola squealed, squirming in her seat. "It's your lucky night, girl!"

I kind of chuckled but was still rubbing my throat.

She leaned into The Promoter. "Bif has this thing for cops," she said and started laughing.

He wasn't paying attention to her, just fumbling around in his pockets. He pulled out a small baggie of powder and threw it across the seat into my lap. "Here, kid, hold this."

I was so shocked I couldn't speak, and then the police officer was tapping at the raindrop-covered window.

"Licence and registration, sir. Have you had anything to drink tonight?"

"No, sir, I don't drink alcohol." His smile made him look even older than he was, and his teeth were quite yellow.

I sat still, not wanting to draw attention to myself. I mean, what could have been in the bag? Baby powder? I had never even done cocaine or heroin and here I was about to get nailed for this? I just couldn't believe it.

The cop left with the promoter's papers, then returned. "Here you go, sir. Thank you for your time." He went back to his car, but I continued to hold my breath for a moment.

Our new friend was embarrassed and said nothing else. He just put the car into drive and took us the remaining eight or nine blocks. Our cheerful mood had vanished.

"Thanks for the ride," said Lola.

"Don't be a stranger, ladies. Please remember to come by any time."

Lola walked away and I stood there in the rain, car door open, fumbling in my purse. I leaned over the front seat and handed him his baggie with great care lest it get wet from the rain. "Here are your belongings," I said quietly. Then I looked him right in the eye and said, "I will never do drugs."

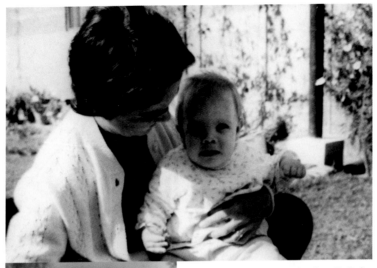

In the backyard in Bareilly, India, with my mom, around 1971.

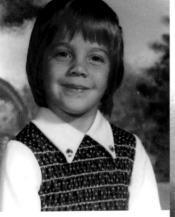

Me at Kelsey Elementary in The Pas, Manitoba, after my father had set up his practice there.

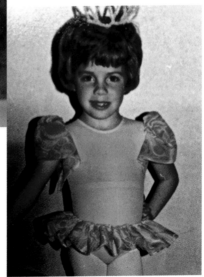

At a ballet recital in northern Manitoba, 1978.

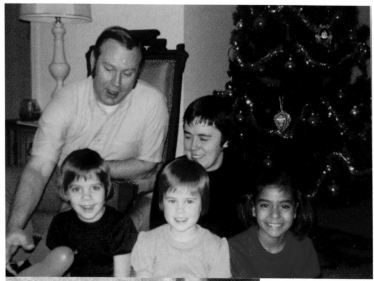

At my uncle's home in Minnesota, Christmas 1977. (I'm on the left.) We moved from The Pas to Kentucky less than a week later.

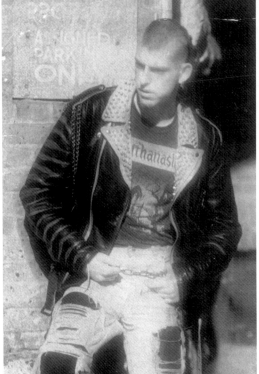

The boy with whom I fell in love: Greenpeace activist, vegetarian, hardcore punk rocker, and drummer Brett Hopkins, in Winnipeg, 1987.

My wedding ceremony with Brett
Hopkins at Winnipeg's West End
Cultural Centre, April 1990.

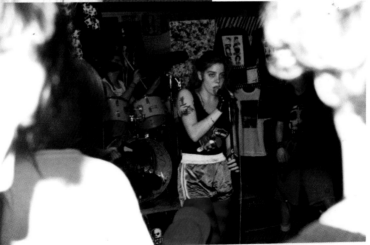

Gorilla Gorilla performing at a free all-ages afternoon concert in P.D.'s Hot Shop
skateboard shop on Pender Street (headquarters of the legendary Skull Skates brand) in
Vancouver to promote the band and the store.

I was the cover story in *Terminal City* magazine in 1990. This was one of several photographs that would capture the attention of Annihilator's manager, Peter Karroll, who later became my manager.

Heather Faulkner

In 1991, Brett and I had broken up, and my mom and sister Heather came to Vancouver to visit me; Heather took this photograph at Granville Island.

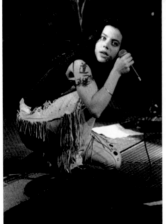

A concert photo from a Gorilla Gorilla performance at Club Soda (later called the Starfish Room) in Vancouver. I was wearing my friend Lola's stripper chaps to complement my Boston Red Sox T-shirt.

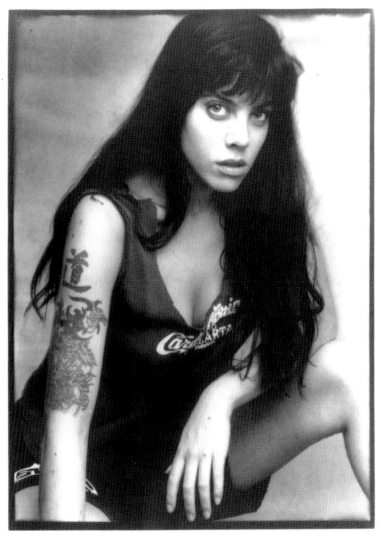

This photograph, taken in Vancouver in 1992, would later prove a factor in the breakup of Chrome Dog, as promoters and press all over America used this promotional shot of me instead of a band shot. Victor Deso

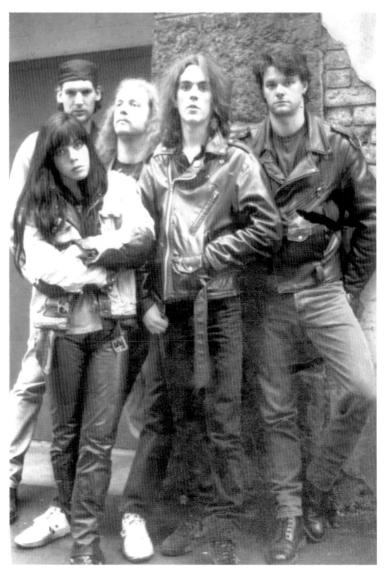

Chrome Dog in Vancouver, 1992.

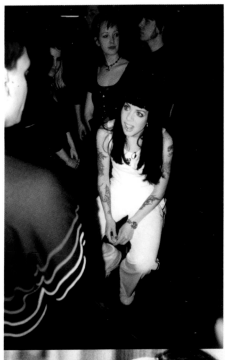

After I became a solo artist, I toured Canada with my band. We appeared on MuchMusic many times. When this photo was taken, my album *I, Bificus* was about to be released.

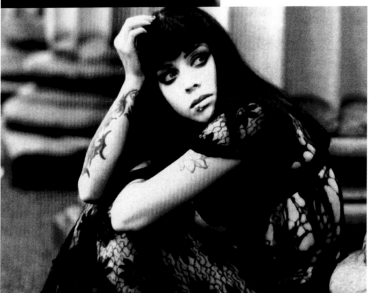

Album artwork for the *I, Bificus* album, shot in Seattle in 1996.

Karen Moskowitz/Sony Music Group

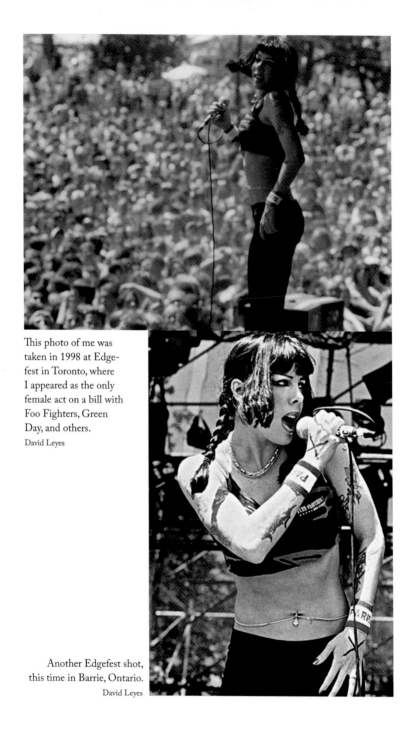

This photo of me was taken in 1998 at Edgefest in Toronto, where I appeared as the only female act on a bill with Foo Fighters, Green Day, and others.
David Leyes

Another Edgefest shot, this time in Barrie, Ontario.
David Leyes

He was silent.

"They make a person do horrible things."

I had never liked pot, even though my crowd smoked it. Frankly, I think marijuana was one of the reasons the band considered moving to Vancouver in the first place. We had a lot of skate friends, and most of those from Vancouver smoked pot. I never caught on to the stuff, though I now liked beer just fine. Besides, I would fall dead asleep the minute I smoked anything and had a real fear that guys would take advantage of me. I had to look out for myself, and doing drugs could mean a repeat of me being in a very bad situation at a party. And I wasn't going to experience that again if I could help it.

# NINETEEN

chrome dog

**AT THE NOW DEFUNCT ARTS CLUB ON SEYMOUR STREET,** we played with the perils of skinhead fights, drug busts in the backroom, and old punk rockers crawling onstage with us, so blind-drunk their presence altered the show every time. Many times I drank so much sherry straight out of the bottle to show off on stage that I wouldn't remember the show afterward. I still can't.

There were many great bands in Vancouver during this era, including Chrome Dog, which was advertising for a vocalist in the local scene paper, *Georgia Straight*. Chrome Dog was an up-and-coming grunge/thrash band. The guitar player, James Yauk, originally from Winnipeg, came to Vancouver via a band called Beyond Possession, and I was a huge fan of his. By this time, Gorilla Gorilla had just completed yet another gruelling Canadian winter tour, and tensions between Brett and me were riding so high, I finally had enough and stormed out of the tour van on the way back home, taking a Greyhound bus the rest of the way, from Winnipeg to Vancouver.

I was tired of the stress and what I believed to be the oppression of my songwriting. I have always been sensitive, maybe even a touch dramatic, with my lyrics. I loved writing; it was my escape, and my very personal, intense, and melodramatic poetry is what I used for lyrics—or desperately wanted to if only the guys in the band would

let me. But now I had finally realized that it was just not going to work for them or for me. My girl-slanted lyrics were just too personal, emotional, or feminine for the testosterone-driven band. I could stand up there on stage night after night and more than hold my own with any band, in front of pretty much any audience, yet the limitations on the songwriting I couldn't get past. It was my biggest battle with being in the band. I fiercely held the lyrics close to my heart, and I felt that the guys in the band always sided with Brett, whom I resented for our failed marriage. In fact, I also resented anyone who had one ounce of sympathy for him: they instantly went on my bad list, not to be spoken to. I was incredibly long on memory and short on tolerance and forgiveness.

The tour had gone well. We were gaining an audience and selling merchandise, like cassette tape demos with handwritten contact information on the back and T-shirts printed by hand in the guitar player's garage, as well as doing press. Great shows, great turnouts, great fans. But I was losing my inspiration both for my writing and for my performance on stage.

During club shows there was no security, and stage divers would continually try to grab a feel of my breasts. This was getting tired, and I had begun punching these guys before they could get back in the pit at the foot of the stage. I'd wrap my microphone cord around my knuckles and whap these assholes on the nose. I'd kick them in the balls like I used to kick the Kentucky bigots. These idiots were embarrassing me with their misogyny and the sheer stupidity of it all.

It was the height of shaming me for my gender and I resented it. I had always worked so hard at not being a girl on stage—I was such a deliberate tomboy. Their behaviour was draining and I was weary of it. The only fun for me was performing the Screeching Weasel covers we peppered the set with.

Although I had no intention of leaving Gorilla Gorilla, I was looking for something more that would stimulate me. Chrome Dog's advertisement was for a male vocalist. I was a female front man, and I was pretty sure I was setting myself up for something that would go nowhere, but I had nothing to lose so I called anyway. It was James who answered the phone.

After a brief conversation we agreed that I should go to a Chrome Dog rehearsal and jam with the band. The minute I got off the phone, I felt anxious and self-conscious about trying out for a new band—I so badly wanted to simply do a good job, to be approved of, to be validated. This was the start of my secret anxiety. For one thing, I am not a jam type of person, on any level. I can excel at improvisation on the stage, absolutely. But unstructured, undefined, in-the-moment jamming with a group of strangers who most likely had never jammed with a girl before was stressful for me. It still is. I'm much too neurotic and self-conscious.

The introductory Chrome Dog jam was my secret. I didn't tell anyone lest the Gorillas find out that I intended to cheat on them.

Chrome Dog had hung velvet paintings and posters of naked girls and porn stars all over the rehearsal room. At the back of the room, on stools, sat three menacing, growling alpha girlfriends, the loyal audience, and they gave me the evil eye the minute I walked in.

Any girl in her right mind should have taken it all as a big, fat red flag, but I simply overcompensated and complimented each girl on her shoes or dress or earrings. "I like your boots! Are they ever cool!" I squeaked at one of the simmering hiss-makers. I felt as insignificant as one could and knew I was talking too fast. I tried to cave in my shoulders and hunch, lest I be thought to be sticking out my chest. I rubbed my lipstick off in between sips from the water bottle, lest I be accused of wearing too much makeup.

I had been dealing with insecure chicks like this since ballet class in grade one. People never outgrow insecurity. Despite the girls' best death-stares and hexes, I got the gig. I became the new singer for Chrome Dog, replacing the male singer.

The next thing you know, Chrome Dog was opening for Bad Religion. I had been with Gorilla Gorilla when we opened for that band on its same tour some weeks before. Opening for them now with Chrome Dog, I believed, was fate.

That I was singing for both bands proved scandalous. The war was on between Gorilla Gorilla and Chrome Dog. I couldn't see how this delicate situation could not work out. It was poised to be a brilliant juxtaposition for me creatively and emotionally. Chrome Dog's successes were yet to unfold, but there was so much promise in every note, there was no need to hope: the writing was on the wall.

# TWENTY

**heroin, my heroine**

**PEOPLE GET CRUSHED IN LIFE. WE GET DEFEATED.**
I get defeated. It's a part of being human.

My mending from the breakup of my marriage to Brett was helped along considerably by my new consoling boyfriend, nicknamed Captain. We had been friends first. He was a gentle person, and made me laugh constantly. He wore his cowboy boots and a dirty Cap'n Crunch T-shirt to bed every night, and we would fall asleep twisted together like a pretzel. "Aw, Biffy," he would whisper, "I loves you so much, little lady," and he'd snort like a pig into my cheek. I'd squeal on cue. Captain was my favourite person. He was just so much fun, and we had a lovely relationship.

Captain and I never fought, except about the drugs, mostly heroin, and usually when he was drunk at parties. I never understood why we couldn't just all drink beer.

But Captain liked heroin, and some of his friends did too. I, on the other hand, did not want him to do heroin. It was as simple as that. I asked him again and again not to dabble in it with his friends. Eventually, Captain agreed to stop, but much to my disappointment, at a party a few weeks later, I caught him doing smack with his buddies. This was the last straw. I was furious. To my crazy way of thinking, there was only one thing to do: I demanded he include me if he

was going to do heroin. Of course, Captain quite happily said "Sure!"

We immediately left the party, going straight back to my apartment to do heroin together. This was extremely romantic, I felt.

Since I had never given myself an injection before, I asked Captain to shoot me up. I considered this to be the ultimate commitment between us, and after everything I had just gone through, I was desperately missing commitment. Trusting someone else with your life, trusting your high boyfriend with your life—genius.

He sterilized the needle in a pot of boiling water on the stove while we shared a beer and talked, sitting in our underwear. The little yellow bird belonging to my roommate was out of her cage, as usual, and flew around and around the kitchen, chirping and crapping all over the place. Really, the whole thing stunk: the idea, the intention, and the bird crap.

We only ever used the same one dull, jagged needle. I don't know why we bothered to boil it. Part of the thrill I got from sharing a needle and having my boyfriend shoot me full of drugs was the blind faith, the blind trust, I had in him. A commitment, as I said. I believe this was completely lost on Captain; he was just trying to be helpful. I don't think it occurred to him that I had placed this responsibility on his shoulders; if it was he who shot me up with drugs, I didn't have to take responsibility for the use or the outcome.

No one in the Gorilla Gorilla camp did smack, it just wasn't cool. I hated pot, hated drugs. I didn't get the rock 'n' roll smackheads and band junkies. It was a different scene, a different crowd from mine. A few of the punks in some of the older bands did heroin, but not those in my generation too much. We were skate punks and listened to lots of reggae, ska, and California bands, and the vibe was positive and natural. We knew lots of skinheads and hardcore kids, but even they didn't like junkies so much. That was until Mother Love Bone and the whole Seattle thing.

Suddenly the grunge people of the Pacific Northwest fell in love with smack, and in love with bands that did smack. It was glamourized. I loved holding my arm out and letting Captain, cross-eyed and drooling, inject me with our only needle, and then counting to twelve and feeling like I'm peeing and sleeping and batting my eyelashes all at the same time. That too was the romance of heroin for me.

I called my mother to announce what I had done. My poor mother. "Hello, Mom?"

"Hi, Beth! How are you?"

"Mom, I did heroin. Shot it into my arm." I had always told my mother every single detail of my life. She was my priest, and I confessed all.

I strained to hear her reaction, hear her horror. But there was only silence.

"Mom?"

She was calm and quiet, no longer surprised by my proclamations. She simply sighed. "Well," she said, "get it out of your system, Beth, so you can get on with your life."

I thought this was the most practical advice I had ever heard.

I knew a gifted photographer, a yogi, and the divinity in me saw the divinity in her, or maybe it was the other way around. She was magic. I first met her when Gorilla Gorilla was on tour with legendary punk band The Wongs and I was still married to Brett.

We had rolled into Toronto, booked to play a sold-out show at the Apocalypse Club. Mr. Chi Pig, the singer for The Wongs, was a star. Not only that, he was a hero of mine. It was a great shot for Gorilla Gorilla. We played a memorable show and gave everything to the moment and the performance. It was a triumph.

In the women's washroom after the set, I waited in line with all the

other punk chicks who had to use the stalls. This was common, since as an opening act we rarely got a dressing room, and if we did, there would most certainly be no toilet in it. You were lucky if you were able to use one of the toilet stalls, as they were usually plugged and icky, or occupied by people having sex or druggies shooting up. At the Apocalypse, I was waiting my turn along with everyone else.

That's when a woman said to me, "Didja come?" She sneered, hand on hip, then started smiling like the Cheshire Cat.

"What?" I was startled. "How rude," I thought. "What? Did I what?" I said.

"Did you come?" Her eyes went wide as she peered from behind the brim of a purple velvet hat. She demonstrably rubbed her nipple to make a point. "You looked like you came up there on stage, sweetheart! It was fabulous!" And then she cackled a laugh that sounded like my grandmother's.

"Um, well, I didn't." I just shrugged. Her words were completely lost on me. I was too distracted by her confidence, her boldness. I looked at the dirty floor, trying to avoid further conversation. She was mind-blowing and I loved her instantly.

"Name's Louisa," she said. "It's Spanish." She cackled some more. "And today's my birthday party."

Later that night, during The Wongs' set and the resulting pandemonium—the Toronto crowd eager to see Mr. Chi Pig as the front man in this new band instead of for their beloved SNFU—Louisa was front and centre, screaming obscenities and shouting gleefully at Chi. They exchanged some banter, and then he bent over to moon the audience. And she bit him, right on his ass. I was stunned, and now madly in love. Louisa was the most amazing woman I had ever met next to Lola. She was so bold, so brave, so cool, so sensual, and so very Spanish.

The next evening, my band was invited to Louisa's apartment for birthday cake—she was turning twenty-four, I think. I hung on to Louisa's every word the entire evening, and held my breath as she held court, sitting on the laps of men and women alike. She extended her celebratory birthday tongue-kissing with everyone. My mind was on fire; I felt as if my brain itself were the birthday cake, with all those burning candles. I had never met anyone who was like Lola doing dirty dances or "doubles" with the other strippers, or a threesome with another woman at a boyfriend's prompting, coming the closest. And my experience with lesbians was limited to a girl from my grade-ten class, and a grade-eleven girl with a blonde moustache who French kissed me and then got mad when I kissed back out of courtesy because she said I kissed like I had been kissing boys. Which, of course, I had been. Who else would I have been kissing? But suddenly, here was Louisa, older and wiser than me, beautiful and worldly, exotic, cultured, and openly bisexual.

The Gorilla Gorilla tour wound its way back west. Louisa's boyfriend, Rupert Dawg, rode with us, all the way back to Vancouver. Apparently, he was leaving Louisa. I wanted no part of it, but the rest of the band didn't mind Rupert tagging along with us. Louisa followed her lover back to the West Coast, reuniting with Rupert for a brief time and then staying in Vancouver long after Rupert had returned to Toronto. It was meant to be. Artistically, Louisa was thriving. We became great friends, and we began to explore life together as budding artists.

Louisa was a promising photographer and started to apprentice with Alex Waterhouse-Heyward. This was a huge opportunity for her. Alex was her mentor and teacher, and he said she was gifted. Having modelled for a few workshops in Winnipeg for a Hungarian painter who lived next door to the Gorilla Gorilla jam space, I considered

myself an experienced art model. Naturally, I volunteered often to be Louisa's subject. We did many long, erotic photo shoots, and Louisa and I became physically and mentally closer because of them. Things were magnificent. And Louisa's art was ravishing, like her personality, and her signature red lipstick. She was the epitome of timeless beauty.

For a time we were inseparable and could often be found drinking Iron Butterflies—we had heard it had been Marilyn Monroe's favourite drink—long into the night, seated at tall barstools in hotel lounges, in the company of an adoring audience of pretentious art-scene adults.

Louisa's apartment overlooked the North Shore mountains and on one occasion we had our boyfriends join us there quite late at night. For the second time that night, I fell out of my chair and hit the floor. The chair's steel legs and the kitchen floor felt so cold. With my cheek pressed into the floor, I watched the others finish my share of the drugs while talking among themselves. I couldn't believe they were doing my drugs, and I couldn't ask them to stop—I was paralyzed, overdosed. I couldn't speak or breathe or blink, or, eventually, care. I just got sleepier and sleepier, eventually falling asleep. Later, I realized I had been close to dying on that floor. They had all passed out that night, Louisa and her new boyfriend snuggled in the bed, Captain asleep on the kitchen chair beside me. I should have croaked, so I was greatly relieved that I hadn't. Afterward, I felt tired but utterly euphoric that I had defied death. I took it as a sign, and it motivated me to change the course my life was on. I simply knew that doing drugs was not my destiny.

I moved away from my beloved Captain, and Louisa moved in with her boyfriend, and we both stopped drugs. We laughed a lot about our tomfoolery, and if we ever considered flirting with the opiate again, well, we never spoke about it. As time went on, we lived our lives as if we had never done them at all.

# TWENTY-ONE

**BACK IN THE NINETIES, WE DIDN'T GET A PER DIEM** for daily expenses on tour like bands do nowadays. Instead, we withdrew cash out of the bank before leaving home. I had no credit or debit card to bring with me for added comfort, just the hundred bucks or so that I hid in my duffel bag and which usually would have to last me three weeks.

All the band members had day jobs. We were starving artists, after all. At one point, I was a dishwasher, choosing to apply for that position despite the restaurant manager asking me to apply as a server. "Honey, you'll make more money waiting on tables," he said. He didn't even look at my completed application.

"Beth. My name is Beth, and I want to apply for the position of dishwasher, it's listed here," I said, showing him the ad circled in my newspaper.

"Yes, I know, but we are hiring for all positions. Waitresses too."

I smiled. "Thank you, but I would like to apply for the dishwasher position."

He shrugged. "Suit yourself."

I started the next day, and I was ecstatic. I wore a hairnet and rolled my smokes up in my short-sleeved white T-shirt under my apron and used the big sprayer and was left alone. There was no pressure. I didn't

want to have to act particularly respectably or feel stressed; I just wanted to make some money. This was before Gorilla Gorilla was to go on its first tour, and we all had to make a bit of money to sustain us while on the road. I thought dishwashing was the ideal job because I could have my shaved head, my tattoos, and my lip rings, and be content just doing some honest work.

The waitresses there were nothing like me. They were all very pretty, and very blonde. They would each ask me about two or three times a week if I spoke English. "Yeah, do *you*?" I'd ask them wide-eyed, spraying the greasy plates amid spaghetti-smelling steam. They would nervously giggle and say, "Sorry, but, well, you know, like, why would you be in the kitchen if you spoke English?" and they'd snap their chewing gum. Obviously, I had to be an immigrant, a special-needs employee, or a parolee. I'd fight to keep a straight face. Generally, I didn't pay much attention to them. We were a different species. I couldn't relate to them, and that suited me fine. What did I care? I just needed the money.

Within a couple of months, me and the rest of the band would give our notice and then get ready for touring. We were always in pretty bad financial shape by the time we returned from tour and would have to look for work again.

Later, after Gorilla Gorilla returned to Vancouver from a national tour with The Wongs, I applied for a job at the print shop of the Real Estate Board of Greater Vancouver. It produced the multiple listing books that realtors used to find properties newly on the market. It was busy and loud in the shop as the pressmen printed and cut pages, and the girls working there assembled them, all day long.

The first day on the job as a collator, I had a ring in my septum and a shaved head, save for my bright pinky-red braids. The boss, Bob Kuznarik, had hired me on the spot. Brett's skater buddy Shakey Jake

had told me about the job and had put in a good word for me—he worked the night shift there. Three other women worked there, and about a dozen men, all working on the presses.

Donna, in her forties, was completely deaf. She was the first one to say hello to me that day, and showed me how to sign "hi." Emily was an older woman with dark hair and big eyes. The third was a beautiful young woman with long blonde hair, big blue eyes, and expensive jeans who refused to look at me. "You can't work here," she said as Mr. Kuznarik placed me at her worktable. I looked at her and she mumbled to the boss, "Dad, don't put that in front of me." She thought she was being quiet, but I heard her. She looked like a supermodel and had the whitest, most perfect smile I had ever seen.

I started assembling the pages together. Donna came over to help. She grabbed my hands and gently showed me a better way to do it. I thanked her, having learned the sign for "thank you" just moments before.

Donna and I often took the bus home together, as we were both headed down Broadway to East Van. I liked Donna a lot, and I really liked learning a new language. American Sign Language, or ASL for short, was a great way to communicate. It seemed easy enough, like anyone could learn it. Donna even taught ASL at a local community college one night a week, and brought me workbooks and flash cards.

Finally, after about two weeks, Kari, the boss's beautiful daughter, spoke to me, having overheard me say to someone that I had a husband.

"You're married? How old are you?" she asked, her blue eyes twinkling.

"Twenty, just turned," I almost shouted, so thrilled was I that she had asked me a question. I was very curious about her and stared at her constantly. I wished I was more like her.

She studied me for a moment, her eyes focused on the ring hanging between my nostrils. "I'm twenty-one. I'm Kari," she said. Then, pointing to the shop's office, added, "And that's my dad."

I already knew that, but I said, "Cool. My dad's a dentist." And from that moment, we practically never stopped talking with each other—every weekday for five years, we worked at that same table, like Laverne and Shirley at their bottle-capping station at the Schlitz factory. We became fast friends.

One summer night—I had been at the print shop for about three years by now—Donna was hit by a car and killed. I felt devastated. I loved Donna and learned a lot from her. She was good person, an affectionate friend, and I missed her a great deal. Kari began to give me a ride home from work—in her brand-new Cabriolet convertible—in the hope that I wouldn't feel sad about no longer taking the bus with Donna. She continued to give me a ride home after work for the duration of the time I worked there.

Her father was a wonderful person and showed it in many ways. He often secretly paid me for time I hadn't worked. When I returned from tour, he would quietly and nonchalantly say, "You forgot something when you left," gesturing toward an envelope on his desk. Inside, my full paycheque, as if I had been there the whole time.

When Bob Kuznarik died of a heart attack, the spirit and energy of the shop died also. I left shortly after. No boss was ever as kind to me as Bob had been, and I never took another day job after that. Nothing could ever be as good.

# TWENTY-TWO

**MY MANAGER, PETER KARROLL, CALLED IT BUS FEVER.** After approximately two to three weeks on a tour bus, a phenomenon previously nameless to musicians engulfs the band members. Their world turns completely upside down. The big picture becomes the little picture, and the little picture becomes—you guessed it—the big picture. What does that mean? A band goes on tour with the goal of making its mark, blowing away audiences, destroying headliner acts, and even becoming legends. When bus fever hits, this lofty goal becomes insignificant and things like a fellow musician drinking a beer that you stashed, or eating some of your cereal, or using more than their share of towels after a sweaty show, or playing their favourite obscure band on the bus's sound system, or—the worst offence of all—farting in an enclosed area, such as the dressing room or on the tour bus, take on huge proportions, with the potential of causing catastrophic damage to a previously tight group. Badmouthing, throwing clothes and personal effects onto the street, trying to jump off the bus while it's in motion, leaving the tour, quitting the band, or firing the offending musician—you name it, we've experienced it.

My goal in life was for no one to get mad. As long as the boys were happy, I was happy. I was a non-confrontationist or, as some see it, a doormat. I didn't care. Despite ongoing discussions with my managers

on how not to and when not to ass-kiss or overcompensate, the message never took hold with me. I never shook my complete and utter need to please; for me, self-sacrifice is easy. It isn't about disassociating; it's about keeping everyone happy.

Bus fever is deadly and could kill a man, a band, a driver, a crew. But it never affected me, and usually not other female band members either. With the bands with girls in them, either all-girl bands or bands with one or two females, one of two things generally happened: the girls got into fist fights with each other or the girls fucked their fellow band members. I frowned upon this former behaviour especially, deeming it the height of anti-feminism because the females were not being supportive of each other, but so was overcompensating. Of course, not all the females I met in bands back then behaved like this, but quite a few did. Maybe it was just the circles I ran in, as Gorilla Gorilla and later Chrome Dog often got thrown on the same bill as touring chick bands just because I'm female. I wasn't impressed by this common tactic of promoters; I thought it lazy. These girl bands were often very drunk at shows—free alcohol was frequently available in the dressing rooms. Combine this with the typical camaraderie between musicians and you have a backstage dating pool. I did my best not to be grouped in with these band chicks, so I usually ditched the backstage action as quickly as possible after the show was done, either heading to the hotel or straight onto the tour bus.

And, of course, my band wasn't immune to the dreaded bus fever once they were on a tour bus—or, in the case of Gorilla Gorilla, on a Ford Econoline with a blown engine. Brett later revealed that the blown engine was why he proposed to me in the first place. The tour offers were starting to come in, and we needed to replace the van's engine. In Manitoba, it is not uncommon for a wedding invitation to have the words "presentation only" printed at the bottom. This means

the couple prefers an envelope of cash to other gifts. At our wedding, with its punk rocker guests, the envelopes typically held only a ten- or twenty-dollar bill. But we did receive enough for Brett to not only contribute to the replacement van engine but also buy a new drum kit and a nice whale tattoo, which he had inked on his chest. This was apparently to commemorate the big day. I also got a wedding tattoo, on my right arm: the Chinese character for *Dao* or *Tao*, for "The Way" or "The Path." I thought this was quite spectacular, and read several books about Taoism at my new husband's suggestion. But no amount of Lao-tzu teachings or even the Hare Krishna mantras we were familiar with could help us when it came to touring.

Chrome Dog was enjoying a growing reputation up and down the west coast of both Canada and the United States. Many of our tours took us south, and we were gaining ground, opening for Bad Religion, Mudhoney, NoMeansNo, Screaming Trees, and even Sublime. We had a new drummer, Brian O'Brien. Like me, he was a pacifist. He was also an artist, painting whenever there was some downtime, just sitting in the van with his sketchbook and watercolours or coloured pencils. The poor guy, having to endure a van-full of guys acting like juveniles. But I loved the guys, and enjoyed playing in Chrome Dog immensely.

The Satyricon in Portland was a great joint, and all the bands wanted to play there. After a show in Vancouver, we'd leave on tour down the West Coast, playing the next night at the Showbox or the Crocodile in Seattle, then travel on to Portland. This three-day run rid us of our sea legs; we'd get our bearings and really start to jell together on stage.

James, the guitar player, and Rich, the bass player, were meticulous about arriving in the bigger markets well rehearsed and into our groove. We were trying our best to break into the next level, and for them, it was all about the riffs and the solos. I didn't care. Whatever

made them happy made me happy. It was not quite the same the other way around. I had been told to write lyrics that were "more represen- tative" of the band, not girl songs. This hurt my feelings, but I tried my best to be a team player and make them happy. I failed, of course; every song turned out to be about my personal sadness and heartbreak.

The Satyricon was in downtown Portland, in a bit of a rough neighbourhood. George the Greek was the infamous local promoter. The show on this particular night was not well promoted, but in fair- ness to George, we were not that well known. But great bands can play an intense and powerful show in front of ten people just as they can in front of a thousand people. So, determined to be discovered, the band played a great show for George and the nearly empty club.

Completely Grocery, a Portland band, was scheduled to come on after us. The guys in the band were good people, not like some of the cutthroat, over-competitive band members who would be looking to fight us; these guys were genuine and thoughtful. They felt so sorry for us after it became apparent that we were not getting paid anything beyond our hundred-dollar guarantee that they took up a collection at the end of the night, giving us an extra twenty-three dollars. We were thrilled. Much celebration ensued, and we were feeling pretty good when we left.

The entire bunch stood at the club door to give us a soldiers' send- off, complete with clapping and waving of handkerchiefs. James was driving that night. He rammed the gear into reverse and drove the van backwards for a few feet, then rammed the gear back into drive and drove forward for a few feet. Then he did this again, back and forth and back and forth. The van filled with cackles, and the Completely Grocery guys were doubled over laughing and slapping their knees. Through the dirty van window I smiled at them, at James's tomfoolery. Only, as it turned out, I wasn't in on the joke. In fact, I was the butt of

the joke, or more specifically, my Mario Lemieux doll was. I brought my Mario Lemieux doll on every tour, and it was my pillow. Lemieux had led the Penguins to not one but two Stanley Cups, and I was winning the hockey pool with him, much to the rest of the band's dismay. I was a Mario fan, and we all called the doll my "boyfriend." The guys, even Brian, trying to fit in, would grab him and pretend to hump him while I tried desperately to grab him back, squealing, "Don't!"

That night, James and Rich had thrown the doll under the wheels of the van during load-out when I wasn't looking. From the guys' banter, I figured out why James was driving back and forth, and I started whining and trying to get out of the moving van, which only made the cackling worse. James continued his onslaught of terror on my prize doll, my Mario. Nearly in tears, I eventually was able to get out of the van and collect it, covered in dusty gravel, soot, dirt, and tread marks.

I was crushed about the state of my doll but relieved that the guys were having such a good time despite our slim earnings that night. The Satyricon was a legendary music room and it was somewhat of an honour to play there. We would actually go back again, and again and again.

We made the drive to San Francisco in record time. We had never been to California before, and now here we were in wonderful San Francisco. The sun was shining bright, the air was warm, and Anthrax was playing there—at a venue called Bottom of the Hill—the same week.

Gorilla Gorilla had never made it that far south—not as a band, anyway—though by this time, Randy, the Gorilla Gorilla guitar player, was managing Green Day; Kent, the bass player, had started working with NOFX; and Brett, my ex-husband, worked on the crews of both and also with the American band Pennywise. I was entering their turf, though I hadn't kept in contact with them during those first tours with

Chrome Dog. San Francisco was where Danielle Steel lived, that's what I knew. Danielle Steel, Ansel Adams, Jerry Garcia, Metallica, the Dead Kennedys, Jello Biafra.

Out of necessity, we slept in the van, parked on a side street, many times during that trip. San Fran's weather can change drastically from one day to the next, and we sometimes slept with the engine running if it was cold outside, or with all the windows down if it was really hot, the sun heating up the inside of the van and baking us awake before we died like dogs left in a hot vehicle. We could sleep four in the van: Brian, then James, then Rich (all six feet five inches of him), and me, the smallest. I slept with my head nestled in Rich's armpit. We were like best friends. Nothing sexual ever happened between us, and I was grateful for that. I loved him very much, and he was my advocate in the band most of the time. We were like George and Lennie from Steinbeck's *Of Mice and Men*—an unlikely pair.

On one of our nights in San Francisco, we were in the van sleeping when a junkie broke in through one of the open front windows. He was halfway through, clutching our removable stereo, when Rich woke up. "Hey!" he yelled, sitting up. "What are you doing?" He grabbed the guy's arm and punched him. The junkie wouldn't let go of the stereo. Eventually, Rich broke his grip. The junkie dropped the stereo and took off.

By this time, we were all wide awake. The sun was just coming up. I think we had gone to sleep only a half an hour before. We laughed at the hockey-fight-worthy hammering Rich had given the dude. But really, I think we were just relieved the junkie didn't pull a gun or knife on us. This was the real America, and we were going to take it all in stride, even if it killed us.

But that episode wasn't nearly as traumatic as what happened when we arrived in the neighbourhood where the club was located and

discovered that the promoter had made his own posters for the show, with only my picture on them. The rest of the band freaked out. They were furious with me. They ran up and down the sidewalk, ripping the posters off the telephone poles. I was embarrassed about being singled out on the posters, and about being blamed for the promoter's actions.

The band was so pissed off, blaming me for the fact that the promoter we had yet to meet had made his own posters and really done up Ashbury Street with hundreds of them, they could have murdered the dude—and me. In truth, what the promoter had done was actually an incredible and rare thing: he had done his job and promoted the show. I'm guessing he chose the photo of me instead of the band photo in the hope that it would spark more curiosity than would a photo of just some Canadian band with a chick. Fair enough, but unfortunately, the guys did not see it this way. As the tour went on, it happened more and more, and it was embarrassing for them and for me. But not for our new manager, Peter. He had sent the promoters the two photos, one with the entire band and one with just me, knowing full well that the single shot would stand out and get used. Although Peter must have known that this was upsetting the guys, he continued to do it anyway.

On that tour, Chrome Dog played up and down the California coast, showcasing for A&R—artist and repertoire scouts from the record companies—including at Los Angeles venues. We played all the way down to the famous Casbah in San Diego. We never turned down a show, and even drove all night once to play a venue in Riverside, California, only to arrive and find that the club had burned down the night before. This was tragic for us, as no gig meant no gas money. Often we'd split a couple of burritos for our only meal of the day, paid for with the leftover cash from a show after the van's gas tank was filled. That night we went hungry.

Somehow, the guys managed to meet girls in almost every town we went. We always hoped that Rich, single, gregarious, and charming, would hook up with a girl and that she'd let the entire band stay at her apartment. On one particular tour, we found ourselves in Hollywood, and in the unfortunate situation of having a few nights off between gigs—unfortunate since we had no place to stay and couldn't afford a hotel room, and sleeping in the van had quickly become tedious. The upside was that Mudhoney and Poison Idea were playing at the Hollywood Bowl as part of a bigger show, and because James knew just every band on the scene, having toured with Beyond Possession, we managed to get ourselves backstage. Everyone who was anyone was there, including Kurt Cobain and Courtney Love.

Rich met a couple of young women there who worked for a publicity company, and we ended up staying with them in their West Hollywood apartment. They fed us and showed us around. Luckily, they had rich parents. These women were like princesses—they had cars, apartments, food, beer, and looks. The guys were falling all over themselves trying to impress them. All in all, it was a good situation for a touring band stuck in a big city with days off. We attended a benefit concert for a Save the Whales charity with them at the Key Club on Sunset Boulevard. A young woman named Beth Hart was performing, and Richard Moll, who played Bull in *Night Court*, was handshaking. We were terribly excited to be there.

The guys were, as usual, trying to meet girls. Typically, I'd follow them around until they told me to get lost. But not this time. No, this time they simply took off, leaving me there. I was in an unknown city, in an unknown part of town, and the trouble was, I had arrived by car with one of the girls we were staying with, the same girl who was now, I presumed, driving my band somewhere, maybe to hook them up with friends of hers. My band had ditched me—something that became a

recurring practice as payback for the Bif posters in San Francisco and elsewhere—and I was in a bad situation.

We didn't have cell phones back then in the early nineties, and I didn't know the address of where we were staying, or even in which part of West Hollywood. I didn't even know the girls' last names. Trying not to panic, I went to stand at the bar, keeping an eye on the door in case they returned.

"What are you drinking?"

I turned around to see a smiling face. A man with brown eyes and a soft tan was leaning in to me.

"Beer," I said, too stressed to return the smile. He introduced himself, and I recognized his name. I had seen many of the Hollywood movies he'd directed.

"What happened to your friends?" he asked, handing me a Corona with a lime wedge.

I explained that they had ditched me the way brothers ditch little sisters—and that I knew I would recognize the street we were staying on if I saw it. He was amused by my tale, and bought me another beer, which I happily drank.

"Want to get out of here? I can give you a lift," he offered.

Since I had given up on the guys coming back to get me, it seemed like the only option, so I agreed and split with him, climbing into his shiny white Jeep parked out front. I didn't know where we were headed, but I had nowhere to go anyway. I would show the guys that I could take care of myself.

We drove through the winding Hollywood streets until we came to an apartment building near the Beverly Hills police station. "I have an apartment here for when I don't feel like driving all the way home," he announced as we pulled into the parking garage. "Great," I thought, "he's married and here I am again making another genius decision."

I followed him into the elevator and then into his apartment, which was plastered with posters of movies he had directed. I wasn't familiar with too many of the movies but knew the actors featured on the posters, who were quite famous.

He was looking through a pile of mail on the coffee table. "I'm going to take a shower," he said.

"A shower? You're taking a shower?" I squeaked. I really thought this was just a short stop and that he was going to, miraculously, drive me to that Naomi girl's place.

"Yes," he said, walking toward the bathroom. "Make yourself at home. Want a drink or something to eat?"

I heard the water turn on. This was surreal. A shower?

"Do you want a sandwich or a beer or anything?" he shouted from the bathroom. He sounded naked to me.

"No. I'm okay."

"What? Did you answer me?"

I walked over to the door and spoke through it. "I'm okay."

The door opened, causing me to nearly fall forward. He was naked.

"I couldn't hear you," he said, smiling from ear to ear. He grabbed my face and kissed my mouth and chin with his open mouth. Instinctively, I kissed him back, wondering if I could eventually ask him about getting a ride to West Hollywood. Before I knew it, I was being undressed and we were enveloped in each other, leaning against the bathroom door. I completely forgot all about my band.

Although I was courteous enough to be prepared to go all the way, he simply wanted to give me a bath. "Sit in the tub," he said and, without saying another word, just washed me. And washed me. I said nothing, hoping he wouldn't drown me. I was often astounded by men's behaviour. I didn't know if I should be getting paid for this or if I should be paying him. After my silent bath, he towel-dried me and

kissed me on the forehead before leading me to his bedroom with white walls and white sheets, like a hotel. He slipped into the middle of the bed, still naked.

"I am happy to sleep out there." I pointed to the door to the living room. I was just trying to give him space, as the evening's events had taken a bit of a strange twist. I didn't know how to act. I was trying to respect whatever it was he was into. Or not into. Basically, the sun was coming up, and I figured I'd made it this far, I might as well try to keep the peace.

"Sleep here with me. Come lie down," he said, patting the bed. I did exactly that, shinnying up next to him, still in a fluffy white bathrobe. He pulled the blankets over us and hugged me, nuzzling my wet hair. I was just bracing myself, scarcely breathing, waiting for what would happen next. But the only thing happening was sleep. He was snoring within minutes. I too was soon asleep, relieved and grateful. I was so squeaky clean, after all.

# TWENTY-THREE

**LOLA SHOWED ME MY FIRST COCKROACH IN VANCOUVER** in 1989, and was she ever proud. "That's a cockroach, Bif!" she announced, pointing to the creepy bug. I squinted at it.

"Looks like a brown grasshopper to me, or a cricket." We were in a hotel in some stripper's dressing room, smoking cigarettes and drinking beer from stubbies. I inhaled deeply on my cigarette and mumbled, "I don't think it is."

Lola laughed. "It's a real cockroach, Bif! A real one. Your first cockroach!" And she laughed and shook her hips, doing that Spanish *rrrrr* trill that she did, and I laughed back. She was right, it *was* my first. I felt pretty good about it too. Lola had a way of making me feel good about everything.

But once I was faced with cockroaches in my own apartment, the apartment for which I worked hard at my day job in order to pay rent in, the humour was lost on me. I did not like those fucking cockroaches, not one bit. Every time I turned the light on in the kitchen, the chipped, yellow-stained, hash-knife-burned white stovetop moved like a wave. People say cockroaches are smart, but honestly, how could they be that smart if they don't notice you coming down the hall? You flip on the light and bam! They freak and scatter. It's like they all drop their miniature sandwiches and run back into the cracks and crevices

they crawled out of, or back behind the stove. Eventually, you begin to understand their deal, and you just co-exist. If you have roaches in your apartment, everybody on your floor or your side of the building has them too; it's simply a law of the universe.

My apartment on Harwood Street, in Vancouver's West End, was sweet. I walked to Granville Street and took the bus to the print shop, over on Broadway, every workday morning without fail. On a clear day I could look up to see the majestic Mount Baker, many miles away in Washington State. Seeing it made me feel good; it made me smile. It was like a secret ritual.

I had moved out from the place I had been living with two friends, and had left the heroin flirtation behind. I was in rehearsals every night, even after working my day job. I liked being busy, I liked playing in both of my bands, and I liked my life; it was uncomplicated.

One day, Lola returned from her trip on the Hells Angels' world run, in Europe. She called me from Spain crying and wanting to ditch the guy she was on the ride with. I told her to come to Vancouver to live with me. She did, and I was so happy that she was back and safe with me. I loved to lie around with her, smoking cigarettes and hearing all her stories about the European ride, about the Reeperbahn in Hamburg, and about Amsterdam and Barcelona and Madrid. I used to hang on every word of her stories, and I wished that someday I would go to these places too, but in a different way. My dream was to tour with my band in Europe, like SNFU and DOA did. I daydreamed about it the way Neneh Cherry sang about dreams, like it was impossible.

I loved to hear about Europe, about Paris and Berlin. I romanticized about being a painter, or a writer like my beloved Irving Layton, or in a band, living and playing over there. Lola was such a good storyteller, every night she kept me laughing until I cried. We lived together

for a few months in my one-bedroom apartment—she slept on the foldout couch in the living room, and I slept in the bed. And she didn't seem to mind the bathroom being filled with my Little Mermaid bath accessories.

Lola was also obsessed, not with touring in a band in Europe, but with a couple of boys she was sweet on—I think they were twins—even though she had several boyfriends already. She landed a job waitressing at the famous Vancouver strip bar, No. 5 Orange. Lola was the most articulate person I knew. She came off like a genius, a genius who was also a great exotic dancer. What a combination. To me, it seemed that she knew everything about anything, including a lot about human rights issues. And she taught me Spanish. Her mom had lived in Colombia for several years, and Lola had gone down to see her a couple times, enjoying Cartagena a great deal. She had stories about bad men there. I loved to listen to those too, asking to hear the same stories over and over again. Lola was a beautiful girl, built for swiftness, for sex, and for master's degrees. But we were young and all the fun got in the way of her reaching her educational potential. But it was her fun as well as mine.

I didn't generally go out to clubs, partly because of my day job but also out of fear of the disapproval of my manager, Peter. He was protective and wanted artistic success for me, so he was not about to approve of some of my and Lola's behaviour, like our public drunkenness and various shenanigans. As well, I was starting to consider other ways of living, starting to dislike the scene and the drinking and the partying. My manager took me seriously, so I thought I should take myself seriously as well.

Peter had advised me against attending any of the underground Bhangra parties frequently held in the suburbs, lest I fall in with gangsters or some bad boy of my dreams—he knew I had a thing for bad

boys. I heeded that advice but did, however, accompany Lola for drinks on one of her nights off. Since this was not an everyday occurrence, I went along enthusiastically. She wanted to go to the Drake Hotel, another local peeler bar: a guy she was hot for—one of the twins—was rumoured to be going there that night. So we went—how naughty can one Corona with lime be? We stayed there for a while drinking with a co-worker friend of hers and with a small collection of young and boisterous men they knew and apparently liked. I got the impression that these men might be on the wrong side of the law. Maybe it had something to do with the full-on Hells Angels accessories they were wearing?

Now, I always put on my best tomboy when in the company of possible criminals. I learned enough as a kid to know not to draw any sexual attention to myself in these situations. Instead, I would play the goofy sidekick. This was likely taking things to an extreme, but nevertheless it was a well-honed self-protection technique. I pulled out the tomboy card whenever I needed to avoid any misinterpretation (like at rock festivals when I was the only chick backstage and wanted to make sure the other bands knew that I was actually not there to have sex with them). So, given my impression of the men we were chumming around with at the Drake, I decided to play that card.

For some reason, I was not at all alarmed when we all jumped into the men's Suburbans and Yukon trucks and headed for their favourite hangout: the Hells Angels clubhouse. This was at the suggestion of Lola: "Bif, we are just gonna go for one drink, okay, honey?" She knew it was a work night for me and that I had to be at the print shop by seven or eight the next morning.

As we walked up to the clubhouse's gate after the short drive, I noticed that the street consisted of twenty or so houses in a row, each looking like the house we were about to enter. A cookie-cutter neighbourhood. Very normal, very modest. But with cameras on every street

corner. I still had no feelings of trepidation, though I began check-ing my watch, knowing that I had to get up early. But I felt too self-conscious to ask if we could go home, and besides, I didn't want to spoil Lola's fun. It was her night off and I didn't want to be the bum-mer friend.

I didn't like any of these (by now very drunk) men. They were more like grown-ups than the guys I knew, the band guys and the skaters at the China Creek skate park. They had probably never even heard of GWAR, never rode a skateboard or snowboard. What did I want with these men? Besides, I had a crush on the drummer of the band that jammed across the hall from Chrome Dog. I resigned myself to just having to hang out, waiting until Lola was ready to go home. Only one problem: I never saw her again that night.

Like a good sport, I played pool in the clubhouse basement, me and two of the men. (Where Lola's co-worker had got to, I don't know.) The walls of the basement room were a dark wood, and the light above the pool table had a ceiling fan, the kind in *Gone with the Wind* and the other movies my mother watched. There was also a bar with bar stools, and a man behind it serving drinks to the other men and women in the room.

The two men were very good at pool and I was completely inex-perienced, so I just goofed around and told jokes. They were pretty competitive with each other, and I made extra sure not to put out any flirty or girly energy.

After the game finished, we bellied up to the bar. By now it was just me and these two men in the basement room, plus the bartender. I was pretty tired and more than ready to go home.

"Another beer," one of the men said to the bartender, who looked remarkably like Steve Perry from the band Journey, only more Italian than Portuguese.

"What'll you have?" the bartender asked me, wiping down the bar and placing a glass mug in front of me. At least he was friendly; in fact, they all were.

"Aw, fellas, that's okay," I said and smiled, trying to bow. "I'm just waiting for Lola."

"Who's Lola?"

I was startled, and tried not to panic. "The girl I came here with—Lola, my friend."

"Oh, she left," one of the pool players said.

My eyeballs nearly popped out of my face. What the fuck did he mean?

"Yeah, she left to go meet some guy," his friend piped in. I wasn't sure how they knew this—I guess word must have got around.

Suddenly, I was no longer tired. "Well, I've got to call a cab then," I announced, standing up. I had no money, but I wasn't about to tell these guys that. I figured I could grab the ten bucks I had stashed at home once the cab got me there.

The man closest to me put his big arm around my shoulders. "No, you don't," he said jovially. "You want another beer, don't you?" And they all chuckled.

I chuckled too, fully aware that I was the only woman in the room. I steadied my breath. "No, I'm cool, I really need a cab." I leaned over the bar, looking for a telephone. "Can you call me a cab?"

"You're a 'cab'!" the biggest one snorted, and they fell on each other laughing.

I chuckled. "Well, that's very funny. But I just need a cab. Can you call me one?" I asked the bartender again.

My two buddies were extremely drunk and the bartender was of no help. He just shrugged. "I work for them," he said.

"I'll give you a ride home. Get your coat," said a voice from behind me. I turned around to see the biggest, tallest man I had ever seen.

"I live downtown," I said in a voice so small it was almost a whisper.

"Get your coat. Let's go," he said. I hurriedly put my coat on and followed behind him. The two pool players said nothing—not to him, not to each other, and not to me. They just looked straight ahead, sipping their beer. It didn't matter if I or anyone else was afraid of him. I just wanted a ride home.

I got into his brand-new Suburban, and he started driving toward downtown. My mind was racing, wondering if I had done the right thing accepting a ride from him. He started to make small talk, asking me about the band, which he knew about, and when and where we played, and about Lola and whether my friends always ditched me, and if I had a boyfriend and then, when I said no, why not, and all the other usual stuff guys ask. He seemed so normal and very courteous.

We pulled up to my apartment building and I was thinking that if I stayed chatting with him, he would expect me to blow him in about five minutes. But that five minutes came and went, then ten. He was still talking, asking me if he could call me sometime. I decided I'd best be polite: he was a big man, I wasn't taking any chances. I gave him my telephone number—I was too nervous to make one up—and he told me he was going skiing for two weeks and would call me when he got back.

I thanked him for the ride.

"Anytime," he said and stuck out his hand. I was so relieved I spontaneously leaned over and gave him a huge hug. He was so astounded he didn't even have a chance to hug me back or press in or anything like that. I was beaming with relief that I had been treated so politely. The fucking skate-park guys, even my own band members, did not treat me with such respect. He was the politest guy I had ever met, and certainly not what I thought a Hells Angel would be like. Still, I had no intention of ever seeing him again, that was for sure.

Lola eventually turned up at the apartment, having left the club-house for another bar after being told that I had already left. She assumed I had gone home. It never occurred to her that I could be in a potentially bad situation. When I told her about my evening, she was horrified but impressed that I had caught the eye of a top-dog Hells Angel. I was indifferent about it; my focus was that drummer I liked. He had a skateboard—what did I want with a motorcycle dude? I mean, Harleys were choppers, and I was into Italian crotch rockets and vintage street bikes.

But then, two weeks later, he called me, just like he said he would. He asked if I would go for Italian food with him. "Of course," I said. It was the least I could do, I thought. He did spare me from harm, after all. I felt like I should go; it was the right thing to do. I was still grateful that his intervention prevented what might have ended up being a very bad time for me.

I went for the Italian food, ate the meatballs, and thanked him profusely for the dinner. Later, when he dropped me off at my apartment, I explained that because I was a skater chick and he was a motorcycle dude with a "motorcycle job," it just really was not possible to date each other. I was somewhat nervous about saying this, but it really had to be said. He was sweet, thoughtfully and quietly listening to me talk. He nodded in agreement. "I know that," he said, "I know."

I hugged him goodbye. "Thank you," I whispered in his ear, squeezing him tight. I hopped out of the truck and walked into my building, feeling his eyes trained on my back, but also feeling good about our conversation. He respected the conversation and he respected me, and that was more than most guys did, and I would never forget that. I walked into my dark apartment and flicked on the light. The shiny brown cockroaches scattered, as always. I smiled, feeling like everything was right in my world. And it was.

# TWENTY-FOUR

**managers**

I HAVE HAD THE SAME MANAGER FOR MORE THAN twenty years.

Peter Karroll toured Canada for many years with his brothers in what he called the country's first indie band. After the band split up, Peter managed Roadrunner Records artists, like metal icons Annihilator, which in the early days was Roadrunner's top-selling band.

When I met Peter, Annihilator had been touring, headlining large shows and festivals in Japan, Europe, and the United States. Peter came to see Chrome Dog perform, befriending us after the show and telling us stories about life in the music business. He kept us mesmerized with funny stories about his touring years before—stories about crazy shows and bar fights—and about a childhood filled with adventure, including burning down or blowing up more than a few barns after playing with matches or lighting stolen cigarettes. And life had been like that for him ever since, a big bonfire. I already knew the stories about him and his bandmates jumping off the stage to fight, basically being the bouncers at their own shows, in some of the roughest bars in Canada.

Peter had been in show business for twenty years by the time my band met him, and we had all heard of him: he had a notorious reputation as a manager. He was fierce with promoters who tried to screw his

bands for money, and on one occasion collected for an entire German tour, including for bands not managed by him, when the promoter tried to leave the last show of the tour without paying. Peter stepped inside the promoter's office, locked the door behind him, and collected the money. All of the bands were paid, and were thankful that Peter was the type of manager who never lets his bands down. Notoriety and a reputation as being someone who gets things done go a long way in the music business. It's kind of like being in the mafia or a crime family; some managers are like consiglieres, others, like hit men. I've met both types over the years, and Peter is definitely in the second category. He fights for his bands and never gives up until they get every opportunity they deserve.

Even Jonny and Marsha Zazula, who later became Peter's co-managers, and who co-managed me for many years with Peter, had reputations. I mean, everyone knew them; they were in the heavy metal history book. The Zazulas were managers of Metallica and Anthrax, among other famous bands, at the start of the thrash metal movement. They owned the legendary Megaforce Records and released a lot of great metal albums. Peter and Jonny and Marsha believed in me. They were kind, and I was honoured that they wanted to work with me. I always felt so lucky being with them, and felt protected by them.

Good managers are like commanding generals who know how to take control. I have no basis of comparison and know little about managing other than what I know of Peter's style of complete everythingness, which, over the years, moved beyond just our artist-manager relationship.

Peter has often told the story of how he came to the decision that he wanted to manage me. "I was at a local recording studio and spotted her photo on the front cover of an alternative-music rag. It was the full cover, with the words 'Bif Naked' in huge type and, in smaller type,

'Chrome Dog' under a striking photo. I stared at the photo for a long time, at this image of a young woman covered in tattoos. I opened the paper up to the article and saw the inside shot, of a dirty, dingy graffitied washroom cubical, and there she was, sitting on the toilet. I read the article, walked into the studio, picked up the phone, called Mike Price, a well-known soundman in the Vancouver scene, and said, 'Bif Naked.' Mike said, 'What about her?' and I said, 'Who manages her?' He said that no one did, and I said, 'Great, I am. Set up a meeting.' And that was that. I knew it was going to be a great adventure, and I have not been disappointed."

Peter later bought the image from the photographer who shot the magazine cover. It was used on the cover of my debut *Bif Naked* album.

Peter has been my manager ever since. I trust him completely. And everyone knows it. I wouldn't change the relationship if I could. I had blind faith in him from the beginning. Why wouldn't I? I knew I had to have complete faith in my manager, otherwise it would be silly to even have a manager. So I simply told him the first time we had a chance to speak one on one, without the Chrome Dog guys hovering around, "I want you to know, Mr. Karroll, that I have 100 percent faith in you."

His laugh was genuine and warm. "Well, that's very good."

I laughed with him. "It's true."

I had no experience with managers, no frame of reference. He believed in me. That's all I needed to know. Jonny and Marsha Zazula also believed in me, and again that was all I needed to know. It was more than I believed in myself, and I had nothing to lose.

# TWENTY-FIVE

cruel elephant

A LOT CAN BE LEARNED ABOUT A CITY BY GOING to its core, where social problems tend to manifest and the "invisible" people live. A separate community, with its own rules and ways, its own value system, Vancouver's Downtown Eastside is a downtrodden place. It is like a city within a city, or even perhaps like a separate country, and we liked it that way.

The smell of hot urine was in the air every night at the Cruel Elephant, along with that faint West Coast pot smell. Nothing I had seen previously compared with this mecca. It wasn't a mecca for me, of course, the defiant, lone non-pot-smoker, but a mecca for many. And, especially at this "it" place.

The Cruel Elephant was the local venue bands wanted to play at when they went through Vancouver on tour. It had relocated from Granville Street to Cordova, in Gastown, but it made little difference, really. Wherever it was, the shows were still put on, the people still came, and the bands were still loud. This was before bands like mine were viable enough to play the bigger venues such as the Town Pump or the Commodore Ballroom. Every city in the world has its local "it" place. And, I'm proud to say, I played at many of them over the years.

At the Cruel Elephant, I was really coming of age, and the other bands that played there were a big part of why I wound up on tour. We

were like family, and they were my brothers. And with them I shared sibling-esque camaraderie and fist fighting. I had to learn how to throw knuckle sandwiches from the stage like the best of them, and learn I did. Many of the greatest times of my young band days were spent at the Cruel Elephant: headlining for Gorilla Gorilla and Chrome Dog; on Mr. Chi Pig's shoulders for the entire duet we performed of "Paradise by the Dashboard Lights" by Meatloaf and Kiki Dee; and during the early days of the Westex music expo. I cut my teeth at this local treasure and learned a lot there as a performer and as a female.

I was a chick singer in the unique situation of singing with two up-and-coming bands. One was made up of skate punks, the other made up of thrashers. It was like having two boyfriends. Luckily for me, the scene at that time was really starting to evolve, and bands like Jane's Addiction and Soundgarden were opening the ears of audiences to a bigger variety of music. People's tastes were evolving, as was I, then barely twenty-one. The alternative-music waves were upon us, and I was a beneficiary of that eclectic evolution. It helped me find acceptance with the audience, and I am grateful to this day for my musical roots.

Getting on a music festival gig was like winning on *Wheel of Fortune*. But once we were added to the lineup of Westex or, later, Music West, the other bands at the rehearsal space ostracized us because *they* hadn't been accepted to play. We accepted the guilt because we felt, deep down, that they were right; we felt like we had sold out. Sure, the local punks accused us all the time of selling out, but they still came to the shows because they liked experiencing a packed club and a great performance. All the successful bands were accused of selling out, and it was how we knew we had made it one step up the ladder of success as a band.

Playing the festival gigs allowed us to play a bigger show than the local all-agers at the skate park, and it gave the visiting record

A&R reps the opportunity to see our band. The big-name A&R guys would want their names on the guest list, so they'd call the club and we would know about it and freak out. Even Flea from the Red Hot Chili Peppers put his name on the list to come see Gorilla Gorilla, in 1991, at the Cruel Elephant. Judging from the word on the street about Flea coming to the show, it was as if Jesus were coming, only for us even better.

Knowing that Flea as well as record-industry people were going to be at the gig, I felt my crippling self-consciousness kick in. I was so nervous in anticipation. The afternoon leading up to it, my Lola took me to the Cecil Hotel's strip bar for a drink. Not yet a straight edge, I happily accompanied her. Predictably, she and I sat there all afternoon, drinking and spinning yarns about touring for all the dancers in the dressing room, pontificating and making asses of ourselves. I was again not able to handle the alcohol and got flat-out drunk and completely lost track of time—I arrived at the venue just minutes away from show time. Worse, I lost my voice—and my lunch on stage that night. Like a complete loser all around. Right in front of the audience, including Flea and the record-company scouts, I failed.

This was the impetus for my years of sobriety. I quickly learned that nothing good ever comes from drinking. I learned a lot about myself and my capability as a performer and was grateful for my mistakes. I began to gravitate toward the straight-edge way of thinking and started to want to excel and improve myself, almost desperately. I never wanted to embarrass myself again (at least not on stage), and embracing the strictness and intensity of the straight-edge mindset was empowering and motivating for me. I was trying to reverse a lifetime of mistakes and shame.

The start of the chain of events that led to my solo career was emotional, uncomfortable, and unstoppable. Chrome Dog was leaning

toward self-destruction—or I should say, I felt like I was about to explode. Writing songs together was becoming daunting, as the guys were continually unhappy with my "girly" lyrics and insisted they had to be more universal if they were to represent the band. This caused me irreparable heartache.

I felt extremely embarrassed and self-conscious a lot of the time, and the dynamic in the band was starting to change. Other band members were not so interested in practising anymore, and when we did, I found it uncomfortable, primarily because of some of the band members not seeing eye to eye, the bass player actively playing in five other bands (which, frankly, I thought was wonderful), and my having much more to say creatively than I could through the "universal" lyrics style being imposed upon me.

Peter was generously adding us to a national tour in which we would be supporting Annihilator, and the dates were being booked. It was a rare and good opportunity.

But we choked. I choked. I knew that there was no way I would survive being isolated in a van with such a negative, falling-apart group, and I became more and more anxious as our departure date approached. I dreaded making the call but knew I had to do the right thing and relieve the band from "the girl" they were so annoyed with.

I wanted out but was sad about disappointing our new manager. Finally, after wringing my hands raw, I blew my nose, wiped my face of tears, and called Peter.

"I thought you'd never say that," he said when I told him I was quitting the band.

I was dumbfounded. "I don't understand. You're not *mad*?" I was basically telling him we would be unable to go on the Annihilator tour.

"I had to let you come to the conclusion on your own. It was only a matter of time."

I was so relieved, I cried. He wasn't angry at all. In fact, he was happy.

"Don't worry about the band. I'll phone them. Just take a couple of weeks off to catch your breath, and we'll touch base then and have a meeting. Okay?"

"Okay."

But in less than two weeks, and before Annihilator even left on tour, Peter called. "There's a band I want to introduce you to that is rehearsing in the same space as Annihilator. They need a singer. I think you should try out."

I was ecstatic. This was great!

I went down to the rehearsal facility on Terminal Avenue the next night and met Peter out front. He took me through the place and introduced me to many of the bands. I met Annihilator's guitarist, Jeff Waters, of whom I was a big fan. Then we went to meet a group called DTBV or Dying to Be Violent. I clicked with them right away. Dale Pleven was the bass guitar player and he had ties to Skinny Puppy. Harry Degan was the guitarist, and Chiko Misomali was on drums.

I joined the band and we started to write songs. Their music was rather complex compared with that of Chrome Dog and Gorilla Gorilla. They weren't quite a prog band, but the music was much more intricate than anything I had ever written to. I loved the challenge and started, once again, to enter a growth spurt. I was thriving creatively and blossoming musically. I felt like I had found my niche. Little did I know, my niche was actually looking for me.

Peter had been corresponding with a producer and songwriter named John Dexter, who had an indie label in Canada (distributed by A&M Records), and John was a fan of mine. He had seen Chrome Dog perform at Vancouver's Town Pump and had been following the band. But John wasn't interested in Chrome Dog. "We would like to

offer you a record deal for Bif Naked," John told Peter. Peter let him know that I was rehearsing with a new lineup of musicians going by the name Dying to Be Violent.

John was not concerned about which musicians I was with on stage; he was interested only in offering a recording deal to Bif Naked.

Peter called me and said, "Plum Records wants to sign you to a solo recording contract."

I asked him what he thought I should do.

"I think you should face the facts. Bif Naked is bigger than any band you have ever been a part of, so you can either be a solo artist with a record deal or you can be in a band with no record deal. It's your choice."

The next words out of my mouth set me on a path that changed the course of my life. "I don't care what I have to do; I want a record deal."

Peter called a meeting with DTBV and explained the situation: they could be a part of the next phase, which included recording and touring, but it was going to be a solo album and the artist's name was Bif Naked.

The guys were all supportive and considered the offer, then came back to Peter saying that it wasn't how they saw the future for the band they started. They had a vision of how DTBV would progress and wanted to see it through to the end. I was worried that I wouldn't be able to find anyone who would play with me on tour or record with me as a solo artist, but Peter told me not to worry. "There will be lots of people lining up to tour with you, Bif," he said, "and I've never seen a musician turn down a paycheque for recording in the studio." Peter was absolutely right.

The album was recorded, with John Dexter producing it and a two-thousand-dollar video for a track that went against all odds.

"Tell on You" was a stark and emotional song about sexual exploitation, which was lyrically very personal for me. The video was shot in a closet with a locked-off camera. The video captured the isolation and emotion of my earlier experiences. MuchMusic added it to its playlist immediately and my solo career was launched.

Everything was amazing until one day Peter told me that John Dexter was considering closing Plum Records, as he was interested in moving in a different direction. John was a creative individual, a songwriter and producer, and I think he should have been also in a band. I can't think of anyone who is more about music than John. The problem, Peter said, was that running a record label had little to do with music and everything to do with business, and John was in it for the music. So all of a sudden, with one video under our belt and a well-received Canadian tour opening for another of Peter's bands, Rhymes with Orange, I was orphaned from my record label.

Peter called me up and said, "Let's start a record label for licensing your album. What do you want to call it?" After some thought I called him back and said, "Her Royal Majesty's Records." I already had drawn the stick-girl logo. He laughed and said, "Perfect. Love the name."

Peter tried to incorporate the company under that name but learned that in order to do so, the name could not imply any connection with the Crown. Thus, HRM Records was born.

Peter always makes things happen; he is that guy who never gives up, who will not quit until he's solved the problem at hand. Peter immediately began doing outreach to record labels to license the Plum Records album. He contacted Jörg Hacker, who was high up at Edel Records in Germany, which had distribution throughout that country. Jörg had a strong interest in me as a recording artist. It was during this time that Jon and Marsha Zazula and Peter started talking about working together. Peter told me, "I sent Jon Zazula the Annihilator

album to see if he was interested in some more heavy metal and he said, 'What else you got?' So I said I have the most interesting punk, alternative girl on the planet. Her name is Bif Naked."

Soon I was in New Jersey, and Peter, Jonny, and Marsha Zazula were my new management team. Jonny brought his New York City music connections to the table, and he and Peter had connections with European labels, and both were good friends with Jörg Hacker.

Once Edel signed me to the European deal, Peter did a deal for Aquarius Records out of Montreal for the rerelease of the album. Mark Lazare ran Aquarius, and René LeBlanc was the radio and promotions guy. At the time, Donald Tarlton, also known as Donald K. Donald, was the owner—and the godfather of music in Quebec. I loved these guys—they were my new family, and René, my new big brother. A host of people worked with us at Aquarius as part of the promotions team, and they became close friends. I felt like I was in the best possible hands. With Jörg and his team at Edel Records, Mark, René, and Donald at Aquarius, and Jon, Marsha, and Peter all working to push my career as a solo artist, I was overwhelmed by gratitude and did everything possible to make sure I never let them down. I wanted to live up to the expectations of these professionals and meet head-on the amazing opportunity that had been given to me.

# TWENTY-SIX

BASED ON MY EXPERIENCE, I THINK IT WOULD BE incredibly difficult to navigate a comprehensive European tour without the gift of a tour bus, supported by a press tour. A press tour on a tour bus would in fact be ideal, provided there's alcohol. Not for me, but for the entourage. Frankly, I don't even know if record labels actually do press tours anymore for artists who are just starting out. I was so truly lucky to experience the power of a label's promotion machine, coordinated to support the release of a new album, and tour dates to support the release of the album.

The stars need to align. Don't let anyone tell you differently. It all comes down to luck, and I most certainly always felt lucky. There is never any guarantee that anyone in the media will want to interview you, even though you, or the label, or your manager, or your mom, may think your record is relevant. My records were not likely all that relevant to anyone other than the people working on them, or to my mom. I was always amazed, and appreciative, when the press was interested in my music or in me as an artist. This made me feel that my music was at least somewhat relevant to the publication or to the interviewer, and that made me feel lucky because they have the power to shape public opinion. They're influential; they're the tastemakers.

It's the big publications that can make a difference for a budding artist, and what gets covered is determined by the editor, the space available, the advertisers, and, again, whether you are worthy of being discussed or talked about or reviewed. Good thing I'm a chick. And a solo artist. Less fighting over who would be the interviewee.

When we were first licensing my debut CD, Canadian labels were not especially interested in it. A&M Records, the distributor of Plum Records, which initially released it, did not want to pick up the album, so we managed to pick up a licensing deal with Edel Records in Germany, as I mentioned. Edel was successful but considered primarily a dance label. I was definitely not a dance artist, though I enjoyed dancing immensely. But to me, nothing could have been better, as there were no other artists in my rock punk alt style on the label yet. This would be a fortunate position for any artist, and especially for a nice Canadian girl such as myself because of the fact that I *was* a girl. It made people curious. It was a bit of a novelty. It made them go all funny too, like I was some kind of pin-up girl in a room full of wise guys. No matter what I did or said, it always seemed like the men at the label thought I was flirting with them. They sure were friendly to me.

I had encountered this unspoken energy frequently in punk bands and thrash, and had overcompensated and fist fought my way out of it since I was a teenager, but this was a bunch of professional people and I couldn't actually punch anybody. I was mindful of what a privilege it was to even be part of the meeting, the press conference, the photo shoot, or the show. I was generally pretty pragmatic. I simply had to be smart enough to not take it personally, to know it wasn't really about me. It would be the same for any chick in any band. It's show business; I got it.

It probably didn't help that I have a curvy figure, big green eyes, and overpainted fish lips. Did I have to overpaint my lips? Did I have to wear black eyeliner and false eyelashes? Of course not, but doing so

was part of my self-expression and self-identity as an artist and as a female. I would dress the same way whether I was making pancakes for breakfast or going on stage—like an adult version of a Kewpie doll, but with Bettie Page bangs and lots of tattoos.

Lots of girls, including my girlfriends, were dressing like this, like vixens from a Russ Meyer film, like tattooed Bettie Page wannabes. We knew we were being somewhat provocative; it was part of our personal empowerment, and part of our armour. And we had a lot of fun with it—our goal was to be able to ollie a skateboard in heels.

My opportunity to stand out in the music business was an accident, and a gift. I say gift because it really was, is, and always will be such a luxury to work with people who are impassioned about the recording industry. I say it a lot: being in the music business is like being in crime, or in a crime family. It gets in your blood and no matter how many times and ways you try to get into another field, either the music business just drags you back or you go crawling back to it, begging to be taken in again.

Little did I know when my manager, Peter Karroll, and I formed HRM Records as a vehicle for licensing our little record that life would find us all wrapped up with the Germans right out of the gate. Germany was the third biggest music market in the world at that time, so it was pure genius on the part of Peter and Jonny to align us with key German record people, like Jörg Hacker, with whom I would eventually become dear friends.

Both Peter and Jonny and Marsha had worked with Jörg before, and loved him. Jörg was quite famous; everyone knew him and Jörg knew everyone, it seemed. He was well liked and well respected. He was a six-foot-four, good-looking blond. His loud, warm laugh boomed from his soul. Jörg would prove to be my greatest advocate aside from my managers.

A great way to introduce a new artist is to find a forum where lots of different types of industry people convene. Fortunately, the music industry holds many conventions, one of the most famous taking place in Germany in late summer. In 1995, Pop Comm was held in Cologne, and I attended. It was the first time I had been to Germany, never mind Europe, and the trip was life-changing for me on many levels. I felt like I was capable of achieving my dreams, yet I was also immersed in the game of promotion—meeting people, and smiling nicely while my managers talked about me as if I was not standing there next to them. It was marketing plain and simple and had little to do with music and a lot to do with connections, relationships, and the good old boys' network.

Back in my hotel room after my first-ever day in Europe, a long day of standing around making small talk with a different person every ten minutes, I was exhausted. I felt like the walking dead. I'd never experienced bad jetlag before, so I was surprised when I couldn't fall asleep. I started feeling anxious, as I had to get up early in the morning for a full day of press interviews, photographs and videos, and television appearances. This was the first time that my anxiety would keep me locked all night long in its grip. I moved my pillow and blanket to the bathtub, to the hallway floor, then back to the bed. No matter how I positioned myself, I simply could not sleep. It wasn't the hyperventilating, panicky type of anxiety, but rather, a chattering monkey in my mind that would not shut up. I lay there worrying about doing a good job and behaving so as to be liked. Then the sun came up, and I was out of luck.

This anxiety would continue to plague me, and still does. It would also eventually lead to further disordered behaviours, or perhaps just enhance the ones that were already there, just waiting to be turned up to ten on the dial.

# TWENTY-SEVEN

EVERY BAND HAS SIMILAR STORIES ABOUT TOURING
Europe: the go-go dancers, the countries, the fist fights, the deli trays,
the bus fever, the sound checks, the puking, the overnight bus drives,
the language barriers, the catering, the fans, the crews, the alcohol,
drugs, criminal element or lack thereof, and the hotel. And every-
one, and I mean everyone, at one point or another, has stayed at the
Columbia Hotel in London.

The Columbia is the band hotel. Located across from Hyde Park,
it's a legend. Some of the rooms have up to four single beds. And it has
bus parking, which was a big deal for all touring bands. Bus parking is
the prized feature of any hotel for a band touring Europe. Since tour
budgets for opening acts usually do not accommodate both the bus
costs and the cost of hotel rooms for the band, we typically rented one
room only, sleeping on the bus and taking turns going to the room and
showering while the rest of the band and crew hung out, usually in the
pub in the lobby.

We stayed at the Columbia every time we played in London and
every time we were just passing through on a tour, usually scoring a
room with enough beds to accommodate us. We met several bands
there over the years, but the biggest deal for me was being introduced
to James Hetfield, the lead singer of Metallica.

We were staying at the Columbia and so were COC (Corrosion of Conformity) and Metallica. The Donington Music Festival (now the Download Festival) was scheduled that coming weekend, and every heavy metal band worth its salt was starting to descend on London en route to Leicestershire and Donington Castle. All these bands together, packed into an eighty-seat pub. It was a dream come true for any fan and most especially for me, on the tail end of my promotion tour. My managers were scouting the Scottish guitarist X-Factor from Warrior Soul, on the bill to play the main stage. COC was to play first, and it was a show I did not want to miss. Luckily for me, my managers and record label deemed it important that I be added to the guest list for backstage, where I could meet other bands and be seen.

Jonny and Marsha had known Metallica since they were a young band, and I was enamoured with the band's rich history. Jon and Marsha were known far and wide as the parents of thrash metal. I felt lucky to be working with them, and fortunate to be at the same hotel on this unique night.

Peter was sitting in the corner of the pub at a table by himself, working, when Hetfield came over and asked if he could join him. I was sitting at the next table over, with my back to them, chatting away with another band when Peter tapped me on the shoulder.

"Bif, this is James," said Peter.

Hetfield extended his hand. "Hi, nice to meet you," he said, smiling.

"James, I would like you to meet—"

Before James could finish the introduction, I stammered, "BBBBBBBBif. . ."

Peter started laughing. "She's usually much better at talking," he said.

After I had been introduced to the rest of the bands, I made my way to the door and quickly made an exit, convinced I looked ugly and

that everyone had felt how greasy and sweaty my handshake was. I was so self-conscious, I simply returned to the room. I locked the door and sat on the bed, feeling like a loser. I didn't return to the pub that night. The next day Peter reassured me that I had handled myself well and that Hetfield thought I was cute, in a little sister kind of way. I felt better.

The Donington festival that year was one of the biggest events of my life. I harassed my managers in the wee hours of the morning to leave for the festival. I desperately wanted to get there early enough to get parked and into the VIP area in time for the first band. We even had our own parking pass, which read "METALLICA—VIP" and which I sentimentally saved for years. I sat side stage, cross-legged like a little kid, chin on hands, watching each band in turn, and watching the crowd throw wine skeins and big plastic bottles filled with hot pee.

The concert-goers would be drinking wine, beer, water, or whatever, from various containers. Sooner or later they'd have to pee, and instead of moving out past the thousands of people jamming them in—the sloping grounds of Donington Castle make for a natural amphitheatre—those at the front or in the centre of the crowd would urinate into their now empty drinking vessels. At one point at some festival, maybe even at an earlier Donington festival, a fan decided it would be funny to send one of these containers flying through the air. Even funnier was that they'd leave off the cap and send the container spinning high up in the air so that it sent a spray of pee onto people's heads. Eventually, the experience was enhanced by the punching of holes in the containers before they were whipped into the air, to rain piss onto everyone.

Metallica arrived at the site in a helicopter. Forgetting that they were covered in piss, now drying in the cool dusk air, the thousands

and thousands of fans went crazy as the chopper hovered above them. A tremendous sound came from the crowd, a roar and a cheer mixed together. It rang in my ears, and in my memory for many years to come. I will always also remember the colour of the sky that early evening— magenta and orange.

I could never have guessed that a decade later I would record Metallica's "Nothing Else Matters" for my *Superbeautifulmonster* album. This was at Jonny Zazula's suggestion, and Metallica loved the idea. Lava Records, my American record label, was generous enough to ask Dave Fortman, an American rock producer famous for working with Evanescence, Mudvayne, and Slipknot, among other bands, to produce the song. I loved Dave and I loved New Orleans, where he and his family lived and where we recorded—in Piety Street Studios. I was a huge fan of his, and even knew of his first band, Ugly Kid Joe, in which he played guitar.

My cover of "Nothing Else Matters" became a fan favourite. The video consists of live concert footage from a summer tour. The song remains one of my most requested ballads.

# TWENTY-EIGHT

THE BAND AND I WERE A MILLION MILES AWAY FROM home. We had played in Helsinki, Oslo, Copenhagen, Stockholm, Malmö, and now we were in Rostock. It was my third or fourth European tour, and we were pretty familiar with the whole deal: the promoters, the bands, the catering, the bus bunks, the label guys, the languages, you name it.

We went to Germany a lot. It was becoming a good market for us, and we were privileged enough to get the coveted main stage on both the famous Pock am Park and Rock am Ring festivals. Sweden's Hultsfred Festival was also a bucket-list gig, and I was excited to be there. I felt so happy to be touring, especially as a female in the same lineups as male bands and not just delegated to being a novelty act. It meant I had a great deal of credibility, which was of the utmost importance to me.

The first time I saw Brett after our marriage ended was at the Hultsfred Festival, in fact. I was performing on the second stage, in a giant tent with room for about two thousand people, and it was rammed. Brett was doing monitors for Pennywise, playing later that evening on the main stage. In Copenhagen the night before, knowing that Brett would be at Hultsfred, I had asked Peter if we could take the song

"Chotee" out of the set. The album hadn't come out in North America yet, and Brett had never heard the song. Peter laughed and told me to get out there and do what I did best to tell the story. And I did it: I sang the song and even dedicated it to Brett, sitting side stage with his crew and band guys. "Chotee" remained my favourite story to tell for years.

Bertie Baderschneider was our faithful bus driver on many of our tours. He was one of the best coach drivers in Europe and many bands requested him as a driver. We always requested him as ours.

One morning during this particular tour week, Bertie pulled the bus up in front of his apartment in Püttlingen and took us all up for special coffee he made with his Italian espresso machine. The walls of his home were adorned with maps of North Africa, as well as with dozens of incredible photographs of the deserts there. And pictures of Bertie in places like Tangiers, where he wore a scarf that billowed in the wind like Snoopy as the Red Baron. We asked him to tell us the story behind the photos, but he just laughed and asked us how we liked the coffee. His life before becoming a bus driver remains a small mystery to me. Maybe he was a prince, or a priest.

We just loved Bertie. He was a big and gentle man with twinkling eyes and a shining spirit. He was always smiling, and he never argued with Peter, which was big. As far as Peter was concerned, the bus was hired to serve the band and he, Peter, was the captain of the vessel. So any anarchy eventually resulted in the captain squashing the rebellion. But even Peter loved Bernie.

Bertie always called me "Mrs. Bif," partly to be funny and affectionate. But he also used "Mrs." as a form of respect, having discerned the pecking order in the band, and that I was considered by the rest of the band as more like a little sister than a solo artist. Even though the guys were essentially backing *me* up, I was never the band leader

per se. Instead, I overcompensated and tried to keep everyone happy. Part of my personality and lack of self-confidence, I guess.

Talking to the artists he drove around was somewhat new to Bertie—bus drivers were sometimes not allowed to speak to the bands. This was especially true with the big American and British bands, bands that were legends in their own minds, and including some I toured with or opened for at festivals. That is some rare level of bullshit ego indeed.

I've said it before and I'll say it again: I have always had the impression that the more successful the band, the nicer they are toward others. The musicians I was fortunate to work with and I always made up a close-knit group, handpicked by my devoted manager, who also acted as tour manager, front-of-house soundman, producer, publisher, business partner, martial arts trainer, co-writer, father figure, and yes, sometimes boyfriend. Ours was a 24-7 job, and we were together every hour of it. We were enmeshed.

Peter had managed me since I was in Chrome Dog, and he knew each and every one of the musicians and crew guys who worked with me. The boys, especially the ones touring with me after I started releasing records, were my brothers, my best friends. After the first Bif Naked album was released, the band and I were often on back-to-back tours, with just enough time after ending one to either travel by tour bus or fly overseas to start the next series of dates. We were in the opening slot on many shows and, embarking on a new tour with a new headliner, never knew what insanity was ahead of us.

No matter what, we were all in the trenches together. It was like we were in the military, a combat unit but without the guns. Of course we never had guns, being good Canadians, but there were a couple of American bands along the way that pulled out a pistol or two. Not on us but just being crazy with weapons outside the tour buses.

In the summer of 1999, we opened for The Cult and drove straight to Lilith Fair for some shows, then over to the Warped Tour, then to FUEL in the early fall, and on to tour with Days of the New, through November. One of the guys from the tour pulled shenanigans on the bus driver after a show and made the man turn the bus around and drive him and the unsuspecting sleeping band members to the band's hometown. Instead of waking up in the next tour stop of St. Louis, Missouri, they woke up one or two states over. This wouldn't have happened if Peter and Jonny were his managers. No way would they have tolerated that. Nor would it have happened if Bertie Baderschneider was the driver. Bertie would never tolerate that either. The band rejoined the tour a few days later and continued on with the shows.

On another tour with another American band a short time later, the singer, who had a history of violence, apparently pulled a gun on a bunch of fans right after a show in Arkansas. Right outside the venue, where our buses were parked. The police turned out in force, and the result was even more craziness. I was bummed. We were in the same Little Rock neighbourhood as the house in the TV show *Designing Women*, and I wanted to get a photograph of it to send to my mom. That imbecile ruined my chance at that photo, as a police lockdown ensued. I never did get a picture.

The bus driver is ultimately responsible for the safety of everyone on the bus. He has their lives in his hands. It's a big responsibility, and a lonely one. The bands are consumed with their own lives, as well as with the show. For the most part, musicians are thoughtful, intelligent, hard-working, and respectful of other hard-working bands. It was not uncommon for an opening act to be the headliner the following year, after radio airplay or a hot video. So the smart headliners understand that it's best to treat everyone with respect, lest

they end up back at the bottom of the food chain and paired with a new headliner with a vendetta.

But musicians on tour are also fun-loving and, especially if two or three bands are touring together for a number of dates, can act like teenagers. This does not apply to all bands, of course. But it does to a good number of bands.

My bandmates were basically good kids. Most of them drank alcohol. Pot and cigarettes were never allowed on the bus, though, and definitely no one was allowed to perform drunk or high. This was strictly enforced by Peter. With our band, there were no crazy hard drugs or anything that I knew of, but then again, what would I know? I went to sleep right after the show if I could, while the band generally stayed up, partying on the bus during our nighttime drives on the motorway. At six in the morning, I'd be waking up just as they were going to sleep. It was a good system, usually. We existed kind of like the Partridge Family, except we were on a rock tour coach, not a modified school bus, and Reuben Kincaid would have been eaten alive on one of our tours. He just wouldn't have been tough enough.

The motorway—the highway—was where we headed to after the gear was loaded out into the trailer and the bus compartments, on to the next city for the next night's show. It was also basically the only place we could spend money. There was generally no opportunity for me to leave a venue unless we were doing press on the same day, and even then it was a tight schedule, with little time for dawdling. Sometimes I was so exhausted I'd fall asleep in the back of the taxi from the venue to the TV station, flanked by a promo person from the label and Peter. Or on the way back to the venue. Sometimes both ways. The drivers must have thought I was a junkie, simply nodding out. And I probably did look like a heroin freak with my tattoos and black eye makeup.

No one cared that I was straight edge except for a handful of fans who came to the shows with telltale *X*s scrawled or tattooed on the backs of their hands, or who'd cross their arms, giving me the salute of the straight-edge movement. I loved it. I was so happy when they came to the shows, as it reinforced my devotion to that way of life.

Some of the musicians and crew from other bands who didn't know us simply assumed I did drugs and drank. They also assumed I had sex with the guys in my band, the record-label executives, my managers, you name it. Rumour had it that I was having sex with anyone who crossed my path. As I mentioned, I usually made an effort to compensate for this and act like a tough tomboy. In hindsight, I don't think that helped. It was just the way it always was: if you were a girl in the music business, you just had to be blowing somebody.

My band was my fun, both on and off the stage. The guys without a sense of humour, especially on tour, are the guys who don't last. This is true of many bands, not just mine. But it was simple: the guys in my band drank; I did not. What's the problem? More beer for them, more soda pop for me. That was when I was still drinking pop, and it was what the venue provided for me. That was before I became a raw-food vegan and was just a non-drinking, non-smoking vegan and relatively flexible with what I consumed.

In the early days, I drank beer and smoked cigarettes with my band. But by the time we went on our first European tour, I was already abstaining from alcohol and cigarettes. I was happily straight edge and happy to be the only one. After all, I was the only girl, so I was used to being the odd man out, so to speak. I compensated by being more aggressive on stage—jumping more and talking some pretty crass shit.

Peter maintained that if I got nervous enough I simply mimicked Eddie Murphy, and they all thought that was pretty funny, though I don't think I talked like that. At times I was heinously jet-lagged,

thinking in reverse, overtired from playing shows within hours of landing or just from the constant driving—the deadheading—and from the shows and the press. I would be "accused" by my manager of creating multiple personalities. The comedian would pop up on stage, telling stories in between songs, or the three-year-old girl with the deer-caught-in-the-headlights look and little-girl voice, which might come out when the audience was happy and I was being ingratiating. Peter's favourite was the tough sexy cool chick. In fact, whenever he was side stage when one of our shows started, that was exactly what he yelled at me over the roar of the crowd: "Tough, sexy, cool." I was a girl up against some very aggressive bands, trying to win over audiences that often started the set as unbelievers. There was absolutely nothing better than triumphing over these audiences, so much so that the headliner would have a difficult time following our show.

Often the venue would be the only thing the band would see in most cities or towns, for weeks on end. So we never missed the chance to hop off the bus whenever it stopped to fill up with petrol and run inside the truck stop to snoop at all the goodies on offer. Sometimes the boys bought beer and cigarettes along with snacks they enjoyed (in Doug Fury's case, nougat). I'd hit the salty black cat licorice and the chocolates.

Licorice was not typically on my menu. Even though I was straight edge, I still managed to party with my band at the end of a tour, to celebrate. "Party" for me meant break from my diet and eat candies. Pretty badass, I know. The only way for me to feel a part of the fun was to show off how much candy I could shove into my mouth, or to eat something they found particularly unappetizing, like salted black licorice. Doug's laugh is a shrill cackle and it may be my favourite sound in the world. If what I did made Doug laugh, well then, I would just keep on doing it.

The band's resounding cheers as I ate more and more of those licorice pieces only encouraged me further. Likely overcompensating (again) for any and all things they might complain about—the pay, the hotel, the food, the guitar strings, the travel, the jetlag, the booze selection, the lack of clean, real-life clothes—I was relentless in my efforts to make them laugh, hamming it up for their entertainment in any way possible.

The sun was just breaking the skyline in Rostock, and the bus was parked alongside the venue, the MAU Club. Our beloved driver, Bertie, had left the bus for the driver's room in the nearby hotel, and the rest of the band was sleeping soundly in their bus bunks. The birds were just starting to open their eyes, and I could hear the distant sound of cars in the early morning traffic. I was outside on the asphalt, my face pressed into its cool smoothness, a pool of vomit, a salty-sweet grey foam, next to me. I was unable to even push myself up off the ground. I was gravely ill and extremely remorseful.

No matter how sick I was, I never missed a show, and the show that night would be no different. Puking was not the worst thing I had ever done on stage. But I would not indulge in salty licorice again, ever.

My mission was accomplished, and I would remain the good kid who got the most laughs out of her band yet again. This was my raison d'être during our motorway partying, and I was proud of myself. Eventually, I peeled myself off the pavement and fumbled my way back onto the bus and onto my bunk, which was covered in my clothes and stuffed animals. Too sick to find my pyjamas, I just put on my Walkman headphones and crawled into my sleeping bag, and immediately fell asleep. By the time we hit the stage that night, I had recovered sufficiently to rock Rostock. I had also learned another of life's lessons.

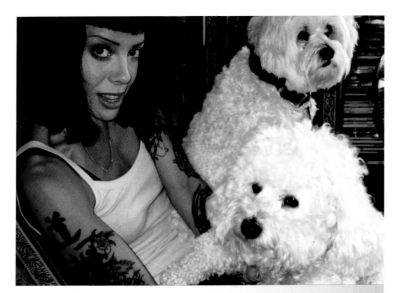

With my two dogs,
Annastasia and
Nicklas, at home in
Vancouver in 2000.

I flew to India in 2000
to visit my dad and
stepmom, Anita. I also
travelled to Bangalore
and New Delhi with
Peter Karroll, who by
then had become more
than just my manager.

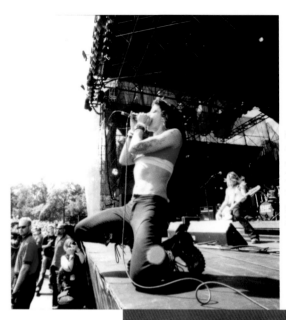

Onstage with Gail Greenwood during the *Purge* tour in Barrie, in 2001. By this time, *I, Bificus* had gone platinum.
David Leyes

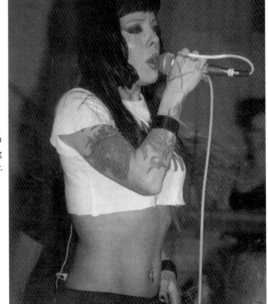

A concert photo from Los Angeles, during a US tour.

I took this photo of my managers, Peter Karroll (*left*), Marsha Zazula, and Jonny Zazula, in studio in Vancouver during preproduction for *Superbeautifulmonster*. Annastasia, of course, was looking for petting and love from anyone, any time.

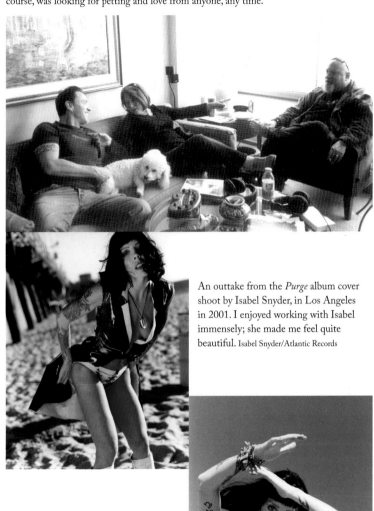

An outtake from the *Purge* album cover shoot by Isabel Snyder, in Los Angeles in 2001. I enjoyed working with Isabel immensely; she made me feel quite beautiful. Isabel Snyder/Atlantic Records

Another photo from the *Purge* shoot. I struggled to keep on weight at the time of this photo session, though it doesn't appear this way on film. I was a size zero.
Isabel Snyder/Atlantic Records

Standing in front of one of the national bus-stop ads for the *Superbeautifulmonster* album, 2005.

On tour in America with the guys. From left to right: Doug Fury, drummer Chris Crippin, and bass player Gabe Cipes. They always managed to make me laugh, and I loved them for it.

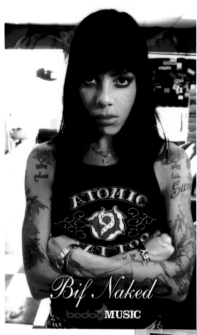

A promo shot for *Superbeautifulmonster*, taken at Atomic Tattoos in Los Angeles.
Tim Harmon

From the shoot for the video for "I Love Myself Today" in Vancouver, 2001.

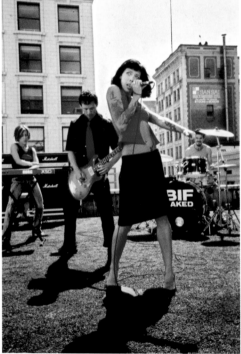

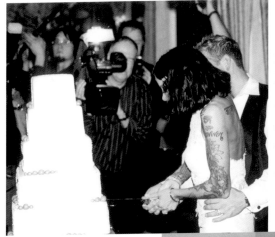

My second wedding, to sports journalist Ian Walker in September 2007 in Vancouver, appeared on a reality-TV show and was featured in *Hello! Canada* and other celebrity magazines.

At the BC Cancer Agency in 2008 while I was undergoing chemo-therapy. I'm wearing my favourite blonde wig, from The Bay.

My dad and Anita came to visit me in late 2008. I had completed chemo and started radiation. Little did we know it would be only a few years later when my dad would be in a cancer battle, complete with chemo, himself.

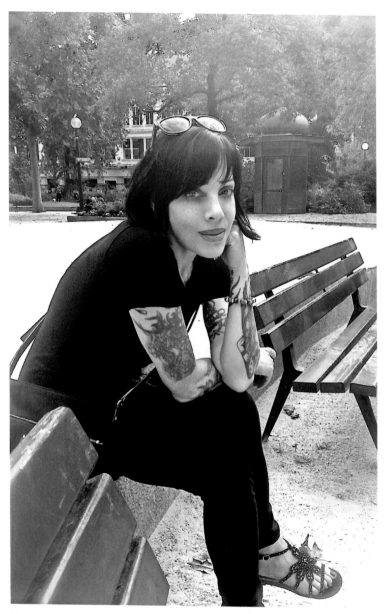

Naz Karroll, wife of my manager, Peter, took this photo of me in Paris in 2013, shortly after I had delivered the first draft of my manuscript to my publisher.

# TWENTY-NINE

I WAS NEVER UPSET OR UNWILLING TO ACCOMPANY MY band and crew to the various establishments they patronized, including the stripper shows, although the occasions of my being included were few and far between because I usually went to bed after our show and therefore missed the festivities. But my best friend was an exotic dancer, so I was undaunted by that type of thing. I mean, who is the fool here—the one taking the money or the one throwing it at the stage? Hard to say. I guess it depends on the situation. But it does seem as though the dancers have a lot of power over the men in the audience, who seem willing to spend every dime they have to try to win the attention of these naked beauties and hopefully take home the prize.

Amsterdam is full of strip clubs, the kind men smoke cigars at, and I'm confident that no in the band or crew overthought things, they just enjoyed the show. Cigars were all the rage among the record-industry people we met. It was something like pot, I think. They all liked to dip their toes into the culture a little bit, but remember, they were executives, suits—not many potheads in that group. Cigars were a status thing. From TV crews to record-company presidents to lawyers to promoters to cops, everyone seemed to smoke cigars, usually Davidoff mini cigars. Luxurious puff sticks, decadent,

pretentious even. Davidoffs were what Peter puffed on during summer tour season.

Peter didn't drink alcohol and hadn't for more than a decade. He is a martial artist with three black belts, including one in sun hang do, a combination martial art. He didn't believe in taking drugs, drinking alcohol, or anything like that. How and when he acquired a taste for Davidoff mini cigars I don't know. If you ask him, he'll point to Clint Eastwood in spaghetti westerns.

Peter was nicknamed "the Colonel," and when he raised his voice or growled at you, it had an instant effect; there was no doubt the Colonel was in command. This was like nothing I grew up with in my house of silence, so it was effective in getting my attention, and it produced swift results from everyone on the tour—the band, the crew, and even the crews on the big festival stages. It was effective in getting people to do whatever it was they were supposed to be doing.

The tour bus is no place to have a mutiny. It is, unfortunately, a ripe atmosphere for problems of many kinds because of the aforementioned dreaded bus fever. Sometimes a band member got a big head or over-sized ego and decided to let the manager know how unhappy he was that he had not been singled out for higher recognition. Sometimes the band member would try to bend the ear of a few of the others and attempt to gain some form of power on the tour. This, I felt, was always an unwise move. Peter would hear the person out, smiling and listening intently, letting him have his time stating his grievances. Usually it was about how the guy carried the show with incredible solos, or with his good looks, great image, or stage presence, and wasn't being recognized for it. The musician had a case of "being a legend in his own mind," as Peter called it.

Peter always started by nodding his head as if agreeing with the person. Then he looked the guy in the eye and asked if he had seen

the posters. "Tell me, whose name is on the posters? It looks to me like Bif Naked's name is on the poster. Is that your name?" This was typically met with silence. Then Peter would say, "How many people do you think would be coming to this show if it were your name on the poster?" He liked to have fun bringing the egos in line. Having vocalized his discontent, the musician would usually find that his days in the band lineup were numbered.

Peter also never ever took an ultimatum from a band or crew member. Instead, it resulted in an immediate firing. I generally tried to avoid being around at these times, by either hiding in my bunk or at the other end of the bus. On occasion I'd be trapped there, and then I'd sit as quietly as possible, staring at the floor. If it were up to me, I would have gladly put any band member's name on the bill who wanted it there. We could have taken turns for all I cared. This attitude drove Peter, Jonny, and Marsha crazy.

The crew was no different from the band when it came to the occasional outburst or acting out. One roadie stole a microphone from our gear and tried to sell it for heroin, in Paris. When Peter found out, he calmly and politely woke the guy up, told him he had five minutes to get his belongings off the bus, gave him some cash to buy a plane ticket back to New York City, and left him on the side of the road wondering what had just happened. All this before nine o'clock on a beautiful sunny morning.

Band and crew members were not allowed to stray by themselves. This was one of Peter's ironclad rules of the road. He had to keep everyone in groups and know where they were so that the tour could keep moving. The musicians were usually good at following this rule, but new crew members were not always. In Slovakia, a new roadie got into hot water with the cops for going on what he thought was a date, with a woman who turned out to be a sex worker. On another occasion,

a soundman hooked up after the show with a girl whose estranged convict boyfriend just happened to have been released from prison that day. He broke down the door of his girlfriend's apartment, beating the poor soundman nearly to death. He was lucky to have lived and lucky his hearing, eyesight, jaw, and teeth remained mostly intact. It was a brutal beating and he was unrecognizable for some time.

Touring is always dangerous on some level. But as I mentioned, the bus driver has perhaps the most responsibility. We were always respectful to the drivers, and Peter enforced this behaviour as a rule. Occasionally, though, the bus driver would not work out as well as we had hoped. Not everyone could be as wonderful as our beloved Bertie. Many times the drivers did not cut the mustard and Peter would have to have a chat with them, one on one.

Many tours seemed never-ending. On one European tour—this was in 1996—it did not help matters at all that our Dutch bus driver, Paul, on more than one occasion during overnight drives, swerved, almost throwing us from our bunks. It felt like we were nearly rolling the bus, and this made everyone extremely nervous.

"I swerved to avoid hitting a dog!" he said, defending his driving one night when interrogated by Peter, all of us having been jolted awake. We knew he had fallen asleep at the wheel. No one believed his dog story. "It's true!" he declared. "In France, many people throw unwanted pets from the windows of moving cars on the highway to get rid of them." We still didn't believe him.

Peter never gave the guy a second chance. By the time we got to Salzburg two days later, Peter had made other arrangements. He told us to unload all our belongings off the bus and take them into the venue.

"What should we tell Paul if he asks what we're doing?" I asked.

He replied, "Tell him you're doing laundry, or tell him nothing." Then he called Paul off the bus.

I unloaded my belongings, but, instead of heading into the venue, I hid around the corner, straining to hear the conversation. My curiosity had got the better of me.

"Paul, sit here with me for a few minutes; I want to have a talk. Paul, that is the old bus," Peter said, pointing to Paul's Prevost parked directly in front of them.

Paul looked puzzled and said, "The old bus?"

"That's right, Paul, that is definitely the old bus because. . ." Peter pointed at the shiny British double-decker sleeping coach coming around the corner, "that's the new bus."

Paul looked bewildered. "What do you mean?" he asked in a high voice. I was cringing, I felt so sorry for poor Paul.

The double-decker bus pulled up beside the Prevost. It was bad enough that Paul was getting fired, but did it need to be so dramatic? Although Peter was still pissed off at Paul for endangering our lives, he stuck out his hand and they shook hands. "Sorry, Paul. It just didn't work out. You can head back to Utrecht."

Paul was quiet. "But it was a dog," he squeaked.

"No hard feelings." Peter stood up, giving him a big smile and patting him on the back. "No hard feelings, Paul. I've contacted your boss and he is expecting you tomorrow, so I guess you'd better go."

Peter saw me. "Bif, go tell the guys to come and put their stuff on the new bus, tell them we are changing buses now."

I couldn't meet the forlorn driver's eyes. I scurried off to find the boys.

We were only midway through the tour and already many things were becoming clear. One was that our new guitar player from New York City was a bit arrogant toward the Canadian band members, who were easygoing guys and had known each other for many years.

The guitarist had been brought in as a ringer—a star guitar player. He had come highly recommended from my American managers, who said that he would add credibility to the unknown lineup and the new solo girl singer. He was originally from Scotland and both his accent and his sense of humour were wonderful. I liked him very much. He was talented and driven, and later we even wrote a song together: he mailed me the music on a cassette tape and I wrote the words and finished the melody using my small keyboard. I preferred to write this way, by myself—I felt free from restraints and self-consciousness.

During the tour, the ringer was becoming increasingly unhappy too about being a support musician to a female singer. I think he assumed it would be different, more of a duet like the Eurhythmics, and was disappointed with the reality that it was Bif Naked, a solo artist. It was difficult for him to hide his discontent, which soon turned into contempt for the guys in the band—at this point, Rich Priske from Chrome Dog, recruited by Peter to be in my touring band, and Randy Black, from Annihilator. Their response was to try hard to irritate him whenever the opportunity presented itself. They were as relentless as schoolboys. They knew he disliked them, knew he felt they were all beneath his level, so they tortured him day and night in any way they could, even speaking pig Latin around him after discovering he couldn't understand it. The guitarist would yell and curse them, and they'd roar with laughter.

This type of dynamic was not unlike that among siblings, and this was both good and bad. It meant we were like a family, with the inevitable occasional emotional outbursts and deeply bonding struggles. We were, as I've said, in the trenches together. Except we didn't face death, as one does in combat—unless, that is, the audience failed to applaud.

# THIRTY

**MY NEW YORK EXPERIENCES CAN BE DIVIDED INTO TWO** parts: before Sony 550 and after Sony 550.

When Peter took me to meet with my new US co-management team, Jon and Marsha Zazula, it was a fun and exciting and life-altering introduction to the local NYC music scene. I knew no one in New York or New Jersey other than the staff at Megaforce Records, Jon and Marsha Zazula, and their children. The offices of the legendary Megaforce Records were in Freehold, New Jersey. Megaforce was the mecca of metal, and I was captivated by it—thrilled at the thought of all the metal royalty who had passed through those doors. Jon and Marsha were warm and enthusiastic, and I felt very lucky having them and Peter on my team.

One of the first times I was out on the town in New York City was the night the city hosted the Grammy Awards. I had yet to be signed to a US label. As Jonny, Marsha, Peter, and I walked up a flight of steps to an industry party, Peter accidentally knocked Quincy Jones down to the floor, right in the lobby. Quincy had tripped and collided with Peter. Suddenly we were surrounded by security. In a split second, though it seemed like in slow motion, things escalated. Two of the security guards picked up Quincy, while three other large men in black suits moved aggressively toward Peter, who assumed a fighting stance,

a martial arts readiness position. Peter has third-degree black belts in aikido and hapkido, and I had seen him train, so I knew it was possible that the security staff could end up on the floor with broken knees and other body parts if Peter chose to make a move.

"No, no! It's my fault, I tripped," Quincy said. Peter and Quincy Jones both started laughing and shook hands, and the situation was quickly deflated.

Later that night, we saw Ellen DeGeneres and Madonna at another industry party. I told Peter that Madonna was eyeing him and he said, "It's your imagination." He was never impressed with celebrities. He saw everyone as equals. If they were respectful of others, he liked them. If they were disrespectful, he did not like them. Simple.

The original rounds of showcases and shopping Bif Naked to the record labels was met with a high level of excitement. The label that was most excited, and which we were excited about, was the powerful Sony 550 Music, a sub-label of Sony Records America and the music home of Céline Dion. They signed me up. I thought it was perfect: we are both Canadians, she's from the east, I'm from the west, and we'd make fantastic label-mates.

Michael Caplan, our A&R man, recognized my potential as a solo artist. He worked with Peter and me and encouraged us as we wrote songs like "Spaceman," "Moment of Weakness," and several others for what would become the record *I, Bificus*. Michael was a lot of fun, and he believed in me and in my team of managers. In New York, Michael introduced us to a record producer named Glenn Rosenstein, who we hit it off with. Caplan started the ball rolling for my record, and in a few weeks, Glenn was on a train to Vancouver. Glenn is deathly afraid of flying, so he get around by trains and automobiles. Glenn brought John Potoker up from Los Angeles to engineer, and the experience

was magical. We recorded at Vancouver's Armoury Studios for ten weeks straight.

As soon as the album was done, we all felt that we had something special recorded. But we ended up having a difficult time getting the album slotted for release on Sony 550's schedule. *I Bificus* was already released in Canada and selling well, and it was also released on Sony Records in Europe, where we were touring and doing summer festivals. We couldn't figure out why Sony 550, in America, was dragging its feet. So Peter and I flew to New York to meet Jonny, who had set up a meeting with Polly Anthony, the president of the label. It was Polly's label top to bottom, and everyone knew it. She was a tough, no-nonsense record executive, and as we walked into her office, we were on edge.

It was the most uncomfortable fifteen minutes I have ever experienced in my adult years. It was clear that Polly Anthony did not seem to like me, although we had never laid eyes on each other before. In fact, I felt as if she hated me and wanted me to disappear from her sight and from her label. Jonny and Marsha, who had already had initial conversations with Polly, were confused as to why Polly was acting so coldly. It was obvious that she could barely wait to get us out of her office. We exchanged small talk but nothing about the album, or promotions or planning—absolutely nothing. It was as if we were there for some reason other than to discuss the release of my album. Jon and Marsha didn't seem to dare raise the subject, or maybe they just felt too awkward to. I never did ask them why they hadn't.

As we left the office, Peter turned to Jonny and Marsha and said, "This deal feels like it's dead in the water." Apparently, Jon and Marsha thought the same but were trying to make light of what had just happened because I was standing beside them. But I knew it was dead. I

was devastated. This was a disaster: all the work everyone had put into the album had just gone down the American drain during one short meeting with Polly Anthony.

Jörg Hacker from Sony Records in Germany had been keen about having the album for Europe and was instrumental in setting up the Sony 550 deal in America. "Fucking hell," Jörg said in his thick German accent when he heard about the meeting. He called the New York office, but again nothing, just silence, no one would even talk about Bif Naked. It was as if I didn't exist. Finally, after recording and mixing and mastering, after artwork meetings and photo shoots, the works, we received word that Sony 550 would not release the record. Whatever the reason, it was over.

Peter, Jonny, and Jörg discussed strategy, and Jörg, after many months of struggle and great effort, managed to persuade Sony 550 to let us move to another label if we could find a taker, while Sony in Europe retained the rights for Europe. The next thing I knew we were back in New York City showcasing all over again. And Jonny and Marsha were again lobbying the label heads and A&R guys to come out and see the band.

Jason Flom, founder of Lava Records, attended a showcase one night. The small club was rammed with industry people and my managers were euphoric. I was nervous. But before I had completed the last song of the set, Jason got up to leave the club.

"Jason, you're leaving before the end. Don't you want to meet Bif?" Jonny said.

"Call me tomorrow and we'll talk," Jason said.

After the set, the dressing room was packed with guys from labels and publishing houses, acting like it was an auction. "I'll take the master rights." "We want the publishing." It was a bit over the top, and I was stunned by such a positive response.

The next day, we met with Jason, who wanted to sign me to Lava and buy the album from Sony 550 for the world outside of Canada and Europe, including the United Kingdom. Jason Flom is a god in the industry. No one is as funny and personable as he is. I desperately wanted Lava to be the home for my music.

Jason asked us which song was the single—we had to kick off the album with the right track. Peter thought we should go with "Spaceman." Jason knew it was already a number one track in Canada on the radio, with the highest spins for an independent artist in radio history (in the world, Peter would say). But Jason didn't hear it as a lead-off single. A few weeks later, the decision had been made: "Moment of Weakness." We were excited to get behind it. Jason introduced me and Peter and the Zazulas to Andy Karp, head of A&R at Lava, and many of the other Lava staff, who became my close friends, my family.

I was signed to Lava Records in America and released the *I, Bificus* album on Lava/Atlantic. It was one of the happiest and most exciting times in my career. There was a tremendous push, with everything working together on promotion and touring. There were many great performances and great times, including an appearance on *The Tonight Show with Jay Leno*. We flew from the East Coast, mid-tour, to Los Angeles and stayed in the Sofitel, right across from the Beverly Center mall, which was a big plus for me—it had a juice bar! Jay Leno was a perfect gentleman, and we performed our American single, "Moment of Weakness." That I was invited to sit on his couch with Oscar de la Hoya and Gina Gershon impressed my managers. I was just happy to talk to Jay about my lip ring, claiming that my dad loved it because he liked fishing. Jay thought this was very funny.

After our *Tonight Show* appearance, we were played on prominent radio stations all over America, and on dozens of other interview and

television shows. It started to seem like we were "breaking" in America, and Peter, Jonny, and Marsha were elated. We performed for the TV show *Buffy the Vampire Slayer*, me singing "Lucky" right when Buffy was losing her virginity, and it became a cult classic. The tours, the videos, the promotions, the magazines—this was all with Lava Records, post–Sony 550.

During the setup for the album release, in the middle of a hot New York City June, I was put up at New York's resplendent Plaza Hotel for a week, as a surprise birthday gift from Peter. Unfortunately, at the time, I was suffering from a relentless bladder infection. No matter what course of action I took, I could not get rid of it. Rebound infection after rebound infection, antibiotics after antibiotics, for months on end. But I was working: tours, photo shoots, press trips, flights, bus rides, car trips, trains, you name it, I was doing it. In the music industry, time does not stop for a girl with a health issue. The show must go on. So I said little about it to anyone and just smiled and carried on with my self-imposed positive mental attitude, or PMA, one of the fundamentals of straight-edge philosophy. I knew I was lucky to be at the centre of all this attention, and this was a pivotal moment in my career, so who was I to complain?

At the same time, I had to admit that deep down I was a bit upset I wasn't feeling well enough to enjoy the experience fully. Plus, I felt self-conscious. After years of punk tours, I thought that all I really needed was a coffeemaker, a bathtub, and a clean bed. The Plaza was opulent, and I felt like I didn't belong there. I was just some skate punk with tattoos and a history of stage-diving and hugging people. I felt like an impostor.

I shared the suite with Peter. It had a ballroom-sized bedroom plus salon, with twenty-foot-long taffeta blackout curtains and luxury sheets on the king-sized bed. Chocolates and wine were part of the

turndown service. I didn't drink wine, didn't eat chocolates—it was all lost on me. But I was enamoured with my manager.

We were in the midst of a secret, full-blown personal relationship. The intense relationship grew naturally out of working, travelling, living, trusting, and relying on each other for so many days, months, years. I remember the exact moment when it turned. One day in the midst of all of the craziness of an international recording career, the relationship with my manager became about more than just business management. The evening began with my confiding in Peter. Then, a small touch, a tender brush of the hair off my face, and soon we were melting together into the night. I was sunk. Drowned and lying at the bottom of his sea.

Peter is intensity personified; he does nothing lightly and everything passionately. He was the perfect fit for me, and he surrounded me with a protective cocoon. For him too, our relationship was the most natural thing in the world. He lives and breathes his personal life and business as one thing undivided.

Even though Peter had been long separated from his wife, we agreed our relationship should be kept secret. It was important to us that the artist-manager relationship be seen as professional only. It would just be less complicated that way. I relied on Peter artistically, professionally, and emotionally.

At the hotel, I felt a bit like an eyesore with my Skull Skates hoodie and blunt-cut Cleopatra bangs. Initially, I was followed around the hotel by security—they must have thought I was some homeless kid, junkie, or prostitute. I was a female alternative musician, and this didn't quite fit with the Plaza's typical clientele.

I often saw things through my skewed gender lens and resented any sexualization or objectification, especially if I was not on stage or not purposely being sexual. I wore provocative stage clothes, as did

my peers, because those were the times. Sometimes I was drenched in sweat on stage, just like the boys in the bands, only they got to take off their shirts. So it seemed like the pragmatic thing to do: cut off my shirt and shorts. And then, of course, stage dive head first into the crowd. One grope, one grab to the breast or between the legs, and I'd respond by throwing hockey punches. It's how things were done. You fought. I was like a female gladiator in the fighting pit. It was how I grew up, and it was how I played on stage.

But with Peter watching over me, that stopped. I was not allowed to stage dive. He was right—it just wasn't smart anymore. In fact, it was downright dangerous: people don't just grope your breasts, they try to stick their hand down your pants, or worse, they might punch you, knife you, or bite your crotch, which actually happened once to me. These are the perils of stage-diving if you are a girl.

Jason Flom and Andy Karp insisted on taking me out for my birthday, which was great because I loved hanging out with them. We went for dinner to a lovely restaurant, where I ordered a small salad.

I had a problem with just about all food wherever we travelled. London, Frankfurt, Oslo, Paris, Los Angeles, Miami, Minneapolis, New York. . . anywhere we went, vegan food was never on the menu. Not wanting to create any fuss, I usually ended up fasting, then eating popcorn on the bus later. I didn't want to draw attention to my eating—I worried that people would think I was simply being difficult or judging their eating. I would rather eat nothing than make anyone feel self-conscious about their meal because of what I ordered. I always wanted to put everyone else's feelings first. Really, it was the usual issue of wanting to be liked and accepted. I was just trying not to make it like everything was about me, Bif Naked the solo artist: I was feeling guilt and therefore overcompensating.

New York City had an incredible an energy I had never experienced in Canada. Jason often took us for dinner meetings to a restaurant in Little Italy called Vincent's, where they bring you bowls of a red sauce to dip your bread in. The band loved playing in New York, and loved eating at restaurants like Vincent's. I loved the people at Lava Records. In fact, I never met anyone I didn't like at a record company, except maybe Polly Anthony. I love the people in the business more than I ever loved the business itself. I think this is because it was an amazing and interesting group of talented individuals who spent their lives figuring out how to make artists like me a success.

The band toured and worked non-stop. A decade later, I would spend another birthday in a hotel, this time doing laundry. Not at the Plaza in New York City but in a Travelodge in Port Arthur, Ontario. As I reminisced about and reflected on the past decade, I felt blessed and happy to have experienced it all.

# THIRTY-ONE

anarchy, rebellion, empowerment, growing up

**ALL GOOD THINGS MUST COME TO AN END, INCLUDING** love. It was natural for the intense intimate relationship to develop between Peter and me, and it was just as natural for it to fall completely apart.

Our being together, both on and off the road, ran at full tilt, at 100 percent, for about five years. It was all-consuming for both of us. We shared an apartment and two sweet little dogs; we travelled together, worked together, and created music together. The relationship was rich and mutually fulfilling on every level. Maybe it worked for us because opposites attract. And boy, were we opposites.

Peter's a born leader, a commanding general. This felt familiar and normal to me, being the girl in a world of male-dominated bands, male managers, agents, and industry weasels. It was no surprise that I fell into my non-confrontational, submissive role. This dichotomy is what allowed me over the years to rely on him to be my advocate and protector, fighting for my artistic honour, and tackling any problem head-on.

Right around this time, as the millennium drew to a close, we began making my third record, *Purge*. This was the first album to be completely funded and released by Lava Records. After *I, Bificus*, we had done multiple, back-to-back international tours, hundreds of TV

appearances, and thousands of miles on the road, criss-crossing North America and Europe. We were never home, just always touring, and starting to break.

Even though Peter and I wrote most of *Purge* together as a couple, lyrically it reflected the ending of the relationship. It was an emotional time for both of us. We had a small digital studio in Vancouver's Downtown Eastside, and worked there with the guitarist, Doug Fury, who engineered and co-wrote on some of the tracks. There was a lot of pressure on us, as we had to follow the hugely successful *I, Bificus*; Jason Flom and Andy Karp at Lava had high expectations.

They liked the album material but didn't hear a big single, so they contacted Desmond Child and Eric Bazilian about co-writing and producing a track with me. This was an incredible opportunity and I was freaking, to say the least. Peter and I flew to Miami, and I went into the writing sessions with Desmond and Eric. For me, this was a different approach to songwriting altogether, like a formulaic hit machine. Desmond had three or four studios operating in residences he owned on the same block in South Beach. He'd actually ride a golf cart back and forth between them, and I'd sit in the back of the golf cart, completely blown away by it all.

Desmond and Eric had worked together on many tracks, and both were hit writers of the highest calibre. Now the pressure was really on: not only did I have to write a song with them in a day, but it had to be a single, a hit.

Desmond, Eric, and I sat at a table facing one another, notepads and pens in front of us. Desmond was cool and calm. "What's the title? What is it? The hook, the phrase?" he said. Somewhere in the midst of throwing out lines back and forth, "I love myself today" got onto the notepads. We had the chorus line. It was a fun collaboration, and we recorded the song that day.

The song reflected in part my growing up in the music business, and my independence. The latter was a theme many women can relate to. Really, it was about someone who finally believes in herself enough to step away from a relationship, or from a bad situation. It was about courage and telling yourself you mattered. It was my note to myself. Looking back, the entire album was a reflection of different chapters of my life with Peter. During this time, this era of touring, my long-time buddy and mentor from Rhode Island, Gail Greenwood, the former bassist of the Grammy-nominated American band Belly and of punk band L7, was playing in my band lineup. Gail and I were like sisters, and she provided the encouragement and support I needed during my and Peter's breakup. Gail was the only straight edge I knew well and was the epitome of positivity.

I had always repeated patterns with guys. Those I was with before Peter were usually musicians in bands, and required just as much care and attention as I did, if not more. Predictably, I ended up being like a mother in the relationship. In contrast, Peter took charge, and he pushed me to perform better, to do everything better. But no matter how much he tried to make me a woman who stood up for herself, who stood on her own two feet, I just couldn't do this while having a personal relationship with him. Honestly, I was probably just still too emotionally damaged to be able to blossom into a confident woman. I was drowning in my vulnerability.

Gail may have been my confidante and support, but it was George who was in many ways the catalyst for the changes I was making in my life. My soft-spoken, intelligent first boyfriend from childhood had come back into it. I was regularly playing concerts in Toronto, where he now lived. We'd hang out and then began to correspond. Eventually, I was reliving my first love all over again. He was very different from Peter, who was that tough, dark type of guy some women fantasize

about, the bad boy. There was a sense of danger about him. Even his smile was dangerous.

George was safe, sensitive, and creative, and there was such important history between us. I gravitated toward him. I loved George, and when it all went down and Peter and I split up, George was waiting patiently in the wings to take his place. Peter eventually helped me move George from Toronto to Vancouver by loaning us his brand-new Yukon to drive across the country in. George and I lived together with his cat, Spasil, and my and Peter's two dogs, Annastasia and Nicklas.

Despite our breakup, Peter and I didn't skip a beat when it came to the business side of our relationship, that of manager and artist. In fact, that was like a well-oiled machine, and it was a relief to still be able to rely on him as my manager while my personal life could move in any direction I chose to take it. It was a bumpy road initially, but Peter isn't the type to dwell on things too long. As Jonny Zazula once said, "Peter is like that commando guy in the movies that no one can stop. He just keeps getting up, no matter what happens." That is Peter, and this was no different; although breaking up was not a happy event for either of us, it was something that we had to do in order to move on in our personal lives. I had been afraid of change for so long, but when our relationship finally did take a turn, it was for the better. It was time to purge, and with the album of the same name launched, we had to split.

# THIRTY-TWO

**I'VE ALWAYS BEEN ATTRACTED TO WOMEN. I MEAN,** who isn't? Women are simply beautiful. And, truthfully, I have been approached by girls over the years, and some have really made me think about my sexuality and my sexual preferences, even question it. But I've mostly identified with heterosexuality because of my being, well, boy-crazy since the first grade. Except when I was dipping my toe in the pool of bisexuality. Sure, I've kissed girls, necked and experimented with girls who, like me, were partially or fully naked and caught up in the moment. For the most part, I enjoyed it. What's not to like? Girls are soft, sweet, vulnerable, feminine, and sexy. Women are sensual, each and every one of them. But this was to be my first-ever date with a real lesbian. Not just some chick wanting to get her boyfriend's or husband's rocks off by having sex with another female. No, this was a woman who was well known and well respected.

I was very serious but also very nervous about the upcoming date. I was in love with George, but he was still living in Toronto, and I knew he would respect the fact that I felt strongly about investigating my "truth," and seriously asking myself whether I could be with not just the wonderful Amie but women in general. Being with a woman was entirely my decision and something I felt in control of, finally—something I thought was important for me. And I was at a point in my life

where I felt ready for women, disillusioned as I was with all the men who had broken my heart. I was determined to see if I could lean in the other direction.

I had met Amie through Peter's girlfriend at one of my concerts in Toronto, and was basically set up with her. What could I say? She was an amazing, gorgeous woman. It was our second date. The first one had been outstanding: dinner at a fabulous restaurant, with conversation that was completely seductive, spicy even. This time, she wanted to make me dinner. I was certain she was anticipating our having sex but I planned to not stay the night, no matter what happened. I wasn't comfortable with sleepovers. I wasn't inexperienced, but I was unpractised and self-conscious and worried that I'd be undesirable. Or get night sweats and wet hair. Or worse, be a disappointment.

I wanted this date to be perfect. Not for me, really, but for her. I had to try to impress Amie and not just be some straight girl she was getting into bed with. I figured that hot queer girls must use dildos. Like most women I knew, I had experimented with vibrators, and this was a positive experience but generally came about because of an adventurous boyfriend instigating it. I was never the initiator, instead just following along with whatever my lover wanted to do. Dildos were unknown territory for me. From what I knew of them, they were made of hard plastic, silicone, or latex, and that's a rash waiting to happen. So I had decided that dildos were not for me. Until this date with a woman, that is.

I had picked up flowers at the flower store and a dildo at the dildo store that afternoon, and I was wearing my good bra. We never even made it to the appetizer, never mind dinner. Amie was faster than any guy I had ever met, and extremely skilled: she had me pinned against the wall at "Hello." She grabbed my face and put her mouth around

my mouth and part of my nose. I was shocked. It felt like she was doing CPR; she was devouring me with her mouth, and her hands were everywhere on my body. I began to sweat. I had to think fast. What could I do? I needed to act cool. This was not how I had envisioned the evening starting. I hadn't even taken my coat off yet.

I kissed clumsily with her all the way down the hall as I tried to take off my coat, banging off the wall as she pushed her pelvis into my belly. She was taller than me by almost six inches. I think she thought she was grinding into my pelvis, but it was my abdomen, just below my belly button.

If Amie were a man, well, it would have been over-the-top sexually aggressive. Truth be told, she *was* forceful, and much too fast, but I never said anything. I was just trying to keep up—my typical M.O. I rarely said anything to guys who were pushy, so why would I stop this beautiful woman? And she was beyond beautiful, like a painting. Like Titian's *Reclining Nude*, or a da Vinci. Amie took her shirt off and her beautiful breasts came out of her bra, first one and then the other, staring at me, singing songs in white and peach. Her skin was luminescent, and the softest I had ever touched, like silk, just like poems are written about. She was a big girl, tall and curvy, with deep brown eyes, the colour of chocolate. She had a hypnotizing, pale face and a pale neck, pale breasts, pale legs, and a pale back. Her dark brown hair fell over one side of her face. Her beauty was timeless.

Amie pulled my head into her sternum, right in between her breasts, practically giving me a head butt. I tried to break the seal and pull my head away, but she clenched both hands on the back of my hair, nearly cutting off my airway. Choking, I pulled back and broke her grip. I tried not to cough or gasp for air.

This was my first real woman sex. Despite the roughness of it, I very much wanted this very real experience with this beautiful woman.

Real, that is, in that finally there was no boyfriend or husband lobbying for it or arranging it. No tour bus scene where this would be encouraged as good party fun. No boyfriend giving me the threesome of my life as an anniversary gift, or as his own birthday present. It was simply me and her—my decision, her instinct. I needed this. It was time. I mean, what if I was meant to be with women? What if all my relationships had failed because I was meant to be with women? What if I had been queer all along? I had to find out. After all, I was aroused by women. And I was definitely attracted to Amie. She was funny, with an easy laugh, and intellectually skilled, a science nerd, and I was very hot for that. I was starved for fresh intellectual stimulation. Despite my successful career in music, I still harboured thoughts of going into medicine, and this was a topic I could discuss with Amie, as she tutored students studying for medical school entrance exams. It was perfect.

"Take your clothes off," she said. I felt like I was twelve again, like when I was in Hibbing with my grandmother's nurse, Jim. Although feeling embarrassed, I complied, then reached for my handbag, which I had dropped by the door. It held my fancy surprise, my treasure, the dildo I had purchased that afternoon at Womyns'Ware. The sales clerk had recommended I get a double dong for the date—it was all the rage in lesbian sex, she said. And I wanted to be current, after all. I wanted to be all the rage in lesbian sex for Amie. It was a top-of-the-line silicone dildo that retained body heat and could be sterilized and was pliable and odourless and all that stuff.

This impressive device was expensive, but the clerk promised it would be worth it. The special thing about a double dong is that it is made for women by women. These devices were in the shape of a *V*, so that women could embrace, the clerk said.

"Embrace?"

"Yes, so they can embrace while they make love."

"Got it," I said, quickly pulling out my wallet. "I'll take one." I couldn't wait to impress Amie with this. I was pleased with my pragmatism, and pleased with myself. I mean, that's what chicks do, isn't it?

Amie saw my dildo come out of my bag and leapt across the bed. "No!" she shouted as she pulled the double dong out of my hands. I was speechless. Then, to my horror, she threw my two-hundred-dollar device across the room. It hit the wall with a thud and landed on the carpet. "You've had enough cock in your life!" she proclaimed. "You don't get any more cock!" Without warning, she shoved her fingers deep inside me. I grit my teeth as searing pain shot up me like fire. Then her fingers went all the way down, then in, then out.

I couldn't believe it. There was absolutely no difference between her and some dude. I tried to stifle my gasps of pain, to muffle the sounds with pretend enthusiasm as we kissed. She then grabbed my head with both hands and pushed it down, down, down until I was reliving an experience from when I was much younger. A head pusher? This woman? I couldn't believe it; I felt like I was in a sitcom. I started necking with her underpants, relieved to be going down on her, as she forgot herself completely and stopped with the finger penetration.

It was a huge lesson for me. I never thought it could be the same with a girl as with some aggressive guy. What I hadn't counted on was the one common denominator: me. I was very much a submissive girl and easily taken advantage of. This was a fact throughout my life, and I should have known that it would cross genders and gender preferences too. The worst part? I never did use my double dong dildo. After five hours of Amie climax-yelling, her post-coital almost-drowning snuggles in the bathtub, and my trying desperately to satisfy her intellectually, she bid me adieu. I happily went home to my dogs. I was grateful to Amie for my education and revelations that night. It was an important milestone for me.

# THIRTY-THREE

**POWER MAKES EVERYONE STUPID, INCLUDING ME.**
For example, I like to fantasize that I could have become rather snuggly with the handsome prime minister Tony Blair, having vacationed with him in Isla Mujeres one January. Well, maybe not *with* him. More like beside him. We were at the same resort.

I was with Peter and his new bride, the exciting and exotic Naz, on their honeymoon in January of 2003. Naz, commonly referred to as "the beautiful Naz," was a stunning Persian woman who turned heads wherever she went. She was a sweet yet dangerous individual, with a warm, infectious laugh, and military weapons training. She also had her real estate licence. She was the perfect match for Peter. They were soulmates. Naz and I had become very good friends during their twelve-month courtship leading up to the wedding, and it felt completely natural for Naz to invite me, along with my new neurologist boyfriend, to join them on their honeymoon in Mexico, where we headed the day after their massive wedding.

My boyfriend was a brilliant man, fresh out of a long relationship, and very innocent from my point of view. My own heart was still broken after splitting for the second time with my childhood sweetheart, George. What was worse was that I had broken his heart for the second time. George and I had been going in circles for some time, doing

the helpless dance that soon-to-break-up couples do, unable to repair what we needed to repair. We were drowning, just like in school when we first dated. It was a lonely time. And, in the end, I was once again attracted to a man who was the opposite of the man in my previous relationship. I was a girl who just couldn't be happy and, suddenly, my new neurologist boyfriend swooped in and took me away. I know it's clichéd, but I assumed my parents would be pleased that I was dating a successful doctor. But I was wrong. My father's response was "Beth, when are you going to be true to yourself and be in a relationship with a woman?" My father was convinced that I was a lesbian and not living my true life.

As I have mentioned, I love anything medical—medical language, hospitals, doctors, yes, especially doctors. My relationship with the neurologist was still very fresh when Peter and Naz married. I had taken him as my date to Peter's opulent second wedding. Peter and Naz were married in a Catholic ceremony, the sacrament performed by the family priest despite Peter being divorced. I think the Church figured that since his first wife was not a baptized Catholic, that marriage could be annulled. Catholic stuff is so weird. I wouldn't be surprised if Peter negotiated this point with the Pope himself. Peter's ex-wife, Nadine, and their daughters, Riley and Brittin, attended the wedding. Riley, his eldest, was his best "man." Then there was me, with my doctor boyfriend, and approximately two hundred other guests, most of whom spoke Farsi. What a scene it was! *My Big Fat Greek Wedding* had nothing on this production.

Peter and Naz had asked me to make a speech at their wedding reception, held at a restaurant overlooking the Pacific Ocean. I toiled over the speech, which included lines from Hafiz and Rumi. I delivered it in both Farsi and English, and to my great relief, pulled it off. Afterward, when Peter spoke from the podium to Naz, surrounded by

hundreds of guests, it was as if the two of them were the only people in the room. Naz just smiled her sexy smile, and my eyes dropped to the floor. Naz was pure sex and everyone around her blushed. She was gorgeous and radiant.

On their honeymoon, the four of us stayed in an exclusive wing at Villa Rolandi. It was one of those resorts with a private lagoon filled with yachts, and a restaurant with guest chefs and a few stars. An opportunity to stay at a resort on Isla Mujeres is not to be passed up! Like many resorts in the area, you could walk out of your room onto the terrace and into an infinity pool overlooking the Caribbean Sea. You could have all manner of things delivered to your beach bed should you decide to go to the private and topless beach. But people generally lounged by the pool, for hours and hours. Gorgeous, stylish people eating ceviche and drinking fancy champagne drinks under the hot sun. Among those around the pool was a Spanish actor and his lover, a writer from Boston, and several politicians from the United Kingdom, one of whom was rather dashing. Yes, his name was Tony Blair.

It was a carefree day. The sky, as always, was a perfect blue, and the breeze drugged you with its warmth. I lay poolside for long afternoons with unobstructed views of the lovely Tony. Me with my shiny black hair and shiny black tattoos and a shiny black bikini. Naz would laugh and laugh, watching me pretend to try to grab his attention. The more she laughed, the more I adjusted my small bikini top, to her delight. My bikini had little effect, as did the telepathic messages I tried to send as I squinted at him from behind the rim of my large black sunhat. He was completely unaware of my existence the entire trip. I was respectful of his privacy, of course. I totally understand politicians.

Thankfully, my boyfriend was also completely unaware of my attempts to send mental lust notes to the chic Brit across the pool. My boyfriend loved to drink away the days and nights, sampling from the

vast selection of fine wines on the property, and leaving me poolside with the bride. Naz's amusement at my attempts to catch Tony's eye only encouraged me, and I continued to try anything and everything to make her laugh, including doing silly walks and throwing drinking straws. I loved Naz and was moved by the romance she and Peter had. Indeed, I was captivated by her. Maybe my father was right after all.

# THIRTY-FOUR

superbeautifulmonster

**"ABANDONMENT," "LET DOWN", "FUNERAL OF A GOOD GIRL,"** "The World Is Over," "The Question Song," "That's Life." This was the soundtrack of the past few years of my life. After Lava released *Purge*, I had a lot of success in Canada, but things did not happen in America the way Lava wanted them to. The result was that I was dropped, abandoned, a letdown. Just like the songs on my new record following *Purge*, titled *Superbeautifulmonster*.

I loved Lava Records and everyone there. As I say, we were family. It was as close as it gets on a platonic level between record-label president and aspiring artist. But regardless of feelings, wishes, or dreams, I was out the door. At a time like this, an artist might find herself left out in the cold in terms of management finding her new projects, and the next step would be to gracefully fade from sight while younger, fresher bands and artists rose up. But Jonny Zazula took advantage of the guilt the company felt over ending my contract to negotiate the solution. I was sent on my way with a packed lunch bag containing the rights to my next album and a cash payout. I have so much respect for Jason Flom, the founder of Lava; to me, he was—and remains—a class act. I look upon every minute of our time together, in the music business and in friendship, as a gift.

Andy Karp was an important part of the group too. If Jason was

father figure, Andy was my big brother. This was my family and it felt like we had disintegrated. It was devastating for me, but as long as I had Jonny, Marsha, and Peter as my managers, I still felt cared about, supported, and loved. They always fought, dug, and pushed for me, taking every opportunity they could to continue my career along the musical path, no matter what.

In America, once you're dropped, you're damaged goods. Especially after releasing two high-profile albums and several videos by a hot music label such as Lava. When you're abandoned, you're considered to be washed up. Many things can contribute to hardships, such as radio not reacting quickly to a single—and suddenly this is a very bad thing. Or a major movie doesn't get the push or marketing from the distributor and *wham!*, your lead-off single and video are not getting added to a station playlist. When you release an album, it's all about set-up and momentum of the singles, and although many of my singles and videos were supported by radio and video stations in Canada, they didn't receive the same support south of the border. Your label can't be your friend, unfortunately, no matter how much you love each other: business is business.

I knew we still had the Pro Tools studio, so we could record and edit and mix right on our computer, as well as a great circle of musicians who were considered inner family. Doug Fury on guitar was key in the whole process of writing and recording the album, and Peter had been involved with many songs on the past albums, including co-writing, producing, and mixing several of the hits. We didn't have distribution, and we were now 100 percent indie all over again. Peter and Doug and I had to write a new record. It was a time of regrouping, reflection, and change.

Then, one evening in late January 2005, I found myself playing an acoustic set at a private corporate party at a restaurant in Vancouver.

Peter had been getting offers for weddings, funerals, prisons, you name it. There were a lot of requests for corporate events, which he hated. He was not ready to sell me out, not yet. An email came in saying, "We would like to have Bif Naked play at our office party at a restaurant in Yaletown next week." Peter turned to Naz and said, "I must have received five requests for Bif to sing at funerals and weddings in the past two weeks, now an office party in a restaurant four blocks from here!" He later told me he was so fed up that he almost threw his BlackBerry over his balcony onto the street below.

Sensing her husband's frustration, Naz calmly said, "I have a good feeling about this, so write back and see if you can book it." Peter wrote back, asking for a very large fee for a thirty-minute acoustic set that would include his daughter Brittin on guitar, Doug Fury on guitar, and drummer Scotty Sexx on the congas. Fully expecting to be told that this was way over budget, Peter was surprised when the person emailed back and said to please send over the contract. And that's how we met Calvin.

At my performance—the office party, as it turned out, was a party for Calvin Ayre of Bodog.com, the boutique online gaming company—Peter stood beside Calvin and the two of them started talking about a joint venture between HRM Records and Bodog, to create Bodog Music, and also to form Bodog Entertainment, encompassing Peter's other entertainment companies.

Two months later, Bodog Music was launched, and I was back on the road doing tour dates, videos, television, and interviews. Peter opened a Berlin office with Jörg Hacker, who had left Sony the year before; a London office; and an office in New Jersey with Jonny and Marsha. It was an incredible time. Bodog Music was kicking ass and taking names—it had the capital to send bands on tour, a wonderful thing and a rare opportunity for many artists. I was once again

resurrected, pulled back from the brink, the precipice, saved and redeemed. I was embarking on another exciting rollercoaster ride. Only this time, it was Peter behind the wheel 100 percent, and driving at a deadly high speed.

# THIRTY-FIVE

bodog battle

**JOHNNY ROTTEN SNEERED AT ME AND I SMILED BACK.**
Johnny was a red-headed firecracker, hurling obscenities and spitting
when he spoke. And, Johnny made me cry in front of thirty people in
a quiet room, on film. It was fucking brilliant television, apparently.
We were shooting a reality-TV show together, along with The Cult's
Billy Duffy, called *Bodog Battle of the Bands*, a talent contest with
celebrity judges and a one-million-dollar recording contract awarded
to the group considered the best live band in America. Peter Karroll
had created and packaged it, much like the other television shows
he created at Bodog Entertainment, Bodog Music's parent company.
*Bodog Battle* was destined for America's Fuse Network. The bands
would compete through tasks and performances, travelling all over
the United States on tour buses to play in clubs and other venues,
everyone fighting tooth and nail to win the *Bodog Battle* recording
contract and a lot of publicity.

The promotion for this television series was huge, larger than any-
thing I had experienced. Peter arranged for a giant billboard in New
York City's entertainment district, with a photo of a rock guitarist
standing on top of a tour bus, the roof of the vehicle blazoned with the
words "Bodog Battle." Everything at Bodog was supersized—includ-
ing the gorgeous "Bodog girls" and the parties Bodog was famous

for. Calvin Ayre was the founder of the Bodog brand, and Peter ran the entertainment divisions, and the music, television, touring, and live events, using our record label, Her Royal Majesty's, as the infrastructure for Bodog Entertainment. "Why reinvent the wheel?" Calvin would say. Calvin would also say, "You can build it, rent it, or buy it," and in this case Peter and Calvin merged it. I really liked Calvin; he was a real man, as Peter used to tell me. Calvin had balls of steel. I'm assuming Peter was referring to Calvin's business acumen.

Calvin was the final judge of the final episode of *Bodog Battle* and rightfully so. He essentially put up the money for the production so that he could see Bodog become the broad entertainment brand he hoped it could be. But prior to that final episode, the celebrity judges had a roundtable at the end of the performances section of each episode, where we discussed our favourites. Usually, this was quite jovial; even our debates were playful. Unfortunately, my opinion differed tremendously from Johnny's, and on that specific day, he went over the Johnny Rotten top and really let me have it.

I felt too humiliated to argue or retaliate. I just looked at my feet and hoped my tears would fall straight to the floor rather than across my face, ruining my TV makeup. I wanted to die from shame. The bottom line was that I just wanted to do a good job and help Peter and Calvin with their show. It really was that simple for me.

True to reputation, Johnny was not going to waste one second before telling me I was a "glorified groupie whore" when I disagreed with him over which band to axe. I felt like I was hit by a shotgun blast.

I wasn't a groupie or a whore but I did feel completely discredited, belittled, and diminished in front of the cast and crew. I think everyone in the room was shocked, including Mr. Rotten himself, when my big, slow tears made an appearance. In fact, they stole the show.

Billy was clearly embarrassed for me, but Johnny couldn't back down in front of everyone, and I understood that. I ate my feelings and let him savour his triumph. Naturally, I got scolded by Peter, and by Jonny and Marsha too, for letting myself be such a victim; they wanted me to stand up for myself. But it just wasn't in me, and I was crestfallen by Johnny's remark. Nevertheless, I pulled myself together and the shoot wrapped. Johnny and I pretended it never happened.

The rest of the episodes were more enjoyable. The shoots took us to Austin, Los Angeles, Toronto, among other places. Every band played earnestly, with all their hearts. It was impossible not to get wrapped up in each band's story, in their triumphs and failures, in their lives. I loved the show and I loved being a part of it. It hadn't been that way in the beginning, though. When I was asked to be on the panel, I had only two days to get myself to Cleveland, Ohio, and was panicking about my dogs. I mean, I had just got home from being on the road shooting *BodogFight*, another of Peter's inventions, and had just moved into a new apartment. I was stressed.

My dogs had been my life for all these years—ten and counting—and I carried around so much guilt about leaving them whenever I was away for work. I took them with me when I could, but that wasn't often, as they couldn't come in the airplane cabin, both being over the weight limit, and so were relegated to the cargo hold—which was not an option. So I was stuck.

As luck would have it, I had just started seeing a guy after five years of being single (my neurologist boyfriend, as it turned out, was not cut out for a relationship with a travelling girl), and he offered to stay with the dogs. I was sold. What a mensch! I was so relieved, I decided right then and there that I was in love with him. With my dogs taken care of, I was free to fly all over the United States to film the show and do my best to assist the bands, the producers, and, most

importantly, Peter. Free to be myself and get to know my co-stars, I was in my element.

Johnny Rotten was not really that rotten after all. The final episode was shot in Vancouver. Calvin chose the winning band and presented it with the recording contract, and I was able to relax and go home to my new apartment, for about a minute anyway.

# THIRTY-SIX

I MET IAN WALKER INNOCENTLY. I HAD MY EARBUDS shoved in my ears during my workout at the gym when this cute surfer dude in flip-flops bowed to me and mouthed the word *namaste*. He was doing bench presses and smiling and waving at me in the mirror as I stood there, trying to get through my supersets of front dumbbell raises, and completely oblivious to him at first. Then I noticed him waving at me. It was kind of annoying and adorable at the same time. But really I just wanted to finish my workout. When he eventually came over to talk to me, I got the impression that he was just a regular guy. Besides being cute, he was funny and respectful, and the best part was that he had never heard my music or seen one of my videos, or so he said.

Although I politely refused to go on a date with him, in part because of my schedule, I gave him my telephone number anyway—I didn't want to hurt his feelings. He called twice, asking me out. I declined, again because of my schedule more than anything else: I was halfway across the world, in St. Petersburg, Russia, shooting the television series *BodogFight* with MMA heavyweight champion Fedor Emelianenko. Ian was persistent and even went so far as to call me at my hotel. I asked how on earth he had found me, at the Kempinski, and he said, "I'm a reporter, it's what I do."

Our conversation was short, as I had a set call at five o'clock in the morning, and he'd called at about four. I was not impressed with his timing but quite charmed that he had gone to the trouble. His persistence was endearing.

Having dated MMA fighters and bodybuilders, and having a history with athletes and sociopaths, I felt I might have more in common with someone like Ian, who was a gym rat, a Vancouverite, and a bit of a hippie like me. We even looked alike and were about the same height, which I thought was sweet. And he seemed to like me for myself, not for being Bif Naked. Plus he was physically fit, easygoing, and not a musician, which made me assume that he wouldn't be competitive about our respective careers.

The fact that he continued to maintain that he'd never heard my music or seen any of my videos or live shows made my manager skeptical. "In Canada? In Vancouver? He's a sports writer? He listens to CFOX and he's never heard your music or heard of Bif Naked?" Peter laughed.

I am pretty gullible, and if anyone knows this, it's Peter. Peter had had to troubleshoot my love life from the get-go. He has physically removed more male invaders, stalkers, and snake-oil salesmen from my presence than I can count. He has removed them from the front of the stage as they climbed up, from the dressing room as they talked their way in, from the autograph lineup where they jumped in front of the young girls who were waiting patiently, from the tour bus, from the washroom, from the parking garage, from the airplane aisles, from my vehicles, and even from my apartment. Therefore, Peter definitely had evidence that I could sometimes be a bit gullible.

On my first date with Ian, after I returned to Vancouver, we went to see the stage show *Aladdin*, starring Bret "The Hitman" Hart. As luck would have it, Peter and Naz also had tickets, so we accompanied

them and two of their daughters, still very young, at Peter's sugges-
tion. This was a safe situation for me, so it was easy to agree to it. The
girls took a liking to Ian right away, from that point onward always
referring to him by his full name: "Is Ian Walker coming over?" It was
sweet, and Ian seemed more comfortable with the little kids than he
was with the adults. The girls recognized Ian's childlike qualities and
loved him for it. In their eyes, he was like a comic book character, and
he was funny.

By the spring, we were engaged to be married. Ian had asked Peter
and Peter's father-in-law, Afshin, for my hand. They both decided this
was a fabulous idea, and the champagne flowed. It was so perfect that
I started to fantasize about having babies. I wanted to be a mom; I
was thirty-six years old and it was time. But my history was daunting.
I mean, what if I couldn't even get pregnant? What if something was
wrong with me? I had not had a period for years, had night sweats, and
zero sex drive.

But now, engaged again and romanticizing about having a baby, I
wanted to investigate my potential for getting pregnant. Never mind
that I had resigned myself long ago to the idea that God would never
give me a baby because I had terminated a pregnancy years before.
I never forgave myself for having an abortion, and I felt that the
universe didn't either. I thought it must be karma. Why else would
I have never got pregnant again? Like, not ever? How weird was
that? None of my boyfriends ever even wore condoms when we were
together. My generation of girls grew up on the pill, and we never
used condoms, ever. And now I wanted to find a way to have a baby.
I knew it was a huge undertaking but decided to go for it. I told my
GP about my absent period, asked for a referral to a specialist, set up
the appointment, and then braced myself for the long wait to see the
OB/GYN.

It seems that there are many women my age who have trouble getting pregnant—every second couple seems to either be on fertility drugs or having triplets as a result. No matter, I was ready. When it finally came time to see the specialist, I sat in the exam room, staring at the greyish walls. I looked at the magazines, at the pile of folded blue gowns, at the boxes of latex gloves affixed to the wall, sizes small, medium, and large. I wanted to steal some for chopping beets. I shifted in the plastic chair. I pulled my hoodie sleeves over my hands, looked at the stirrups of the exam table, and shuddered.

The door opened. She was sorry to keep me waiting, the doctor said, followed by an "ahhh!" before she was even fully through the doorway. Looking me up and down, shaking her head, she said, "Come back when you're serious."

"I'm sorry?" I was floored.

"You're too skinny; you will never get pregnant."

She was now seated, looking over my file. "Look, Ms. Hopkins, you're wasting your time, and you are wasting mine. Go gain twenty pounds, and come back to see me when you're serious."

"But I am serious. I'm getting married, and I'm thirty-six years old."

"You don't look serious; you look like you need a turkey sandwich."

"I'm a vegan."

"Then you'll never get pregnant, I'm afraid. If you want to get pregnant, you're going to have to eat some dairy and a little meat."

I stared at her.

Her face softened. "Listen, I'm not trying to burst your bubble, but vegans have a lot of fertility problems. Given your age and your body fat, well, it is highly unlikely you will get pregnant."

"I get a lot of protein and fatty acids from my food. I'm a raw-food vegan," I replied.

She rolled her eyes. "Well, I see we have a real effort on our hands, then, don't we?" she said.

Usually, there is no use explaining vegan diets to doctors if they are meat eaters. I just sat there watching her and her French manicure. I was no longer listening, instead trying to think about what I would make for dinner.

She told me I needed to get bloodwork done, then paused and looked at me. "He is going to have to get tested too."

"He eats meat," I said. I thanked her for her time and left with my lab requisition.

When I was in town for a few weeks in a row, I went and got the tests done—the pelvic, the pap, the bloodwork, the works. I was into it and enthusiastically went for the exams. I wanted a baby, and I thought about it constantly. I still wanted to adopt a baby as well, given my karmic responsibility as an adopted kid. But this was different.

Eventually, the doctors needed structural imaging of my lady plumbing, a hysterosalpingogram, a special X-ray using contrast dye, to look at the structure of the fallopian tubes and uterus. But before doing the imaging, they needed to be sure I was not already pregnant, as the test could cause irreparable damage to an unborn child. So I was sent for bloodwork the day before to determine if I was pregnant.

I was very much looking forward to any insight that might be gleaned from the hysterosalpingogram, which I had the next day after the staff checked my chart. The X-ray itself took no time at all.

The rain was light and the sky was light, a pale grey, almost transparent, like the colour of tracing paper—my favourite weather. I sat in my car, a small black Mercedes I had had for a couple of years. My cell phone rang; it was the doctor's office.

"Beth, you're pregnant."

"I'm sorry, can you please repeat that?"

"You're pregnant, Beth. Don't go for your hysterosalpingogram. What time is your appointment?"

"But that's impossible, I can't be pregnant. I just went, I just had my appointment." I was stunned; she had to be wrong. Or had there been some kind of mix-up?

"Well, your numbers are elevated on your bloodwork. I'll order another requisition, and you go back to the lab on Monday and we'll see." Her voice flattened, then trailed off.

I couldn't believe what she had said. There was no way I was pregnant. I was skeptical though happy, but afraid now because I had had the X-ray.

I still had to work. I had to fly to London for a day for an appearance, then race back home for a promotional trip to the States. My schedule was relentless. Exhausted and in full makeup, I arrived in London to find that my breasts had basically grown over the Atlantic. I already felt like a cartoon character. They grew again in the cab, on the way from Heathrow to the Sanderson Hotel. I knew the lobby would be packed with our European record-company people, and I had an entrance to make. It looked like I had got a breast job, and I thought that was pretty great. Let's be honest: it looked good on my skinny body. I often joked that I looked like an eleven-year-old boy wearing a bra stuffed with tissue—my C-cup days of the Chrome Dog era were gone now that I was some twenty or thirty pounds lighter—so this was like a small dream come true.

Time went on, and my breasts kept growing, and I was feeling pretty special. I was beginning to get excited, and fantasized about everything from baby names to learning ASL, in case my new baby wanted to sign with me. I started poring over books on how to bring up a baby as a vegan, and looking into prenatal yoga, doulas, and

water births. I was in love with my baby already. I was so into being a mommy.

And then, twelve weeks later, I began bleeding, and it never stopped. I knew it was game over. I was so disappointed. I cried, sitting there on the toilet, knowing all was lost.

# THIRTY-SEVEN

**DREAMS ALWAYS COME TRUE, JUST NOT ALWAYS HOW WE** expect them to. Certainly, I had been caught up in the short pregnancy, and utterly disappointed that it simply was not meant to be. But, luckily for me, I was still The Girl of Someone's Dreams.

Television was the Great Suitor, and me, a ready and willing bride-to-be.

Peter was wrapping up multiple seasons of *BodogFight*, and the first season of *Bodog Battle*, and he was looking for some situation video content for the BodogTV website. With cocksure swiftness, Peter's social media team came up with the title *Bif Naked Bride*. Ian and I were to shoot short episodes of our lives, from engagement through the wedding planning and into the wedding itself. Eight episodes in all were launched on the Bodog YouTube channel and on BodogTV.

Ian was a natural, and he loved the camera, the antics, and the opportunity to be showcased with his rock star fiancée. Performing in front of a camera can be heady stuff, and I've seen a lot of people start to grow major egos when they get a bit of attention, deserved or not. I think Ian was pretty natural in his role. We played up the regular-guy-meets-rock-star angle, and the directors and producers thought it was pretty funny stuff. I often played the straight man to his antics. I

was the mommy and he was the boy ready for adventure. He was an extreme-sports writer for the *Vancouver Sun* and I was a touring musician. Two polar opposites—perfect sitcom material.

By the time we got to the wedding day, in late September 2007, it was a media circus. It was truly the wedding of my dreams. My first wedding had also been the wedding of my dreams, but now my dreams were bigger and better. I wore my custom-designed dream gown, which had a long, hot-pink veil and an Indian influence, and traditional Indian jewellery. The beautiful ceremony took place in a huge United church in the heart of downtown Vancouver, St. Andrew's-Wesley, and I was surrounded by family and friends. Ian had invited close family and some of his newspaper colleagues.

The reception was held at Maurya, an Indian restaurant with a celebrated chef from New Delhi. Our amazing friend and wedding planner, Soha Lavin, had transformed the place, now dripping in vibrant orange and pink flowers, and the music and smells were intoxicating. It was all exotic and sensual.

The happily-ever-after ending was perfect, and it was the final episode of *Bif Naked Bride*. National and local news cameras were lined up outside the restaurant. Ian was living life to the fullest, enjoying his new-found fame.

Calvin Ayre was such a generous friend. He wasn't able to attend the reception but sent us a special video message, congratulating us. Moreover, Calvin in his generosity had picked up the tab for the wedding. Peter had convinced Calvin that the price tag on the wedding was a small production cost compared with those of the bigger TV shows such as *BodogFight* and *Bodog Battle*. Calvin loved the idea. I was blown away by it all.

A strange thing can happen to people when things come easy. If you watch the *Bif Naked Bride* episodes on YouTube, you can see that

this show was a full production, with multiple cameras, sound, lighting, scripting, editing, voice-overs, the works. It was packaged and released with a full press and media push. It was incredible. As a performer, it was easy for me to put this all in perspective, and I've come to understand that TV, albums, tours, awards, and so on are all just episodes in my life, business as usual, the day to day. I call it my day job. For Ian, however, this was something new and completely different, and it was bringing on a change in the boy.

Ian is a natural extreme performer, pulling stunts for his newspaper column and then, later, for his blog. He would put himself into ridiculous situations and report on them for the paper, such as trying out for the BC Lions, or enjoying dressing-room shenanigans with the WHL's Vancouver Giants and with the Vancouver Canucks, or traversing the side of a skyscraper dressed as Gene Simmons from Kiss. This was hitting full stride during the well-publicized *Bif Naked Bride* production, and his being filmed for the show. I realized that my sweet, low-profile, humble fiancé who had never heard of me or my music was beginning to live *la vida loca* and to eat, sleep, and breathe the show and media attention.

Who was I to deny him his fifteen minutes of fame? As long as he could handle the ups and downs of the entertainment business, what could be the harm? He had the rock star life, the rock star Internet show, the rock star everything. But I was lonely. What we needed was everyday intimacy, love, affection, respect, more than the rock star existence. I wanted that regular guy back.

The wedding came and went, the show ended, and we went to Mexico. As a wedding gift from Peter, we were put up in a romantic, über-cool, and private condo-hotel on the beach in Playa del Carmen. And we fought. I began to have the terrible feeling that Ian didn't think much of me at all.

When we returned from the honeymoon, in October 2007, things were different from how they had been before we married. Ian seemed different. So, as per my modus operandi, I began to overcompensate and become the mommy in the relationship, just like in the *Bif Naked Bride* episodes. And as part of overcompensating, I did everything to regain that feeling we had pre-ceremony. I wore sexy clothes, bought new lingerie, walked around the apartment naked in high heels and full makeup. But the show was over and, though I didn't realize it at the time, so were we.

# THIRTY-EIGHT

WITH THE MEXICAN HONEYMOON BEHIND US, I WAS GRATEFUL to be reunited with my dogs, and was kept sane and sound by my dear friends. I resumed my work plans and was happy not to be travelling before Christmas. I was making Christmas cards to send to our wedding guests, continuing with my daily workout, and even considering discussing again with the good doctor how to get pregnant. I threw myself into my routines and forgot about my fears for a couple of weeks, determined to be committed.

Then, one night, just after I had crawled into bed, I found what felt like a chickpea in my left breast, on the upper left side.

I had never done a breast self-exam because my breasts were always a bit lumpy. Who could tell what a lump was supposed to feel like? There was nothing *but* lumps. But this one was different. It was a lump-lump, and I knew it the minute I touched it. I had never been so certain of anything in my life. It was a tumour.

The noise of the television drowned out my gasp.

I made an appointment the next morning to see my doctor and went straight there. My GP thought that the likelihood of the lump being cancerous was slim. I was young, I was athletic, I was a vegan—there was just not much chance, he said. I understood what he was saying and I even agreed with him, but still I knew it was breast cancer.

I simply accepted it, and kept it to myself. Until the doctors are sure, you can't really announce it to your family or friends. It's like telling people too early that you're pregnant. It's better to wait to make sure. So I sucked it up. But it was the strangest thing: I had no real fear about it. I didn't really care either way. I could take it or leave it. I was a bit depressed from my isolating and lonely job of being Bif Naked, and I actually kind of hoped it'd kill me. Going for mammography was just a formality.

I was not anxious about the mammogram; I knew what the results would be. Ten days later, I was back at the same medical building I had frequented only two months before, when I was trying to get pregnant.

The mammogram machine sounded like a winning slot machine in Reno, ringing and dinging. To me it seemed like the whole thing lit up, bells ringing and whistles blowing, coins coming out the slot. It was like a Ren and Stimpy cartoon, and I was simply watching it. There I was, in my thin blue gown tied at the back, immobilized by this machine, and the technician clucking like a hen. "Miss Beth, just hang on, we are going to do another picture. Just step back, dear, we are going to get you in there again." I stepped back and my throbbing red boob felt like a wounded mouse sprung from a trap.

The technician motioned me back up to the machine and positioned my breast again. As the plates flattened my breast, she mashed and kneaded it, stuffing it in between the plates. Then she manually tightened them, further and further. "You okay?"

I was holding my breath. "Yep, you bet." I smiled at her, being as cooperative as possible. My breast was flattened and it hurt a great deal, but I sucked it up. I knew the doctors need an accurate image, though I knew what they would see.

The technician ducked back behind the shield and the beeps and breath-holding requests commenced. In between the shots I couldn't

help but yawn. I just needed to get this appointment over with and get back to my car, parked at a street meter. Instead, I remained in mammography the rest of the afternoon while the technician checked and rechecked each side of my left breast and each film.

The radiologists one by one poked their heads into the room to take a peek at me. Less than 10 percent of patients screened have a suspicion of cancer and certainly not many in their thirties, so they were being looky-loos. Plus, whether I liked it or not, it was Bif Naked who was lighting up the bells and whistles of the mammography machine. It probably really broke up the week for everyone.

Finally, the exam was finished. "You're going to have to wait in your gown," the technician said. "There's been an opening for ultrasound across the hall." The doctor wanted to see me right away and sneak me in between a couple of other patients.

The ball of the ultrasound probe rolled back and forth, up and down, then over and over, back and forth, pressing harder each time. The technician paused and concentrated on one spot. I didn't need to look. I knew it was the tumour. "Beth, I think we need a biopsy."

"I know," I answered, almost bored.

"Let's get you dressed and get it booked for this coming week."

I told her that I was off to Winnipeg for a few days and asked if we could do the procedure when I was back. I got dressed, quickly doing up my cardigan buttons and tying my shoes, but to no avail—my car had been towed while I was in the mammography clinic. What a day.

I went to Winnipeg as planned and didn't think much about the upcoming appointment, but just before I left to head back to Vancouver, I did tell my mom about the possibility of the biopsy results. She listened intently, nodding quietly. I told her I wasn't panicking and I would let her know how it went. She asked me to call her right away once I knew, and she told me she loved me. I hugged her and told her

I loved her right back, and promised to call. Then I flew home, for my appointment the next morning.

And that's when I had the harpoon, the core needle biopsy. The syringe had a snapping motion, like the piercing gun used when my friends and I got our ears pierced in the mall in Lexington when we were twelve. *Snap!* The spring-loaded needle extracted the smallest amount of tissue from my breast. It hurt immensely. I don't remember getting even any local anesthetic.

"Got it," the technician said to another technician, taking only one sample. I think I yawned again, mostly for their entertainment.

"You can get dressed," the first technician said as they both left the room. There was a small bandage over the biopsy site, which was bleeding a bit.

Fuck it hurt. I was given the brown paper bag before I even got my coat on. "It will actually get there faster if you drive your sample to St. Paul's yourself," I was told.

"I can drive my own sample there?" I was surprised.

"Just ask for pathology and they'll tell you where to leave it. The sticker here has your name and your patient ID."

"No problem!" I happily took the sac and drove to St. Paul's Hospital, on Burrard Street. I parked, entered though the side doors, and followed the line painted on the hallway floor to the pathology department. It was filled with people waiting. I looked at them all and they all looked back. I left the sample with the receptionist and walked back to my car. I didn't give the biopsy another thought.

Four days later, my GP called me, asking that I come to his office. I knew what he what he was going to say.

"Beth, you have breast cancer."

"I know," I said right back to him. My doctor was even, and I respected him a great deal. He made an appointment for me to see the

breast surgeon at the cancer centre, for about a week later. I thanked him and made a follow-up appointment with him. Outside, all I could think of was getting back into my car before I lost my shit. If I was going to cry, I really wanted to be in the car.

But I didn't cry. I couldn't. I simply was not fearful or sad. But I did have to tell my mom, and my dad, and Peter and Naz; they could all take it from there. The news spread like wildfire. There were family dinners, dinners with my girlfriends, dinners with my manager's family, and yet more dinners. I wasn't broken up about the diagnosis, but it wasn't fun. I was not this fun girl; I had cancer. For Ian, a new wife with cancer was like a new puppy getting lots of attention and advice.

I felt pretty excited about my first appointment with the surgical oncologist. She was in running shoes. Clearly, she was a runner, an athlete. I was impressed. She sat down and looked at me sitting up on the exam table. Ian was sitting nearby in a chair. She put her hand on my arm and said, "Beth, you have breast cancer"—although, of course, I already knew this. Then she turned and looked at my new husband and said, "Your wife has breast cancer. She will lose her hair."

The three of us were silent; her words hung in the air. The room was way too quiet for me.

"It's okay, doc!" I happily chimed up. "My husband's an ass-man." I started snort-laughing and slapping my knee. Silence. She was surprised. After a short pause, she laughed.

We talked about mastectomy and I told her to just cut off my breasts, both of them, and she said the outcome would be the same with radiation and chemo, and that the doctors would determine the best course of action after more testing. So I signed up for whatever she thought was best. She was the doctor, that was my bottom line. The rest would work itself out, or I would work it out, but she was the boss, I figured. I didn't have years of medical oncology training; she did.

That night, at home getting ready for bed, I sat in the bathroom with a hand-held magnifying mirror and pulled out every single eyebrow hair I had. I plucked them all, one by one, like that guy in the Pink Floyd movie *The Wall*, in the scene when he's digging in his face in the mirror. I was determined to get rolling with the appearance so that it wouldn't be weird for me. I was going to control it. My longtime friend and hairdresser, Van, cut my hair into what will always remain my favourite haircut, the one we decided on and the one I controlled. It was liberating and empowering. My transformation was beginning, and I was up for it. Somewhere along the way, my attitude had changed. I didn't want the cancer to win. I was ready. I had to be.

The next month, including over Christmastime, I went through a series of tests. It was a full-time job, busier than my regular job. A body covered in tattoos is definitely something many of the technicians and nurses were not familiar with. And my body piercings were not exactly compatible with many of the machines used for testing. Many girls in my senior year of high school had had their belly button pierced, and I was no different. I wore a belly chain attached to the piercing. I'd had a belly ring pretty much as long as I'd had tattoos. It was just a normal piercing, nothing too crazy.

I'd had my nipples pierced many years before, both of them on the same day, not seeing the point of having only one done. I had been so pissed off during an argument with Peter that I marched right down to the piercing shop and got the two rings. "That will show him," I thought. That will show him? Genius. The rings always hurt. To maintain them, I had to put alcohol and soap on them, turn and wash them, then pat them dry. I had to baby them for months and they never seemed to heal. Although I was happy with how they looked, and with the reaction the double nipple piercings generated, what motivated me to get them in the first place—to somehow punish my manager—was

perhaps not well thought out. Peter had laughed and said, "Maybe you could tie a string on them and I can pull it to get your attention."

When I went for an MRI back in the nineties after having mini-strokes (it turned out I had a patent foramen ovale—essentially, a hole in my heart), I had to take out the rings. You can't wear any jewellery in one of those machines. They use incredibly strong magnetic forces and there's a risk that the jewellery will be quickly ripped clean out of your head, or nipples, or belly button. In reality, it's more likely to overheat. But either way, I was happy to remove the nipple rings, and I didn't put them back in. But two years later, I decided to wear nipple jewellery again, except this time I chose dainty little barbells, rather than rings. They never hurt, and I thought they looked much better.

I was inspired to wear them in part because of a strange sequence of events. I was dating a guy who ended up being a fantastic boyfriend, except he had a secret. The secret was his other girlfriend. She looked like a cross between a porn star and Brigitte Nielsen, and she wore small diamond-tipped barbells in each of her chocolate-chip nipples. They were magnificent.

How do I know about her barbells? I had made them both—my boyfriend and his girlfriend—a nice dinner in my apartment. He had been my boyfriend for a month or so; I'd met him at the gym, and we'd gone bowling on our first date.

He was a bodybuilder, which was perfect for me because I was a gym rat and loved the gym culture. He had a platonic training partner, an incredible female bodybuilder, and they were inseparable. She was sweet and funny and kind. Shortly after he and I started dating, she suddenly moved to Los Angeles, for the training opportunities there, apparently. But the truth was that she was heartbroken that he was dating someone else. My boyfriend was secretly madly in love with her, so when he eventually confessed this to me, simply spilling the beans

one night in bed after snuggling with me, I hugged him and insisted he go after her. I assured him it was the right thing to do. I probably had known it deep down all along anyway—she was almost all he ever talked about. He was relieved that I wasn't upset, and he was so excited that he left that same night for California to go after his true love. They called me a couple of days later, and we promised to have dinner together upon their return.

Being the perfect ex-girlfriend, happy to celebrate their true love, I offered to host the dinner. It turned out to be a relaxed, enjoyable evening. Until I almost dropped the plates I was clearing off the table.

"What are you doing?" I asked. He had come out of the bathroom, naked.

"I want to share her with you, and I want to share you with her," he said quietly, in all his bodybuilder nakedness.

"We just want to show you our appreciation for bringing us together," she said.

I felt like I was in a sitcom.

I scurried away and began scraping the plates. "Oh gosh oh gosh oh gosh," I said, then laughed politely. "It's so not necessary, I totally understand. You are most welcome!" I turned on the tap to fill the sink with water. I wanted to die of embarrassment.

He walked into the kitchen and touched my arm. "Beth, please, let us do this."

He was such a nice boy, how could I be rude? I shut off the tap. "Well, maybe for a minute . . ."

After spending as much time with them as I felt would be courteous, I bid the happy lovers a good night and left them in my bedroom, going to sleep with my dogs in the guest room. I had bailed as fast as I could. Besides, nothing beats snuggling between two little fluffy dogs.

...

Christmas was weird and everyone cried a lot. I tried to make them feel better, tried to reassure my family and friends that I wasn't going to croak. I was good at this because of all my training as a performer and having a show-must-go-on mentality. It was easy to lie. I had been practising my whole life.

Peter and I discussed things and we decided we should make a definitive "Bif Naked has breast cancer" statement. Already the word was out. A couple of national newspapers had called, asking Peter if it was true. I marvelled at how news spread.

We had a saying we thought was funny: "Tits and tattoos are all you need to get media attention," and once again it appeared to be the case. I found it interesting that breast cancer seemed to get more attention in the media than other types of cancer. More frightening for people, more dramatic, and more of a story. It was showbiz, and soon it became clear to me that both the world and the medical waiting rooms were a stage. I was actually quite embarrassed about the whole thing and felt that I had to hide this and instead put on a show. People love a good drama, and they *really* love a good comedy.

Peter had arranged for me to speak about my breast cancer on George Stroumboulopoulos's radio show, about three weeks before I was to start chemotherapy. It was to be the one and only time I would speak about it. I had first spoken on the radio with George many years earlier. George is a good guy and well respected. If there was only one interview where I would come out about the cancer, George would be it. The national papers ran the story. I was quoted as saying how happy I was that it was me and not my mom or one of my sisters who had the cancer. Peter was quoted as saying, "She has shown a lot of

strength and courage. When she is feeling sick, she won't be doing much. And when she's not sick, she'll be working." And that was the truth. I was deeply grateful for my having breast cancer instead of anyone else in my family having it, and I did work a lot, right through chemo. In fact, I never stopped working.

I was to go to nuclear medicine, where I'd be injected with a radioactive fluid in the armpit for lymphatic mapping. The doctors wanted to find the lymph node the cancer would sneak off to first—this node is known as the sentinel node.

"Sentinel?" I chirped.

"Yes, sentinel. The first one. The one the cancer is most likely to spread to first," the doctor doing the procedure said.

"Just like the Judas Priest song!" I announced enthusiastically. To my disappointment, no one in the room thought I was all that funny. But I remained undaunted. I started singing my best rendition of the Judas Priest song "The Ripper," in the highest voice imaginable. I thought this was an incredibly funny offering, and I was laughing like a hyena. Nothing. No reaction. The medical team became even more serious. I settled down, trying to compose myself and feeling suddenly shy. Did they assume this was nervous laughter, like little kids get? They had never met me before, so how would they know that I can bust out a metal song and whip my hair in a grocery aisle too?

The injection seemed like it would be simple enough, no problem. After all, how bad could it be?

I think I let out the loudest "Ow!" I have ever said in my life. It hurt so much, I could not believe it. The tears shot straight out of my eyes and into the doctor's face. I was quiet the rest of the day, including throughout the scanning procedure that followed the injection.

Soon afterward, my surgery day came (I was having a partial mastectomy, often called a lumpectomy), and so did my girlfriends, Denise,

Kari, Mindy, and Nina—my home girls, my posse. The only ones missing were Lola, who was in school; Gail, who was in Rhode Island; and Louisa, who was in Spain. These girls were my people. We had history together and had shared practically everything together over the years, the way girlfriends do. We were family. They all wanted to come inside to the surgical area and wait with me in recovery. But they were not allowed beyond the double doors.

I always felt a tremendous responsibility to be positive and entertaining, no matter what—I always had my game face on. You're not supposed to wear makeup or jewellery during surgery, but I always wore a little makeup, and this day was no different. I mean, I had plucked out every last eyebrow hair that first day I had met with the surgeon. I had no eyebrows whatsoever, and if I didn't wear some makeup, I would look like a fat Marilyn Manson, a Goth wannabe, and not a hot Goth either, just a frumpy one with no eyebrows. None of the staff at the hospital seemed to notice I had drawn my eyebrows on, and they didn't seem to make one bit of difference to anything.

I was out of it, recovering from surgery, groggily watching the doctors and nurses interact with one another and with the other patients. I couldn't talk—I was still half asleep from the general anesthesia. I felt numb yet shivered violently. A nurse covered me with warm blankets, replacing them one after another as they cooled. "We vegans are always cold," I said quietly to the nurse. She just smiled. I asked if she knew what I meant, and she laughed and told me that I hadn't actually said anything—I had imagined I had spoken to her.

Based on the pathology tests done on the tissue removed during my surgery, the doctors staged the cancer and determined whether it had spread to the lymph nodes, and also assessed the tumour's hormone sensitivity. They found invasive ductal carcinoma of the left breast. I was estrogen receptor–positive, progesterone receptor–positive, HER-2/

neu–positive. In other words, not cool; the cancer was fast-growing and aggressive. But I was very lucky that the sentinel node was clear, and that none of the nodes was positive for malignancy. Once the doctors had figured this all out and staged the cancer (putting me at stage two), they could determine what chemo cocktail I needed, and whether I would also need radiation, which I did. They could pretty much know whether or not I'd survive a couple of years, they said. They were all hoping for the best.

I wanted all the details tattooed on my chest, or at least my patient number, or something. I liked being able to name the cancer. I liked knowing that stuff and, once I was home from the hospital, began studying like crazy—finally, I was putting my MCAT guides, medical dictionaries, and medical textbooks to use. I was also concerned that somewhere, somehow, animals had been used in the testing and had died for me, and I was distraught about that. My parents suggested I do whatever it took to survive cancer and follow the doctors' advice, and also pray a lot. I always felt guilty, but the love for my parents was bigger than my guilt, and I wanted them to be hopeful. From the day of my diagnosis, I decided to offer myself for any and all experiments so that maybe some animals could be spared. Even if I was deluding myself, somehow I had to put it out there that I wanted to be available for experiments. It is not that simple to become involved in clinical trials, but I knew I was contributing to making a difference if I signed up for them, so I did. The one I was accepted into was on exercising during chemotherapy and was headed up by the doctor who would come to be my own oncologist.

The week following the surgery, I was scheduled to have a surgical port inserted, as the doctors were anticipating I'd have seventeen infusions, one every three weeks over the next year or so: six cycles of chemotherapy followed by eleven cycles of antibodies/immunotherapy.

Radiation, twenty-eight treatments in all, was to start after the first six chemo treatments. The chemotherapy could damage the veins and heart, and the surgically implanted port would help protect against this.

"Oooh, I loved my port!" my friend Nina exclaimed when I told her. "That's a good thing, Beth, you're gonna love it." Nina, sixteen years older than me, had had breast cancer four years earlier. She had stage-three inoperable cancer and had been given eight rounds of chemotherapy before eventually having a double mastectomy. She also had twenty-eight rounds of radiation, and wigs, chemo sickness, the works. Nina knew everything there was to know about breast cancer, it seemed. She told me things like "If you smoke a cigarette during your breast radiation, the skin on your breast will turn black." That's what a chemo nurse told her and Nina never questioned it. She was my cancer coach, and my mentor.

"Great," I said, "can't wait!" I was always trying my best to stay positive in front of anyone. Little did I know that the port would prove to be worse than the partial mastectomy.

It was day-surgery. I was directed to the basement of the hospital. It looked like the geriatric ward—full of men with pacemakers and wispy hair, balm on their heels, coughing and humming Benny Goodman songs. The predominant scent was pine, or maybe it was Old Spice. I liked it, and I felt safe around them. I was just hoping I wouldn't puke in front of anyone and that my gown wouldn't fly open and that I wouldn't simply have a stroke and die, embarrassing myself.

I horsed around, of course, and had a great afternoon in my favourite Slayer sneakers and the hospital gown labelled "Property of VGH," which I threatened to steal. I had already had my hair cut short, and I felt pretty great by then. I mean, they had already cut the tumour out.

In fact, I felt fucking fantastic! That's the thing with cancer: often you don't even feel that sick. But I assure you, I felt so good in comparison to how I had felt, even just a few days after they cut out the tumour. I marvelled at the idea that I could have just not found it and left it growing and growing.

I maintain that everything happens for a reason. This theory drove my dad crazy—he believed it was just a way to frame stuff and justify it. He said I am a "great justifier" and a "shameless predestinist," and that holding this theory enabled me to find a reason for anything. But I still believe it, even if the truth may be that I simply enjoy believing this. I had breast cancer for a reason. Cancer shows a person who they really are, and it also shows a person who their spouse is and who their friends are, and who the grocery store cashier, the bus driver, and bandmates are. Cancer, I believe, is the great revealer. Meanwhile, I had to soldier on and get through it.

I could not have anticipated that the port, with its catheter that ran down my neck and into my jugular vein, would limit the mobility of my neck. I was in twilight during the portacath implantation, when the plastic tubing was threaded into a vein, but fuck! I could not turn my head for days. Even after that, I had a limited range of motion.

Nor did I know that the port would bulge beneath my skin below my collarbone like a bottle cap trying to push its way out. This is common but was even more pronounced on me because of my lack of body fat—I was athletic but very underweight. I was incapacitated for a couple of days afterward, and shocked by how uncomfortable I was. My chemotherapy would start one week later, when they'd stick the needle and the cancer drugs and medicine in there.

I had bought new shoes for the occasion and carefully laid my clothes out on the bed. I had made a big tub of hot-air popcorn to take with me, as I knew the treatment would be almost six hours this

first time, as the drugs needed to be administered slowly in case I had a bad reaction. I had laughed when they told me this. "Bad reaction? To chemo?" I found this funny—did they mean to be ironic? But I put on a brave face and so much makeup I looked like a Kabuki dancer. I wasn't a cancer patient, I was Bif Naked, whether I wanted to be or not.

There were four chemo chairs, one in each corner of the tight room, with the IV stations beside them, waiting for each patient's mix-in-a-bag, plus the glorious sodium chloride that patients get in order to stay hydrated. I hated the sodium chloride. It makes a girl puffy, and let's not forget, I was rail thin and had every intention of keeping it that way.

One of the chairs was unoccupied. The guy to my left was well dressed. He wore beautiful black loafers and a dress shirt under a plum sweater. He was already hooked up and underway, the IV in his hand. He smiled at me.

"What are you in for, brother?" I said, doing my best Don Rickles impression.

He smiled again. "Colon cancer. Second time." We fell silent, as if waiting for organ music.

Then I said, "*Second* time! Exciting!"

He laughed. "Yeah, I guess it is."

The nurse was flushing my virgin port and hooking up the line. *Snap.* The needle pierced my skin over the weird bottle-cap implant like a knitting needle slamming through a taught snare drum. "Perfect," she said, and busied herself with the machine settings. I remained fix-ated on my neighbour.

"What's your name? I'm Beth."

"Paolo."

"You got an ostomy bag?"

Ten minutes of silence must have passed before Paolo laughed.

"Yes," he said.

"Let's see it!" I squealed.

He was laughing at me. "You're kidding."

"Come on! I've never seen an ostomy bag." I was kicking my feet, which were dangling in the La-Z-Boy-style chemo chair. I forgot all about my port and the drip. Not only did Paolo show me his ostomy bag but he shared stories about the perils of dating. Eventually, the woman across from us, Grace, bald and frail from lymphoma, joined in the laughter.

I believed my experience that day set the bar for me, personally and spiritually, and I figured out that all I had to do was never ever shut my mouth. Not for a second, not ever, in order to get through cancer and for everyone else to get through theirs. People were always so fearful and shy and quiet in the chemo unit and the waiting rooms, and I just couldn't stand it. I was on to something: as long as I kept talking, others would add to the conversation, answer the stupid questions I asked, or simply say something to be polite. I would kill them with kindness and force them to talk, even if it was just to make me shut up.

When I finally met Dr. Gelmon, an oncologist who was recommended to me by a chemo nurse and whom I would end up seeing regularly, I was an instant devotee. She was my Dhanvantari, my goddess. She floated into the room with her fluttering beautiful eyes and easy smile. She wore a blazer, long skirt, and killer boots—knee-high with a heel. I was taken by her worldly demeanour. Karen Gelmon is a warm and supportive doctor, a researcher, an author, a scientist, and a compassionate woman. She is also a wife and a mother. She really seems to do it all. I was in awe of this woman.

I enjoyed our meetings very much, always deferring to her expertise. She was encouraging and positive. When she said, "We are going

to beat this, Beth. You are going to beat this," I believed her with every cell of my being.

I called this year of having cancer and the subsequent treatment the Year of the Tit, and it would reveal so much more than my bone marrow biopsy ever would. It would reveal more about my own resiliency and patience than I ever had imagined possible.

Somewhere along the way, my marriage ceased to exist, unofficially anyway. My husband seemed a figment of my imagination. But I continued to be optimistic. I went to the recording studio every single day. My managers had moved our recording studio up the block from my apartment so I could walk there, even though it was uphill. Once the effects of chemo had subsided enough for me to get out of bed, I would drag my feet up that hill, like Quasimodo, one foot after another, hands shoved in pockets. There were only two times in any given day that I allowed myself to cry: in the morning in the shower, where I could freely sob without detection, and at night when I washed my face and brushed my teeth.

I was bald and covered my head with my Boston Red Sox baseball cap, an embroidered "B" emblazoned on it. I wasn't a big follower of baseball, but I sure liked the "B." All my ball caps were now too big for my hairless head, and I looked pretty sickly. Just a few months earlier I had been in the prime of my life, and now here I was, reduced to a puffy, yellow-skinned woman with a surgical port in her chest and a great big dent in her left breast.

I didn't look like Bif Naked; I looked like a bald, yellow, fat frog. I was self-conscious, and every day I had to eat the shame I felt, confessing to no one, swallowing my embarrassment. I felt I had no one to confide in, not even those closest to me, like my mom, or Peter or Naz—for some reason, I thought that I was expected to be Miss Positivity. But deep down, I just felt too ashamed to talk about my

illness and failing marriage. Thankfully, I still sounded like Bif Naked, and I started making my record.

The recording studio is generally a place I dislike, but it was better than being at home, given my domestic situation—I was finding it very difficult to be around my husband, who I felt often blamed our problems on my cancer. So to the studio I went for my escape, and the production of *The Promise* album went ahead as scheduled.

My sanctuary would become what I called the cancer gym, which was a clinical trial group study I volunteered to participate in—a randomized, controlled national clinical trial of combined aerobic and resistance exercise in breast cancer patients receiving chemotherapy, also known as the CARE Trial. The principle investigators were Dr. Gelmon, Dr. Don Mckenzie, and Diana Jespersen of the University of British Columbia's sports medicine centre.

I was the first woman in Canada to sign up. Eventually, ninety-nine other women joined me in the Vancouver portion of the study, and we became a sisterhood. Three times a week, we all went down to the cancer gym, where our hour-long individualized exercise sessions were supervised by trained staff. I was determined to exercise as usual—every day, like I once had—during my cancer treatments, determined to control what I felt like and looked like. Control was the goal, but I soon learned that I could control nothing, not how I looked, not whether I survived breast cancer, and not whether my marriage survived. But I was still determined to give my survival my best shot.

I managed to get through the chemotherapy, despite the malaise and unpredictability of it. My hair started to grow back—lanugo, like babies have, that downy-soft fuzz that allows your bald head to shine through. I felt like a lady monk, and I loved it. I felt better every week.

The radiation was focused directly at my breast, five days a week for about four weeks, with sixteen regular rounds and a few booster

doses. These were supposed to reduce recurrence of the cancer by 70 percent. A CT scan had been done to determine precisely how I would be positioned so that the radiation beams would go where they should go, and spare my healthy tissue. Two small dots of ink were tattooed on me, one in the centre of my chest and one on the side of my left breast.

The technicians doing the tattooing were serious and focused, no matter how hard I tried to make conversation with them or joke. I assumed the cancer centre would have tattoo guns, like at the tattoo shops. When the women pulled out an ink bottle and a rather large needle, the size used for sewing leather, I laughed.

"Just like in jail!" I exclaimed. They did not laugh. I lay quietly on the table and let them do my tattoos in peace. I still call the dark-blue dots my jail tattoos, and they remain favourites.

The daily routine of radiation therapy was at first a pleasure for me. No longer sick from chemotherapy, I was happy to move ahead with my treatments. Although I still went to the chemo unit every three weeks for infusions, it was the antibodies/immunotherapy I was now receiving, not the chemotherapy drugs, and I was growing enough curly hair that I looked like Jerry Seinfeld. I loved this. Radiation would surprise me with its incapacitating fatigue, but I continued to work and record my record, with Jason Darr co-writing, producing, and playing.

*The Promise* was released in 2009, just three weeks after my ovariectomy, which was the cherry on top of my cancer treatment, the last nail in the coffin for that evil estrogen, to rid my body of any growing tumour. This meant that I would promptly go out on a national tour, whether I was ready or not, to support the album. I looked thirty pounds heavier and now had a terrible complication that I had not counted on (likely caused by a blood clot that formed in my surgical port): I'd choke constantly, my face and neck turning purple. This

happened at almost every concert we played, even after the surgical port had been removed to try to fix the clotting problem, leaving a piece of plastic tube lodged in a vein directly under my collarbone, and leaving me to get the last few rounds of treatment before I left for tour via a vein in my hand. I think of this scar by my collarbone as a commemorative badge and feel lucky to have it. In my world, scars are badges of honour.

We did a show almost every single day on that tour. By the end of each performance I was embarrassed about my neck and face swelling up and impeding my ability to perform. I was always exhausted and struggled every night. Sometimes I felt ashamed and stupid, and I lost my confidence. It seemed as though there were no faces in the crowd, just a sea of iPhones recording and streaming images of my swollen face to the universe.

Entire performances were uploaded to the Internet before we were even back at the hotel after the show. I felt humiliated and disillusioned. I wanted to quit playing music all together, didn't want to tour ever again. I was feeling so bad about myself that I wished I were still in treatment. I wished I were sick just so I wouldn't have to feel ashamed about my appearance all the time. I felt like a huge failure.

What saved me out on the road was my band: Flavio Cirillo, J.D. Ekstrom, Joe Veltri, Eddie Tiegs, and Doug Fury. They never judged me or said one word about my purple face or my obvious fragility. They were tremendously kind and supportive, and I felt completely safe with them. They were my protective big brothers, who helped me every day. They made me laugh and we had a good time together. I was caught between feeling like a failure and grateful for being with these great musicians and friends, and back on the road.

Being Bif Naked was all I knew how to do. But I was determined to be positive and optimistic, unfailingly. "Every day was a gift," I thought, and now, after surviving breast cancer, that was even more true.

# THIRTY-NINE

THE TRUTH IS THAT I ACTUALLY LIVE A LOT LIKE my bichon frise, Annastasia, lived. She didn't have an off switch—it was all or nothing. Same with me. When anything in life came my way, when the great bag of life spilled before me, just like Annastasia would attack a bag of dog food left on the floor, I'd rip it open and eat the contents until there were no more, then I'd stick my head in the bag, risking stomach ache and even suffocation, to finish every last morsel. And then lick the destroyed bag clean. Life, love, career, touring, recording, my dogs, it was all or nothing with me.

Annastasia Louisa Monalisa Molinare was her full name. She deserved this name. Anna was regal. She was unyielding, completely unstoppable. She never stopped eating, never stopped wagging her tail, never stopped loving. No matter what anyone ever did or didn't do, Anna kept being Anna. I am pretty certain that if terrible things had ever befallen Anna, like many abused dogs, she would not only have forgiven the person who hurt her but go on to love them, and try to make them happy, even more feverishly.

The first time Annastasia had a surgery, she was a year and a half old. She had torn her ACL chasing Nicklas, my Maltese poodle, around Ian's and my apartment. She was barking and laughing as she tortured poor Nicklas. Until she let out a dog-scream (referred to by

many as a yelp, but for me it's a scream) mid-run, then quickly turned and hid under the bed.

I didn't know she had a torn ACL when I took her, crying and limping, to the vet, but I knew something had happened. I'd do whatever I could to make her feel better. Annastasia had surgery and recovered completely and before long was running and chasing her beloved Nicklas again. Then, about a year later, she tore her other ACL, had surgery again, and again recovered completely.

Then that summer, Annastasia started deteriorating for no apparent reason. Her organs were failing. I believe she may have been poisoned, maybe from eating something at the park. It was heartbreaking. I took her back to Canada West animal hospital, which offers the best pet care money can buy in western Canada. It's where you needed to go if your dog was dying for apparently no reason. Like any parent, I would do anything to save my child. Annastasia stayed at the animal hospital for about ten days, heading downhill, and I went to see her every day, twice a day, without fail, both with and without Nicklas. Her tail wagged and she got excited every time she saw me. I worried that her IV fluids would spill out all over the place, she was so wiggly. I'd hold her, sobbing into her soft, curly hair, but trying to be brave for her.

I loved her so much and naturally was very upset. I was basically preparing to say goodbye to her. And then she started to improve, just like that. It was like a miracle. I took her and home and she eventually recovered fully. Then, almost a year later, her disc slipped. Herniated disc disease is common in people, and also fairly common in little dogs with short legs and long backs, like my twenty-three-pound bichon, Anna.

The veterinary team said that if she had the surgery to fenestrate her disc, it would mean a life without pain for her. This was all the encouragement I needed: Annastasia got her first back surgery, five

days before a tour, bus booked, venues booked, the band rehearsed, crews hired, the works. With the blessing of the vet, I left on tour with the two dogs. At every venue stop, I took Annastasia for her daily rehabilitation walks, Nicklas in tow, though he was not helpful and often required much more attention than Anna. Anna was strong and eager to play with Nicklas, and although I did my best to keep her calm, she was rambunctious.

She got physiotherapy on the bus. She would lie on her back or side as I took her little toes in my hand and rotated her hips one way, slowly and carefully, then the other way. I had it down; she was so good about it and I didn't skip it a single day, despite my heavy schedule. Anna never complained, even when she had to walk with a big sling around her belly to aid her in her recovery. After many weeks of this, Nicklas was eager to resume his place as the centre of attention, but he was incredibly patient and seemed to intuitively know that this was Anna's time.

Those two little dogs were always so happy on the tour bus, sleeping in my bottom bunk with me, especially Annastasia. And what a time she had on tour. She made the rounds, climbing into every bunk on the bus to share a special snuggle, with band and crew alike. Annastasia loved everyone and everyone loved her. It took about ten weeks for her to make a complete recovery, and by the time we went for her checkup in Vancouver, Anna was able to run in the door, excited as she was to see the team she knew so well.

I always believed Anna's truth was that she lived for the happiness of others. Nicklas was shyer, more interested in being with me than anyone else. The Maltese in him, his loyalty, kept him skeptical of others and a bit of a fear-biter, a teeth-gnasher, and a barker. He'd behave well in order to get deli-tray snacks snuck to him by the band. Annastasia, on the other hand, was a saint all the time.

Over the course of the next decade, Annastasia would have more herniated discs, and she'd go through the surgery and subsequent rehab and recovery every time. And at every single checkup, she would be running, giddy and barking, straight into the vet to thank everyone for her mobility. Once she was fully recovered, she continued to thrive and excel, year after year, and she was always-pain free for at least another two years, in between surgeries. The girl was invincible and sweet.

Until one Sunday morning, in 2008, just after my cancer radiation was completed and all I had left to do was get through the rest of the infusions and finish recording my album. My little bichon once again lay on the floor in the bathroom, where it was cool and dark, and for the second time in her life she did not come to the kitchen for breakfast when the rice cooker shut off. This was a big, fat red flag. That *click* of the rice cooker shutting was Anna's dinner bell. She never missed it—she could hear it in the middle of her dreams. It would wake her out of the deepest sleep.

Anna's last back surgery had taken place on the first day of my chemo treatment, only a few months before. I couldn't imagine a disc had slipped again so soon. She was ten years old, and I knew that the time might come when the operations lost their miraculous effectiveness and we'd have to seek supportive methods, like anti-inflammatories or pain medication. I sighed and kissed her, pressing my cheek against hers. "Don't worry," I whispered, "Mama get everything better."

I called the animal hospital. The receptionist knew my voice. "Is it her back?" she asked.

"I'm afraid it is. Can we come?" I was pacing.

"We'll get her into ultrasound and assess what's happening before the neurologist comes in this morning."

I carried Anna, quiet and still, down to my car. The drive to the

animal hospital took around twenty minutes. I didn't speed because I didn't want to jostle Anna. I had left Nicklas at home with Ian—Anna needed my full attention. The staff at the animal hospital took Anna from my arms and told me to go get a coffee—they would do an ultrasound and call me in a couple of hours once the surgeon had reviewed the images. I thanked them and returned to my car. I figured I should go home and get Nicklas's daily routine started—I was confident he had not yet been taken out for his morning walk. As I pulled up to my building my cell phone rang. It was the animal hospital asking me to come back for an emergency meeting.

"Beth, it's not her back," the vet said.

I was alert. "I see." I was steady, listening intently. The ultrasound had revealed that Annastasia had a tumour in her liver, which was leaking and about to burst. They did not expect Anna to live, and had put her on pain meds to keep her comfortable. I asked what they could do, and they said there was nothing other than keep her alive with chemotherapy for a few more days. I was numb. "I need to tell my family," I said.

"Take your time. She's sleeping comfortably now; she's fine."

"I'll be back there in about an hour. Is that okay?" My mind was racing.

"Take all the time you need."

I parked the car and went to Peter and Naz's suite, and we called a family meeting. Naz and I were both crying, and Peter offered to accompany me back to the animal hospital. He drove, and we were both silent the whole way.

We were met by one of the senior vets, who explained that although we could keep Annastasia alive for a few days longer with chemotherapy, she would have to stay in the hospital. Cancer had been detected in her blood. There was no hope for recovery. I was heartbroken. Peter

and I agreed that Annastasia would not want to be kept alive for only a few days more, stuck in a hospital and sedated and losing her functions. The vet knew what had to be done, and we trusted her. I could never have anticipated this moment, never.

She carried Annastasia, on a pillow, out to our private room, the room for families in times like these. Anna was limp and could barely open her eyes, and her breathing was shallow. She was not stressed or in pain, just quiet and still.

I lay on the floor with her, my face at her face, my mouth touching her nose. I started talking to her about how love was surrounding her and how everyone who ever had the blessing of ever meeting her loved her so much, and how God loved her so much that he needed her to go to be held in his arms. The tears covered my face and tasted salty in my mouth. I sang Hare Krishna ragas in her ear as Peter showered her with his sweet tears of affection. We left sobbing and did not talk all the way home.

Nicklas did not seem to notice that Anna never returned home. He simply went about his day-to-day barking and running and biting and eating and sleeping, never missing a beat. But I believe that he secretly knew, the way animals do, that Anna was going to die, and I like to believe that they were both okay with this. I always maintained Annastasia was a Buddhist. Perhaps it is true. Regardless, I will always miss her.

# FORTY

**IN THE TIME IT TAKES TO WRITE A MEMOIR, LIVES PASS.**

If you were to ask anyone who knows me, they will tell you that Nicklas, my dog, was the love of my life. I would have to agree. He was my life partner. For sixteen years, Nicklas was my every deliberation and my muse. He was the inspiration for most of my artwork, both cartoons and paintings, the subject of my songs and poetry, and he even had his own twitter account, @nicknaked.

From the day we retrieved him from the cardboard box in Mr. Anh's Burnaby garage in 1997, he and I were in mad love. Peter and his daughters, Riley and Brittin, and I drove out to see the seven-week-old puppy, the runt of a litter born of the Anh family dog, a poodle, and the Maltese next door.

"Very unfortunate love affair," complained the Hawaiian shirt–wearing senior citizen. "My wife very angry." And he picked up Nicklas from the cardboard crate—the last puppy left—and swiftly gave him an injection with a syringe. "Shots done," he said, handing the dog to me. "You need more shots from the vet," he added, "puppies have worms."

We drove back to our apartment downtown and played with Nicklas the rest of the evening, letting him out of his little crate every time he cried. He cried every time he went into his crate, and this set the tone for the rest of his life. He was a spoiled puppy, having

my complete attention, the attention of Peter and his two daughters, and anyone else who was around him. Nicklas was lucky to have such a loving family. He went just about everywhere with us, and I even carried him constantly, as he quickly discovered that he preferred to be carried rather than to walk. To a six-month-old Maltese poodle, this was ideal. He easily milked my sympathy, and I gave it to him in spades. This shiksa was the perfect Jewish mother.

After we found four-month-old Annastasia in Kelowna, and after she chased Nicklas, sending him running and hiding in terror, for much of the first week, life settled down fabulously for these two dogs and me. Nicklas and Annastasia were inseparable, a bonded pair. They were like my children, and I did everything for them. I cooked for them (rice and spinach or peas or chickpeas, and tuna) and took them on tour with me. Touring with two fluffy white puppies was difficult: Nicklas enjoyed immensely barking and nipping at any strangers who came onto the bus. He was a nervous little guy.

He tolerated every man I dated (and, usually, subsequently lived with), enduring both the good ones and the bad ones, and was the competition for most gentlemen suitors. Nicklas had watched me deal with some awful, awful boyfriends and as a result was ever mistrustful of men. Even when my friends hugged me affectionately, Nicklas took it upon himself to warn them that he was watching. He was my knight in white fluffy armour.

He slept on my bed with me, and I spoon-fed him papaya at bedtime. He slept in a baby onesie, as did Anna, and often wore a T-shirt to either keep him warm in winter or protect his pink skin from the summer sun. I loved to joke, to bring comic relief to the shock of this barking, snapping little dog, that I shouldn't have breast-fed him. Which I obviously did not.

Nicklas was much more resilient than Anna, who seemed to be chronically recovering from her herniated disc operations. After Anna

died, it was as if the pressure was off; he became a much more affec-
tionate dog—with me anyway. He was resplendent in Annastasia's
hand-me-down dog dresses. Nicklas was always dressed in some man-
ner of baby attire—either his baby onesies cut off at the waist (to make
the perfect doggie T-shirts) or made-for-dogs dresses and jackets.
Especially rain jackets.

He never minded being dressed. In fact, he pranced around
proudly like a glamorous drag queen being crowned belle of the ball,
although it was rather misleading. He seemed to be just begging peo-
ple to bend down and pat him, at which time he'd become enraged and
hurl all fifteen pounds of himself at them, snapping like a trap, trying
to bite them. This always startled everyone (including me, no matter
how many times he did this). Nicklas would bark relentlessly until the
shaken humans walked away from us and my apologies and pretend
scolding. He was such a naughty boy. Were he a bigger dog, his men-
acing sneakiness would definitely have got us in much hot water.

His hearing started to go when he was twelve. For the first time,
he started sleeping through the entire night (and, as a result, so did
I). For the last two years of his life, he was using a puffer, an inhaler
for kids with asthma, because of his collapsed trachea, which is quite
common in dogs of his breed as they age. His airway needed to be
kept open and clear because his windpipe cartilage had deteriorated,
causing him to sometimes have what sounded like whooping cough
and looked like an asthma attack. But most of the time, Nicklas was
healthy despite this chronic condition. He also developed Cushing's
disease, which was also common in his breed and at his age. Nicklas
had the typical symptom of excessive thirst—I placed a bowl of water
for him in every room of the apartment. He slurped and spat water
everywhere all night long. I also began to modify his diet until it was
almost vegetarian. My belief was that the more sattvic (an Ayurvedic

classification for a pure and clean way of eating and living) his diet was, the less stress digestion would place on his body, freeing his adrenal glands to do what they needed to do to compensate for his high cortisol levels, among other things. I began to celebrate every day with him and to spoil him. Nicklas wanted for nothing, and that's exactly how I wanted his life to be.

Except for his constant thirst, increased appetite, budding Buddha belly, and his hair on his back thinning to wisps, revealing his bright pink skin beneath, Nicklas was relatively asymptomatic, and we enjoyed life together a great deal. When I did have to go out of the city for work, my mom flew to Vancouver to stay with Nicklas. This was such a lovely time for him and for my sweet mother. My mom didn't like to use my car, since she was unsure of directions, so she walked everywhere. She and Nicklas went for morning and afternoon walks, and he was respectful for the benefit of his "grandmother." I don't know that *I* ever saw such good behaviour from him. It was the stuff of dreams, and when my mother described it, I was incredulous, thinking she must be talking about some other dog entirely.

Nevertheless, in my mind, he could do no wrong, and should he have been an axe murderer, I would have still loved him. There is no love, they say, like that of a loving mother. That's how I felt my mother loved me; she selflessly came to care for my animals over the years. Eventually, my mom no longer wanted to travel on an airplane, for various reasons. I had to try to understand, despite my disappointment. I had always appreciated that she would get on an airplane and come to me should I not be able to fly to her.

As luck would have it, my beloved George Finch came to the rescue. When, in 2012, I went into hospital for heart surgery to close up that hole in my heart, it was dear George who took Nicklas in. They had been good friends from the start.

Nicklas loved George, who doted and fussed over him the same way I did. In fact, I dare say that George spent more time hugging and rubbing sleeping Nicklas than I ever did. George was always such a tender friend to my animals, and of course to his own lifelong sweetheart, a beautiful cat named Spasil Rathbone, whom Annastasia had tried quite demonstratively to befriend.

Spasil had died, and George never seemed to stop missing her—until wee Nick took over George's apartment. I think the two of them were so good for each other, both were unwittingly working hard at healing each other's hearts. Nicklas went between my apartment and George's on long work days or if I had a long photo shoot, even if in Vancouver. The situation really was a blessed one for my old, increasingly sick dog. George was a blessing in Nicklas's life and in mine.

Nicklas celebrated his sixteenth birthday at home. I made a celebration dinner complete with birthday cake (and a special birthday cake for Nicklas from Three Dog Bakery). George's dad, ninety-year-old Wilfred; his girlfriend, ninety-year-old Skya; and George and I ate and laughed and wore party hats. Nicklas wore his (or was it my?) favourite baby T-shirt, which had a picture of Animal, the drummer on *The Muppet Show*, on the back, and sat on my lap at the dining-room table as we sang him "Happy Birthday" and laughed and laughed. It was one of the best days of my life.

Thirty-two days later, I would take Nicklas to the Canada West animal hospital, that familiar emergency destination, for the last time. Nicklas had been their patient four times in the past few months, primarily because of his trachea. Always treated there with tenderness and the appropriate attention, he'd be discharged within forty-eight hours and we carried on, me hugging and kissing him all the way home.

One day I thought he was experiencing the same issue, so I decided to take him to the animal hospital once again. The intake doctor and

I both thought that his idiopathic restlessness was because of the Cushing's or perhaps from his trachea, and she advised me to leave him. They'd sedate him to keep him comfortable and do an ultrasound. This was old hat for us, and the little dog was at ease with the staff. I left him there in the morning and was told they'd call me before afternoon to discuss his medication or perhaps further testing.

Instead, the doctor called me within a couple of hours and asked me if I was sitting down. I became hyperaware, and steely calm.

"Beth, Nicklas has a leaking tumour, and he doesn't have much time," she said. Her voice trailed off and I asked her what I need to do, what surgery could be done. She softly said that I needed to come to say goodbye to him.

I tried hard to maintain a steady voice as I asked if I could come right then. I stopped and picked up George on the way. I felt that Nicklas would want to see George, who had been co-caring for him for the past year. Nicklas loved George so much.

We silently entered the animal hospital. The staff led us to one of the family rooms, similar to the one Peter and I had been in with Annastasia just five years before. Anna's photograph hung on the wall of this facility, like that of many other late animals for whom the staff had cared.

Nicklas was brought in, and although he was heavily sedated because of his increasing abdominal pain, he began to wiggle and squirm when he saw me. I tried hard to be stoic and strong for my dog, lest I alarm him in any way. I took him into my arms and reclined on the small couch so he could lie on my chest, belly to belly, heart to heart. He became still and started to cry softly. I cried too, the tears running over my cheeks and lips and neck, endless rivers of love drowning me. I stroked his head. George came to sit beside us. He leaned into Nicklas and began to speak to him in whispers between kisses on the top of his head.

We stayed like this for some time, caught up in our emotions. Nicklas would close his eyes, falling asleep, and then wake up and stir slightly, only to fall back asleep again. The doctor eventually returned and had with her the blessed needle of his relief. She injected Nicklas's IV line with the dose, a combination of love and mercy, and he became quiet against me as I told him how I had loved him every day of his life and that I would continue to love him for the rest of my life. And then he died, ever peacefully, along with a part of my heart.

# FORTY-ONE

**"HEY, YOU LUCKY KID! IT'S YOUR OLD MAN! IT'S**
Dr. Naked!" I had saved this message on my voicemail to replay over
and over again. My dad always thought it was funny when his dental students, knowing that Bif Naked was his daughter, jokingly asked
him if his name was Dr. Naked. It never got old.

We laughed about absolutely anything.

The morning my dad told me he had prostate cancer, I was having
breakfast with him in the lobby bar of New Delhi's Oberoi hotel. I was
stirring four or five heaping tablespoons of sugar into my chai. "*Chini
kya ek bahut!*" he said in perfect Hindi, laughing. "Sure is a lot of sugar!"

It was the year 2000, seven years before my own cancer diagnosis, but my then sixty-six-year-old father was not at all worried about
his cancer. He and his wife—my stepmom, Anita—were living in
Ludhiana, about four hours from New Delhi by train, teaching dentistry and dental therapists at the Christian Medical College and volunteering with the United Church Mission and Service. I had come to
India to visit and had already travelled through Mumbai, Bangalore,
and Puttaparthi, arriving in New Delhi on Republic Day to attend the
parade with my father and Anita.

The cool fog of the January morning felt heavier as my father
confessed that he had been diagnosed with prostate cancer before he

left North America, more than six months earlier. I cried and asked him what they would do. I was afraid of losing him. In typical Dr. Naked style, my father laughed it off and promised to get radiotherapy as soon as he got home. But I was scared. In Canada, prostate cancer is the third leading cause of death from cancer in men.

When my dad returned to Canada in the summer of 2001, he did undergo radiotherapy, as well as hormone therapy, designed to stop testosterone from being released or acting on the prostate cells. My dad found the notion of hormone therapy hilarious, saying in a high-pitched voice "I'm fabulous!" whenever anyone asked him about his treatments. For almost a decade, my dad managed his cancer and continued to work, in the remote communities of northern Saskatchewan and Manitoba, training dental therapists and doing dental exams.

But in summer 2012, his prostate began to "misbehave," as he put it. Eventually, it was discovered that he had bladder cancer. He underwent chemotherapy at the Saskatoon Cancer Centre. Finally, in 2013, the treatments were done. But his cancer was not. Devastated, we knew the truth was that we would lose him.

My dad wanted to remain at home with his wife. Anita was a nurse and she wanted him safe and close also, to keep him happy and comfortable. I wanted to be there as much as I could. I loved being around them and learned so much from their grace. For some twenty years they had been a joyful couple, and nothing could change that.

My dad's church choir in Prince Albert came in the evenings to sing at his bedside, Dad contributing the tenor parts. I stood on a chair beside my stepmom and my mom, who had come to visit, and took pictures at his request, smiling ear to ear, though tears ran down my face. My dad was so happy.

I was writing my memoir at the time, and he was eager to help with fact checking, and confirming stories about his work with the Civil Rights Movement of the sixties. He wanted me to read my just-finished manuscript, and so I read to him for hours as he chuckled, commented, and drifted in and out of sleep. He'd wake and tell me, "Really, it's not boring," then break into laughter, teasing me about my writing. His jokes never stopped and neither did our laughs.

Anita later told me that on those afternoons, my dad in his bed and she seated beside him, they got lost in the stories; they allowed them to forget themselves, even if only for a few moments. Storytelling and laughter provided a respite, a welcome escape for all of us. We enjoyed just being together.

I am fiercely proud of my father and his courageous and noble cancer journey, one filled with love, gratitude, and laughs. He taught me the true meaning of "It's the journey, not the destination, that matters," and I will carry these memories in my heart every day on my own journey for the rest of my Dr. Naked's-lucky-kid life.

# EPILOGUE

MY SKIPPING HOME WITH A BAG OF FRESH CHERRIES for my mother might not be enough to convince me that I made her sufficiently happy.

Eating thirty or forty cherries in one sitting, to her uncontrolled laughter, would, though. So I did just that. I loved my mother's soft laugh. It was quiet and felt like feathers against my ear.

I had not seen her since my dad's memorial service in March 2014, as I had been in France most of the summer, and we both had a schedule that had kept us apart for much of the harsh Winnipeg winter. But now it was June and we had the chance to spend time together. I was in heaven. It was pure joy to be in her company. All we did was talk and eat fruit, for days on end.

We talked about my dad a lot, and about my mom's parents. She patiently answered all my questions, and I listened intently to her stories about her life. I couldn't get enough. I loved them!

My mom's apartment building, in Saint Boniface—the francophone and Catholic centre of Winnipeg—was filled with her friends, sweet, mostly Franco-Manitoban, seniors with whom I could practise "*mes mots Français.*" We were all having great fun. I learned about their stories as well, and loved to piece together some of the interesting puzzles that made up people's histories. People are always revealing

their hearts and secrets, and I loved listening almost as much as I loved talking. Everybody has a story.

And, my story, so far, had been remarkable, unusual perhaps, but utterly lucky.

I feel so lucky to have had such a life, and even luckier to have had an opportunity to write about it. Pinch me.

I had come to see my mother in between performances, having returned to my shows just two weeks before, and preparing for summer touring. My hair was long again, my tattoos freshly shined with coconut oil, my makeup trademark dark. The inevitable return to "Bif Naked" was familiar and, finally, good. With my health tumbles, stumbles, and surprises; the sadness from losing loved ones; my divorce; and many of my fears now behind me, I felt like I was finally climbing out of some other life, emerging from a cocoon.

Everything was blossoming.

I was in love with a boy named Snake (of course) and dreamed of marrying him, and of asking Peter to walk me down the aisle, and George being my "maid" of honour. Naturally.

I was back to hitting the gym six days a week, immersed in my yoga practice and volunteering, fantasizing about returning to Paris, and spending time with dogs, cats, mice, monkeys, pigs, audiences, hospice patients, or anyone else who needed me.

My mother, however, did not need me. My amazing mother was thriving. She was feeling healthier and more energetic than she had in some time, fulfilled as she was by her volunteer work of serving lunches to her neighbours in their communal cafeteria in the basement of her building. She enjoyed her routine. It's not that I was cramping her style, but she had been trying to encourage me to go home early for a few days, citing my impending schedule and that people needed me at home.

The truth was, I needed to be with my mom even if she didn't need to be with me.

She was always completely confident that I would roll with the punches, continue to handle everything thrown my way with "proper grace," and float and flutter my way through life like a butterfly dancing above the cherry trees.

Her undying faith in me, not to mention my dad's, Peter's, George's, or anyone else's, was generally all I ever needed to have faith in myself and to keep going no matter the circumstances.

It still is.

Life is good, because it's meant to be.

Life is not just a bowl of cherries, it's an orchard of cherry trees, with millions of butterflies flying over top.

I asked my mother one night if she wanted me to start reading the final draft of my manuscript to her, and she said, "No thank you, Beth. I will wait to see what it says, like everybody else."

My cancer is now a memory, my last treatment being in 2009, making me a Big Girl Survivor with five-plus cancer-free years under my belt. I still use chemoprevention to prevent recurrence, and am enjoying my full and racy menopause. I know I am lucky to be alive and am proud to have a piece of catheter tubing, left from my surgical port, in my chest, as a souvenir.

I also have my divorce papers as a reminder of my struggles. I know that I swore up and down my commitment, to my husband and to God, in that big church, and my vows I took seriously. My marriage to Ian was crushing, and I spent much of it in cancer treatment. My cancer was the best thing that ever happened to me, really, as it revealed so much more to me than if it had not been thrown into the mix. I feel bad that things in my marriage to Ian did not work out

the way I thought they would. But the cancer experience truly forced me to start really growing up, and for that I will always be gratefully Snoopy dancing.

The future is like sun rays to me, and I tilt my soul in the direction of this light. I am still unshakable in my faith in people and in my relentless positivity, and I will not ever change that. I love life, even more every day, no matter what's ahead of me. I love it all: the past, the present, and the future. My goals in life are simple, really—to make and keep everybody happy. On the stage, on the page, in the sick wards, or in my mother's kitchen. Butterfly hearts everywhere!

# AFTERWORD

by george finch

**IF THERE'S A COMMON THREAD LINKING ALL THAT** you've just read, it's survival. Clearly, Beth was blessed with a capacity to roll with the punches that would have impressed Jake LaMotta.

This is a good thing, because Beth is routinely inviting people to punch her in the face (metaphorically, at least). Selfless to a fault, she is forever choosing a course of action that is of greatest benefit to anyone other than herself, despite the inevitable toll this takes.

Beth and I both grew up in active religious families. I have long joked that she is one of the Lamed-vav of Hebrew legend, the thirty-six righteous individuals whose existence is the only reason God chooses not to pitch the universe into the trash and start over. They serve as humanity's kidneys, flushing out the toxins so the rest of us can get on with what we need to do.

Sympathy is cheap. Hallmark sells slices of it for a couple of bucks apiece. Empathy comes at a much higher cost, yet Beth has a seemingly inexhaustible supply. She resists cynicism and accepts most people (and all animals) as being inherently good and deserving of her faith in them, at least until they demonstrate otherwise.

As her book amply indicates, this belief system has led Beth down any number of dicey alleyways, with a small army of sketchy characters in tow (some of us twice). Throughout, as the song says, she has chosen

to believe that love is either in her heart or on its way. Whether or not that belief is justified, it's hard not to take inspiration from her resolve.

There are all sorts of reasons to be grateful that Beth chose to stride up and introduce herself to me that Saturday afternoon at the Dauphin mall all those years ago. Chief among them is having had the opportunity to watch Beth continue to pick herself up off the canvas, dry her eyes, look around, and observe: "Okay, so that didn't kill me . . . What now?"

# ACKNOWLEDGEMENTS

I WISH TO ACKNOWLEDGE TWO GENTLEMEN WHOSE patience, dedication, generosity, kindness, and conscientiousness shaped this book: Jim Gifford and Peter Karroll.